JOHN MALCHAIR OF OXFORD

ARTIST AND MUSICIAN

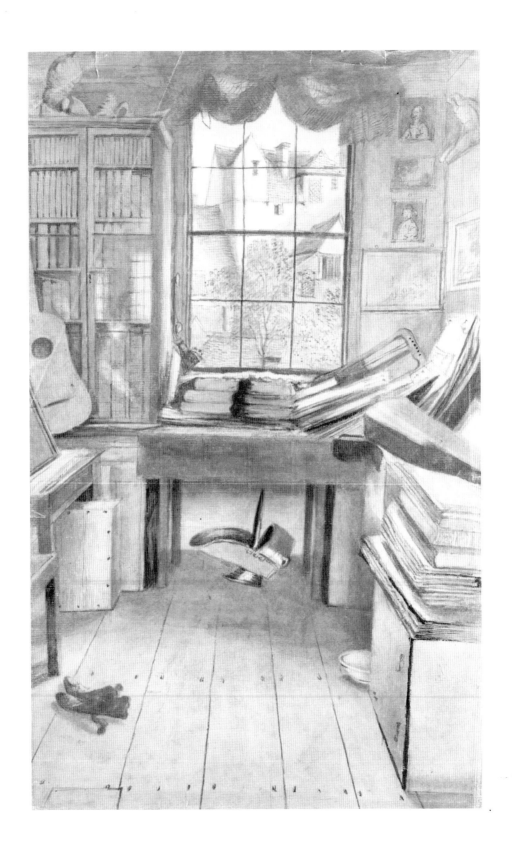

JOHN MALCHAIR OF OXFORD
ARTIST AND MUSICIAN

COLIN HARRISON

WITH ESSAYS BY

SUSAN WOLLENBERG AND JULIAN MUNBY

ASHMOLEAN MUSEUM, OXFORD 1998

In memoriam
Ian Fleming-Williams (1914-1998)

Published to coincide with the exhibition in the
Ashmolean Museum, 22 September to 13 December 1998

ISBN 1 85444 112 4

British Library Cataloguing in Publication Data:
a catalogue record for this book is available from the
British Library

Designed by Tim Harvey
Typeset in Monotype Baskerville
Printed and bound in Great Britain by BAS Printers

Frontispiece: cat. no. 82

Lenders

London, Trustees of the British Museum 15
London, Trustees of the Tate Gallery 87
London, the Royal College of Music 110
London, Cecil Sharp House, the Vaughan Williams
 Memorial Library, English Folk Dance and Song
 Society 109
Oxford, the Warden and Fellows of Green College 64, 65
Oxford, the President and Fellows of Corpus Christi
 College 1, 8, 10, 14, 16, 19, 81
Oxford, the Curators of the Bodleian Library 25, 27, 29,
 30, 108
The Rt Hon. the Earl of Aylesford 82
R. E. Alton, M.C. 73, 83, 88
Julian Munby, F.S.A. 12
David Thomson 33, 107
Mr & Mrs E.A. Williams 31, 32, 68, 85, 89
Private Collections 4, 5, 7, 24, 51, 69, 75, 80, 84, 86, 90,
 91, 92, 93, 94, 106

Acknowledgements

This is the first exhibition devoted to one of the most distinctive figures in eighteenth-century Oxford. It would have been impossible without the generosity of lenders, both institutional and private. I am grateful to all those responsible for the collections in their care.

Particular thanks are due to the following: Miss Anne Lyles, Tate Gallery; Antony Griffiths and Dr Kim Sloan, British Museum; Dr Mark Evans and Mrs Christine Mackay, National Museum of Wales; Dr Paul Joyner, National Library of Wales, Aberystwyth; Charles Nugent, Whitworth Art Gallery, University of Manchester; Dr Malcolm Graham and the staff of the Centre for Oxfordshire Studies; Robert J. Bruce, Bodleian Library, who made available his article for the forthcoming revised edition of *Grove's Dictionary of Music and Musicians*; the family of the late Iolo Williams, especially Mr & Mrs Edward Williams, and Mr Richard Keene; the family of the late Ian Fleming-Williams; Prof. Luke Herrmann; Dr Stephen Gamble; Henry Wemyss and Miss Loveday Manners Price, Sotheby's; and Walter Mitchell, who has scoured the University Archives for references to drawing masters. At the Ashmolean, Dr J.J.L. Whiteley has offered wise advice and practical help at every stage, and Miss Judith Chantry has, as usual, provided indispensable assistance in describing techniques and media. Photography has been arranged by Miss Anne Steinberg, and the photographs taken by David Gowers, Nick Pollard, Jane Inskipp, and Anne Holly.

Dr Susan Wollenberg has most generously written an essay in this catalogue while preoccupied with her onerous duties as Chairman of the Music Faculty Board; and Julian Munby has written the third essay, has prepared a complementary exhibition of photographic and archival material on *Malchair's Oxford* at the Centre for Oxfordshire Studies, and has patiently guided a novice through literature more familiar to antiquaries than art historians. Leslie Parris of the Tate Gallery provided at very short notice the tribute to Ian Fleming-Williams, and David Thomson has made possible the publication of this catalogue.

My greatest debt is to Ian Fleming-Williams. His gift to the Ashmolean in 1996 inspired this exhibition, and on several visits I made to his house at Batheaston, he eagerly communicated his notes, knowledge and enthusiasm. I have also made extensive use of the chapters of his unpublished book on Malchair and his pupils. In person and in his writings, he has guided the selection of the works exhibited, and the compilation of this catalogue. I only wish that he might have lived to see the results.

Colin Harrison
Ashmolean Museum

Preface

This catalogue is dedicated to the memory of Ian Fleming-Williams, who died on 6 March this year, at the age of eighty-four. Although he became a leading Constable scholar, his first art historical research was into the work of John Malchair and other eighteenth century drawing masters. He was one of the pioneers in this field, both as a scholar and as a collector. This first ever exhibition devoted to Malchair would not have been possible without access to his published and unpublished writings on the subject, while nearly a third of the exhibits at one time belonged to him, including many items which he presented to the Ashmolean Museum in 1996.

Appropriately, it was during Fleming-Williams's years as the art master at Charterhouse (1947-70) that he developed his interest in his eighteenth century predecessors, and in Malchair especially. A novel and inspiring teacher himself, he readily appreciated the originality of Malchair's methods. Malchair's musical activities were another attraction for Fleming-Williams, a viola player with a lifelong passion for music of all kinds. A love of the Welsh mountains was something else they had in common. In 1995, Fleming-Williams chose to mark his long association with the Tate Gallery by presenting to it *Moel-y-ffrydd*, perhaps the finest of Malchair's Welsh drawings.

While teaching others, Fleming-Williams was also teaching himself. As an art historian, he was a self-taught amateur who, by the late 1960s, had become a consummate professional, though he never saw himself as such. It would be difficult to exaggerate the importance of his

subsequent contribution to Constable studies, not least to the understanding of the drawings. Malchair proved to be a training ground, but Fleming-Williams also realised that there were historical links between Malchair and Constable through two of Malchair's pupils, William Crotch and Sir George Beaumont. Constable appears to have known Crotch by 1805, when he adopted the latter's schematic, ovoid tree forms in his own watercolours and drawings. And the character of Constable's work in the Lake District in the following year, Fleming-Wiiliams argued, would be partly explained if Crotch had shown him the Welsh drawings which had passed to him from Malchair. The work of Malchair and Crotch certainly influenced the tonal technique that Constable so brilliantly developed in the first two decades of the century. In co-opting him as a Member of the Great School, Crotch clearly saw Constable as working in the same tradition as the Oxford group. Beaumont played a larger part in Constable's life, acting as his mentor for a number of years from *c*.1795 onwards; after 1819, when Beaumont praised *The White Horse*, they established a more equal relationship. In his early years, Constable benefited from studying not only Beaumont's Old Masters, but also Beaumont's own paintings and drawings, some of which sprang freely to mind on his tour of the Lake District in 1806. Beaumont's Lake District oil studies of 1807 may have played a role in Constable's return to outdoor oil sketching in 1808, and Constable sufficiently valued the baronet's Stour Valley drawings to make copies of them as late as 1823.

When, around 1970, Fleming-Williams decided to devote himself to Constable, he was returning to one of his earliest loves. Although trained in the Royal Academy Schools between 1930 and 1934, he used to say that what really inspired him to be a painter was one of the works included in Wildenstein's Constable exhibition in 1937, a small oil study of a hilly landscape under an expansive sky, then known as a *View in Kent*. In recent years, this picture hung on his own walls, on loan from his good friend David Thomson, but it did so not as a John Constable, but as a work by his youngest son, Lionel. Having decided before the war that he had, after all, nothing to say as a painter and having then become an art master, Fleming-Williams eventually developed his art historical skills to the point where, in the late 1970s, he could help make that masterly reattribution and finally come to terms with the source of his inspiration forty years earlier. The main purpose, of course, was to define more closely the *oeuvre* of John Constable, but in the process, Fleming-Williams had helped resurrect an unjustly neglected artist, performing for Lionel Constable the kind of service he had already rendered John Malchair. Above all, Ian Fleming-Williams had a wonderful ability to open other people's eyes, and in this, perhaps, lies his deepest connexion with the subject of the present exhibition.

Leslie Parris
Tate Gallery

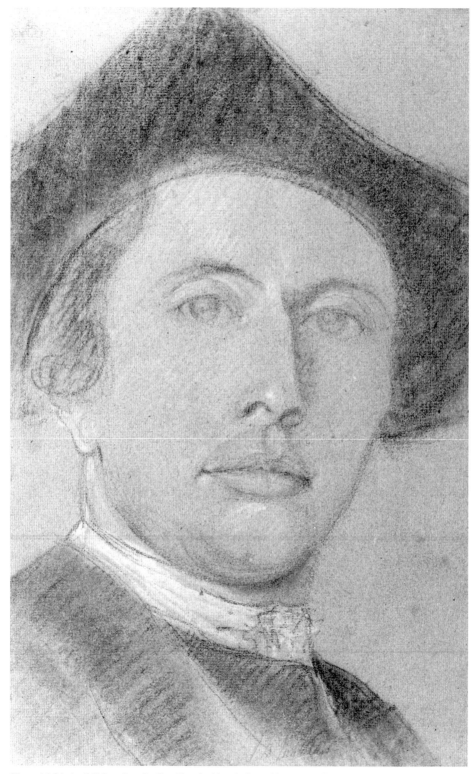

Fig. 1. Malchair, *Self Portrait*. 1765. Pencil and white chalk on blue paper. Brown, no. 991

Malchair the Artist

by Colin Harrison

In his inaugural lecture as Slade Professor of Fine Art at Oxford in 1870, John Ruskin claimed that he was 'introducing, among the elements of education appointed in this great University, one not only new, but such as to involve in its possible results some modification of the rest'.[1] Although this was substantially true, it denied any place to a succession of drawing masters, some officially granted permission to teach members of the University, and others working on a more informal basis. The most important and influential drawing master in eighteenth century Oxford was a German violinist, John Malchair, who for over thirty years supplemented his meagre earnings as leader of the band at the Music Room by giving drawing lessons of a kind unique for their period. For his pupils spent only the minimum time in copying the work of the Old Masters and other suitable models, and quickly learnt that sketching from nature was an end in itself, not merely a step on the road to making historical landscapes or compositions elaborated in the studio or at home. Working in a provincial backwater, he could afford to ignore contemporary aesthetic debates, and quietly continued to develop his responses to landscape, in a style that was as unconventional as it was effective. Each of Malchair's drawings was seen by only a few individuals: his pupils and those who accompanied him on a particular sketching expedition, and the friends who were shown the sketchbook or portfolio afterwards. He exhibited only once at the Royal Academy; only two of his drawings were engraved and widely distributed, although reproductions of several more were published by Malchair himself; he made only a handful of etchings, with an extremely limited circulation and no commercial exploitation; and no oil paintings. Yet his influence was wide, and the discoveries he so painstakingly made were later rediscovered by far more prominent painters in the nineteenth century. Among his pupils were Sir George Beaumont, the driving force behind the foundation of the National Gallery; the fourth Earl of Aylesford, among the best amateur artists of the period, and the architect of one of the most radically original neo-classical buildings in England, the church at Packington; and Dr William Crotch, first President of the Royal Academy of Music, prolific amateur artist, inventor of the 'Great School' which perpetuated Malchair's teachings well into the nineteenth century, and friend of John Constable.

Early Life

Joannes Malchair (fig. 1) was baptized on 15 January 1730, in St Peter's Church, Cologne, the eldest son of Joannes Malchair, a watchmaker, and Elizabetha Rogeri, who had been married in the same church on 21 April 1727.[2] The family lived in the Sternen Gasse, in a humble house next door to that where the Rubens family spent a difficult period between 1578 and 1587.[3] The young Joannes applied to join the cathedral choir as an alto on 2 October 1744, and was admitted a fortnight later; it was left to his younger brother, Cornelius, to follow in his father's trade. He successfully negotiated the break from alto to tenor, but resigned when he was twenty-two; his successor was appointed on 26 February 1751.[4] After leaving his moribund native city,

he moved to Nancy, the thriving capital of Lorraine, where he presumably practised as a musician. He also began to draw landscapes from nature, at least one example of which he preserved and was able to show Farington some fifty years later.[5]

In c.1754, Malchair came to England, and, apart from short tours of Wales in his retirement, he never left his country of adoption. England was not only a popular destination for immigrant musicians, but Malchair also had more personal reasons: he remembered from his childhood 'the good humour of ye English centinels who would shake hands with him, and let him ride on ye gun'.[6] He settled first in London, where he 'taught music on cheap terms to mechanics &c school [and] also got into little concerts at public houses'. It was at this period of his life that he 'became a drawing Master before he cd speak English to a boarding school at the instigation of a French Master of ye same school who managed it all for him'. He was restless, however, and when he met one of the English officers, a certain Captain Bonfield, who had known his father at Cologne, Malchair followed him to his quarters at Lewes in Sussex.[7] Bonfield introduced him to the young Sir William Hamilton, whose acquaintance seems to have brought him no profit; and to Robert Price of Foxley, who was to have a profound influence on his life and career.

Price was, in effect, Malchair's first important patron and one of the most cultivated squires in England. Born in 1717, he made the Grand Tour between 1738 and 1741, during which he took drawing lessons from Giovanni Battista Busiri and studied music with Andrea Basili in Rome. Together with William Windham and his tutor, Benjamin Stillingfleet, he later formed the Common Room Set at Geneva, devoted to mountaineering, art, music, theatre, and practical jokes. When the group dispersed in

1742-3, Price went to Paris, where he met the engraver, Jacques-Philippe Le Bas, who 'was just come from walking … it is his custom when he walks out, to take his book with him, and in case he sees anything picturesque, to sketch it out.'[8] In 1743, Price married Sarah, sister to the second Viscount Barrington, and returned to his estate at Foxley, which he set about improving. The changes were always made to emphasise the natural qualities of the existing landscape, not, as his contemporaries were doing, to create artificial vistas taken from paintings by Claude and Gaspard Dughet. When visiting Foxley in 1756, Dr Richard Pococke commented that it offered 'altogether the greatest variety of prospects I ever saw without going two miles from the house'.[9] Price also continued drawing, not in Busiri's stylised penwork, but in a more sophisticated mixture of pencil and wash (fig. 2). He toured Wales in 1758 and 1759, keeping a diary and making sketches as he went, one of the first to undertake such an expedition.[10]

At Foxley, Malchair was no doubt employed as a musician, but must also have taken informal drawing lessons from his patron, and adopted his habit of using a sketchbook: in a note in his own first sketchbook of 1757, he wrote:

> The first lot of drawings after Nature. The few attempts I made before this were on single papers. The method of drawing in a book was adopted from Robert Price, Esqr. of Foxley in Herefordshire. From him I received a deal of useful information [instruction scored through] respecting the art of drawing, for he was himself an excellent artist as well as patron.[11]

Malchair also followed Price in his use of pencil and wash, an unusual combination in England, but one that had been much used by Jan van Goyen and other Dutch artists in the previous century. Finally, a distinctive feature of this first sketchbook is the careful

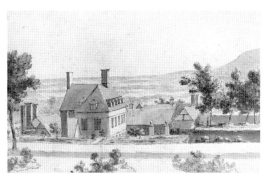

Fig. 2. Robert Price (1717-1761), *A View from the Parsonage Garden at Ross.* pencil and grey wash on laid paper, 176 × 279. Presented by Ian Fleming-Williams, 1996 [1996.500]

inscriptions on the backs of the drawings, the date (but not yet the year), and the place. From these inscriptions, which became increasingly detailed over the years, we can follow Malchair's movements and his development as an artist. The subjects are mostly landscapes around Bristol or in Herefordshire, with a brief visit to Lewes in July 1757, and another to London in 1759. His drawings are already very varied, some schematically drawn in pencil alone, more often in pencil combined with painstakingly applied grey wash.

From the surviving drawings, we know that Malchair spent more than two years at Bristol, where he lodged at Stony Hill (Brown, no. 1219), and worked as a musician. Among his associates was Edmund Broderip, organist of St Mary Redcliffe, whom he described as a 'good-natured, worthy man'; and his tailor, one Hagley, who 'took Drawings of Artists by way of payments for Suits of Close; he also loved and Patronised Music.'[12]

Oxford

After making his first appearance at the Three Choirs Festival in September 1759, where he was to play annually until 1776, Malchair came to Oxford to compete for the position of leader of the band at the Music Room after the death

of Thomas Jackson. Through the influence of the Revd and Hon. Shute Barrington, Robert Price's brother-in-law and one of the stewards of the Music Room, he won the competition, and made his first appearance either at the Widow Jackson's benefit on 29 November or the choral concert on 12 December. He must surely have been appointed by 27 November, when he felt sufficiently confident to make his first drawing of his new home, a feeble effort in which he seems to have forgotten all the lessons he had taught himself at Bristol.[13]

When Malchair arrived at Oxford, the city was known principally as the seat of one of the two ancient English universities, and essentially contained within the mediaeval city walls. As the first guidebook to the city, published in the year of Malchair's arrival, described,

> *The Town is situated on a broad eminence, which arises so gradually as to be hardly perceptible, in the midst of a most beautiful extent of meadows, to the south, east, and west, and corn-fields to the north. The vales on the east are watered by the river Cherwell, and those on the west and south by the main stream, and several branches of the Isis. Both rivers meet towards the north-east. The landscape is bounded on every side, the north excepted, by a range of hills covered with woods. The opening to the north admits a free current of fresh air, and entirely removes all the inconveniencies, which would otherwise arise from the noxious vapours of a watery situation. From some of the surrounding hills, the traveller is entertained with an unparalleled prospect of magnificence and plenty; of numerous spires, domes, and turrets, with the combined charms of verdure, water, and trees. The soil is a fine gravel; and on the whole, the situation is not less healthy than agreeable.*[14]

As an earlier foreign visitor more succinctly wrote, 'Were it not for the more important colleges, the place would not be unlike a large village' (fig. 3).[15] Walking was naturally a

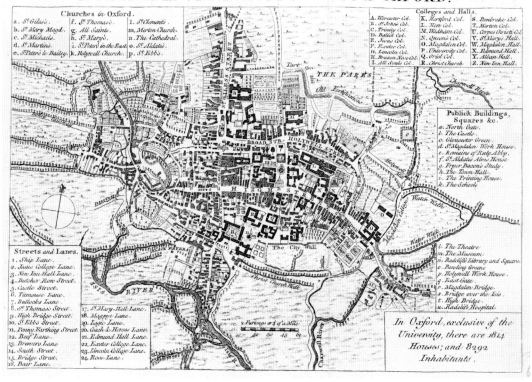

Fig. 3. Map of Oxford, from *The New Oxford Guide*, 1759

popular pastime in such pleasant surroundings, among both dons and undergraduates, in the streets, in the college gardens, and farther afield to the nearby villages, to Headington in the east, with its magnificent views from Shotover Hill; to Binsey and Medley in the west; to Kennington in the south, and to Wytham towards the north.[16] The city was also one of the principal centres of print publishing and selling outside London, and the monuments provided antiquarian and topographical artists with ready subjects.[17] Among innumerable publications of this kind, one of the most remarkable was the reprinting of Ralph Agas's map of 1566, under the title *Ancient Oxford Restored*, 'to which are now added in the margin complete and accurate representations of the college Public Schools and Divinity School as in 1566 drawn by T.

Neal STB, price 4 shillings'.[18] Finally, there was a significant tradition of patronage and collecting: the Bodleian Library was perhaps the oldest picture gallery in England, and colleges regularly commissioned portraits of their Fellows and Heads to hang in hall.[19] Yet the University gave little thought to teaching art or its history: even General Guise's magnificent bequest of paintings and drawings to Christ Church was not made with the specific aim of providing material for education in the fine arts, but 'in order that the same shall be preserved, as the collections are very good, and that none of them or any part thereof shall be at any time sold, but kept for the use of the said Colledge.'[20]

As Julian Munby shows (see pp. 45-56), Oxford was a fashionable home for topographical artists, but for those with higher

claims, it did not provide the necessarily varied viewpoints, nor, owing to the great wealth of some of the colleges and the building boom of the seventeenth century, enough picturesque ruins. It certainly did not appeal to the high priest of the cult of the Picturesque, William Gilpin, who, whether as an undergraduate or visitor, spent no time drawing it. So, on his planned tour down the Thames in 1764, he omitted the journey from Oxford to Windsor because 'the character of the Thames is rural …[it] passes chiefly through meadow-lands, and scenes of cultivation,' both antipathetic to the pilgrim in search of the picturesque.[21] Later, his opinions hardened: at the beginning of the tour of the Wye Valley in 1770, he travelled through Oxford, but noted that between Wallingford and Oxford, 'there is nothing very interesting in these scenes … we did not observe one good view, except at Shillingford;' while between Oxford and Ross-on-Wye, he made the specific objection that 'none of these landscapes however are perfect, as they want the accompaniments of foreground.'[22] Nor, as we shall see, were there many rivals for the position of drawing master, although, as Malchair later told Farington, 'Oxford being a national seminary was a desirable place for an Artist to settle in as He might become known, as was His own case, to persons coming from every district in the Kingdom.'[23]

Malchair quickly settled into the rhythm of rehearsals and concerts required at the Music Room, and took his first pupils for drawing very soon after he arrived. He married Elizabeth Jenner, a minor, at St George's, Hanover Square, in London, in 1760, and later declared this to be the 'happiest event of my life.'[24] The marriage was barren, but Mrs Malchair offered support and companionship to her husband. She took drawing lessons in the late 1760s,[25] and participated in the vogue for etching in Malchair's circle in c.1770.[26] She

also kept him company on his walks, not the expeditions with his pupils, but the more gentle rambles around Christ Church Meadows or down the lane to Ferry Hinksey (cat. no. 67). It is tempting to identify a female figure who appears as a motif in several of the drawings of the early 1770s, always with her back towards us, as Elizabeth Malchair.[27] When she died, 'after a lingering illness' which may have been consumption, on 14 August 1773,[28] Malchair was deeply affected, and in later years frequently thought of their happy years together.

As a draughtsman, he took some time to get into his stride, and his ouput during the early 1760s was tiny. For the mid-1760s, many of the slighter drawings have disappeared, leaving only finished and painstaking studies. In general, he used pencil mixed with grey wash, but whereas Price used both conventionally, the pencil for outlines and the wash for indicating mass and shadow, Malchair mixed the two, making only faint exploratory outlines in pencil and combining wash and pencil, almost indistinguishably mixed, to create tonal drawings of great complexity which reveal their secrets slowly. 'With the range of expression this innovation provided, he was able to respond to a host of new visual impressions and in consequence to turn a composition, which any topographical artist of the time could have chosen, into a work which transcended contemporary experience.'[29] On one occasion, he experimented with colour, but the view of Kirtlington Church dated 10 March 1765 (Brown, no. 1230) is little more than a tinted drawing, the colour applied in unmodulated washes. He also experimented with etching, publishing a set of *XII Views consisting chiefly of the Environs of Oxford, by John Malchair* in 1763. They are as much the work of a novice as the early drawings of Bristol, and all copied from the artist's own drawings. Their circulation

must have been extremely limited, and only one complete set is known to survive.[30] Most are distant views of Oxford, but two views of the Avon are left over from Malchair's days at Bristol. Another, of Nuneham Courtenay, offers the opportunity to speculate that Malchair had somehow made the acquaintance of Lord Nuneham, who was making vigorous etchings of his own around this date.[31]

From 1767 onwards, Malchair's production of drawings rose considerably, and until 1789, the numerous dated drawings in the sketchbooks and albums in Oxford collections allow us to follow his development and movements, often day by day, although with long intervals when he made no drawings, as his time was taken up with teaching and performing. He also began to move farther afield, making a tour of the West Country after the Three Choirs Festival in the autumn, probably with John Skippe, and travelling south to Salisbury in late September (cat. no. 8). Another innovation, which came in 1769, was to annotate the *verso* of his drawings with indications of not only the date and location, but also the time, with a solidus indicating noon. Hence, '10/' indicated ten o'clock in the morning, and '/6', six in the afternoon. The precision came from an increasing awareness that light changes constantly, and that a difference of an hour in time was as important to the atmosphere of the drawing as the difference of a change in viewpoint of a few feet was to the composition. In the same year, he also annotated a drawing for the first time with the name of a companion: the earliest such inscription reads *The House-boat expedition No. 1 July 21 1769 P Rashleigh W Roundel and J.M. Worcester College Oxford from near High Bridge* (CCC, I, fol. 8). Thereafter, Malchair often refers to his companions, but it is not always possible to be sure whether they were pupils or merely onlookers. Sometimes, he makes it clear, as in 'with my scholar Mr Charick of Pembroke College' (Brown, no. 1259) or 'Lesson after nature with Lord Lewisham' (see cat. no. 17); but often, the relationship is not so explicit: 'Mr Swire the Vicar of Coleshill and Mr Booth were present at the time of drawing' (see cat. no. 16) and similar inscriptions are ambiguous. During these early years of teaching, Malchair often attached charming epithets to the expeditions, derived from what or where they ate: Pork and Griskin, Bacon and Eggs, Wheatsheaf; but this did not last.

The Oxford Almanack

Malchair's position as the leading draughtsman in Oxford was confirmed when he was commissioned by the Delegates of the Clarendon Press to provide the head-piece for the Almanack in 1767 and 1768. The Almanack they had produced since 1674 had generally been designed by an artist of negligible merit, and showed views of the various colleges and university institutions, in allegorical representations with their founders. Some, such as that for 1716, were used to advertise new buildings, much as they are today. Malchair broke completely with this tradition, by providing designs which owed nothing either to allegory or even, much, to architecture. Instead, they concentrate on the idyllic landscape of the countryside around Oxford. The first design, a distant prospect of Oxford from Cumnor Hill, was engraved by Mason, the calendar engraved separately by Cole, and the plates printed by the bookseller, Daniel Prince. For their respective labours, Malchair received £7-7-0, Mason £52-10-0, Cole £12 and Prince £11-19-8, the artist considered the least important member of the team.[32] Significantly, his name did not appear on the plate, although even after his death, Joseph Skelton could identify him as the designer.[33] In 1768, Malchair's design (fig. 4) was much more successful, and, indeed, with

Fig. 4. T. Bonnor after Malchair, The Oxford Almanack for 1768

the drawing of a similar composition in a private collection (cat. no. 7), his best drawings of the 1760s. Both the published engraving and the unrelated but similar drawing show Merton College from Christ Church Meadows, and have become studies in foliage rather than architecture, the strong vertical shapes of the elms on Christ Church Walk and the spaces between creating a surface pattern. For their work, Cole again received £12, the engraver, Bonnor, the same as his predecessor, and Malchair slightly more at £7-11-0. However, this was Malchair's last design, and the accounts show that, at their meeting in December 1767, the Delegates resolved to hand over the whole process of commissioning and producing the Almanack to the Oxford printer, William Jackson, in return for an annual rent of £20.[34] Jackson turned for his designs to a smart team from London, Michael 'Angelo' Rooker and his father, Edward, who made the engraving, and the Rooker family retained their monopoly even after Edward's death in 1774, his son engraving his own designs until 1788. It must be admitted that their closely observed views of important buildings fitted into the tradition of accurate antiquarian townscapes that the Delegates must have expected for their Almanack.

The only other commission of Malchair's career also dates from this period. In 1771, the Fellows of All Souls fixed on the popular German artist living in Rome, Anton Raphael Mengs, to paint an altarpiece for their chapel, and turned to Malchair to provide a drawing showing the position his painting would occupy in the chapel. For this, he was paid five guineas.[35] Two years later, in 1773, he had his only showing at the Royal Academy, as an honorary exhibitor. This 'landscape' was no doubt a drawing, and may have been intended to attract the notice of potential patrons. It failed.

The second phase of Malchair's etching took place at a time when print making at Oxford almost became a popular activity among amateurs, though professionals were rare.[36] Two volumes of etchings assembled, probably in the 1780s, by the Revd James Chelsum, a Student of Christ Church between 1760 and 1780, are dedicated 'In memory of Contemporaries & of the Cultivation of the elegant Arts at Oxford'.[38] At least three of the artists represented were pupils of Malchair, Lord Guernsey (later the fourth Earl of Aylesford), the Revd John Gooch and Sir Thomas Frankland, and others may have been. The majority of dated prints in the albums are from 1769 to 1772, when Malchair was also making his second and more successful group of etchings. The largest shows the ruins of Godstow Abbey (cat. no. 15), while the remainder are rustic scenes of the kind associated with most amateurs. Their originality lies only in their technical naivety – they are effectively drawings made with a needle rather than a pencil, with dense scribbling for the masses and few defining contours. It is unlikely that Malchair was responsible for this burst of activity with the etching plate, and the catalyst may have been Lord Guernsey. Whereas several of the other artists represented in the Chelsum albums continued etching into the 1780s, Malchair's

last dated plate is from 1773, and Guernsey's continuing enthusiasm seems not to have been contagious.

Topographical Drawings

With the passing of the so-called Mileways Act of 1771, mediaeval Oxford was threatened with eradication. The Act enabled the city authorities to make new roads approaching Oxford on the east side of Magdalen Bridge, destroying part of St Clement's churchyard in the process; to demolish and rebuild Magdalen Bridge itself; to widen the road between St Clement's and the High Street, demolishing the East Gate; to take down the North Gate and the houses on the north and east sides of St Mary Magdalen Church; to remove Carfax Conduit, demolish buildings in Butcher Row, erect a new market, and widen all the main roads, especially Broad Street, and remove obstructions such as bow windows. To the young and thoughtless, this represented undoubted improvement: James Woodforde, for example, who had been an undergraduate at New College in the 1760s, was pleased to find on a visit in autumn 1771 that 'the streets in Oxford are much improved, all the Signs are taken down and put against the Houses, the Streets widened, East-Gate & Bocardo taken down & a new Bridge going to be built where Magdalen Bridge now stands…'.[38] To the conservative Malchair, however, the changes were set to destroy much of the fabric of his beloved city, and he immediately set about recording them. He did this sporadically, but by the end of the 1780s, he had drawn most of the casualties and many of the more picturesque parts of the city, the lanes and gardens which, perhaps, he felt were threatened by the improvers. Many of these drawings were made for himself, sketches of Magdalen Bridge (see cat. no. 70), Friar Bacon's Study on Folly Bridge (cat. no. 11), the North Gate (cat. nos. 64-5), and, later, the East

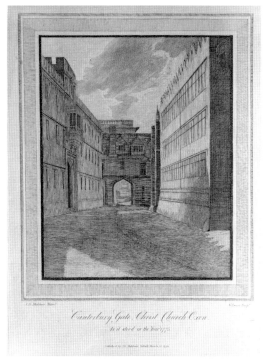

Fig. 5. George Jenner after Malchair, *Canterbury Gate, Christ Church Oxon. as it stood in the Year 1775*, etching published by Malchair in 1793

Gate,[39] and Little Gate (fig. 12);[40] but, even in the 1770s, Malchair may have thought of publishing prints after them, and taken advantage of the thriving trade in topographical and antiquarian prints.

In 1776-7, however, Malchair made his most sustained attempt to record the highways and lanes of Oxford in a series of 32 drawings which he bequeathed to the Revd George Cooke, and most of which are now in the Bodleian Library. There are now twenty-eight drawings in the collection, mounted on stiff card with wash lines and arranged chronologically, bearing numbers in ink up to 33. Nos. 4, 5, 19, 24 and 28 have been separated, of which only no. 5 is known to have survived (cat. no. 24), although one of the missing drawings was probably the view of *Canterbury Gate, Christ Church Oxon as it stood in*

the year 1775, which was etched by George Jenner in 1793 (fig. 5). The first twenty-six drawings were made between 7 February 1776 and 30 November 1776, while four were added in the following year and the remainder even later – they are on thinner mounts, and no. 32 is dated 1791. It is possible that the fairly anonymous copper plate handwriting on the mounts is that of Jenner,[41] and that he may have intended to make prints of the whole series after Malchair's retirement. On the mount of one drawing, no. 20, the vault of St Peter's in the East, the calligrapher has written details of the subject taken from Camden's *Britannia*.

Malchair presents us with an eccentric collection of views, many exercises in deeply recessed perspective with, as their focal point, only a gateway or an arch. Garden scenes and lanes predominate, to the detriment of more obviously appealing architectural elements, and although many of the classic Oxford buildings are included, such as the mediaeval towers of Magdalen and Merton, and the recent Radcliffe Library, the great majority show scenes unknown to the casual visitor to Oxford: there are three drawings of Queen's Lane made within a hundred yards of one another, two of St John's Garden, three of Merton, and so forth. The majority were made at one or two o'clock, when the sun was high and the shadows darkest, although several are more conventional scenes in the early morning or evening. Fleming-Williams argued (MS V, pp. 5-7) that it was undoubtedly in an attempt to replace the surviving Rooker as draughtsman of the Almanack that Malchair made this series, Edward Rooker having died on 22 November 1774. However, apart from no. 1, the drawings are vertical and consequently the wrong shape for the Almanack. Rather, they represented his working capital, which he occasionally used as an additionally source of income: in a letter to

John Skippe of 6 July 1784, he wrote that

I meditate a tripp to town, where I shall spend most of my time with Bartolozzi to trey to get a little better Knollege of Etching, and if I succeede, I shall begin uppon a fiew of my Oxford Views, Something must be done to gett even with the world, for as times are now, I find myself getting behind hand, for nobody pays now.[42]

Nothing seems to have come of this plan, and he was obliged to use others to make his engravings. The series of large drawings of Kenilworth and Warwick Castles of 1785 and 1787 may be the beginnings of another projected set of prints, and Malchair would certainly have known of the success of Paul Sandby's sepia aquatints of *Four Views of Warwick Castle* published by Boydell in 1775-6. Malchair's drawings are unusually large, but most suffer from his inability to fill his compositions with interesting staffage and foregrounds, and nothing came of the project. In their own right, however, these drawings are among the grandest Malchair made, full of subtle shading and stumping and intriguing points of view.[43]

It was no doubt the precarious finances of the Music Room in the late 1780s which caused Malchair to think again of prints. The earliest and best of those after his Oxford drawings were two aquatints of the North Gate by Mrs Howorth, for which a successful subscription was opened in 1789 (cat. nos. 64-5). Her later aquatint of Magdalen Bridge is now rare, and its sale may have been slower,[44] while George Jenner's etching of *Canterbury Gate* was advertised twice in *Jackson's Oxford Journal*:

John Malchair begs respectfully to inform his Friends that he is about to publish, by Subscription, A PRINT from a Drawing made by him, of the OLD CANTERBURY GATE-WAY in Christ Church, Oxford; being an exact Representation of it as it stood before it was taken

down in the year 1775. Price to Subscribers, Half-a-Guinea; to be paid at the time of subscribing. The Print will be ready to be delivered on or before the 25th of March next.

The plate was not ready until 22 April.[45] The last of Malchair's drawings to be published was another of the series of 1776, the *High Street* (cat. no. 24), issued as an etching by Jenner in 1795 and, unlike *Canterbury Gate*, extremely rare.[46]

Malchair the Drawing Master

Ever since Aristotle, drawing has been considered a necessary part of the education of a cultivated man.[47] Castiglione in *The Courtier* recommended him not to omit drawing from his armoury, for its utilitarian value to the soldier as well as for the pleasure it gave; and in England, ladies and gentlemen employed artists to teach them or their children, so that by the seventeenth century, it had become commonplace. In naval and military academies, too, drawing was a necessary skill, and generations of officers and men were taught by artists such as Paul Sandby at Woolwich, Bernard Lens II and Alexander Cozens at Christ's Hospital, and William Gilpin at Cheam. At the two ancient universities in England, however, it was not so easy, and, until Malchair's establishment as a drawing master at Oxford in the 1760s, lessons could be had only from third-rate artists or charlatans.

It was, however, possible. William Bellers (*fl.* 1734-1763), for example, was primarily a print dealer, but also gave drawing lessons at both Oxford and Cambridge in the 1740s.[48] Even during Malchair's heyday as a drawing master, he had competitors, if not rivals. Mrs Mary Seeley, the widow of a grocer, and her daughter, Lydia, offered drawing lessons in 1775 in their houses at 9 and 10, Broad Street, almost next door to Malchair.[49] They had no

doubt been taught by their former lodger, the portrait painter, John Cornish.[50] In 1784, an unnamed pupil of John Hamilton Mortimer offered to 'instruct ladies and gents in the art of drawing, painting, also etching on copper';[51] while in the following year, Mr Keymer placed the first of several advertisements as a picture restorer and drawing master.[52] The only serious rival to Malchair was William Peters, R.A., who had established himself at Oxford in the 1780s,[53] and was patronised by the colleges as a portrait painter. After the exhibition in the Bodleian Library of Peters's portrait of the Revd Joseph White, the Laudian Professor of Arabic, in 1786, it was suggested that it might be appropriate to found an Academy of Painting.

> *We hear that a plan for establishing an Academy of Painting at Oxford has been for some time in agitation, and has received the approbation of a Great Personage. Our Universitites furnish the most favourable opportunities of improvement in severe as well as ornamental literature; and if to these were joined the cultivation of Sculpture, Architecture and Painting, what might not be expected from such an union. Where indeed could these elegant arts be so successfully cultivated as under the auspices of fancy corrected by learning, and of taste formed on the exquisite though modest graces of classic antiquity!*[54]

The proposal was the latest in a long line of similar initiatives in England, beginning before the Civil War, which had foundered for lack of energy and interest. Fortunately, for Peters was a mediocre painter, nothing came of the idea, and Malchair's position remained secure.

Malchair must have begun to teach drawing very soon after his arrival at Oxford, for in a letter written in 1782 to John Skippe, who was up at Merton between 1760 and 1764-5, he makes a passing reference to setting him to copy prints after Carracci at Merton.[55] Moreover, one of three drawings Malchair

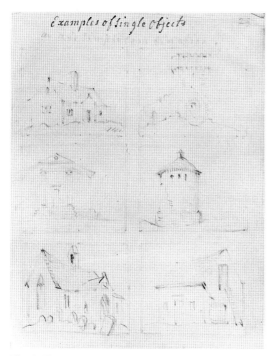

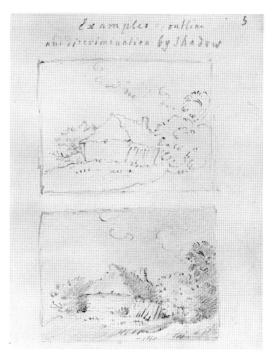

Fig. 6. 'Examples of Single Objects', from *Observations on Landskipp Drawing* (cat. no. 96)

Fig. 7. 'Examples of outline and discrimination by Shadow', from *Observations*

made in 1760 is a view of Ledbury, and clearly shows Skippe's home, Upper Hall. His practice as a drawing master grew quickly, and soon took precedence over his musical tuition, until, by 1784, he could complain that 'I teach from ten till eight in the Evening, without intermission which is the only way to bring it about at last'.[56] The number of his pupils must have been considerable: we know of some forty names of those who either took lessons or watched Malchair draw, but this probably represents only a fraction of the total. Most were undergraduates, but some were fellows of colleges, wives of dons, and even children. The work of only a few pupils can be identified (cat. nos. 97-106), and it shows that, while Malchair instilled a certain discipline in the choice of subject and in technique, he did not impose a style, and his best pupils all quickly developed their own. Malchair owed his success as a drawing master not only to his

teaching methods, but to his character, his German accent and spelling, his sense of humour, and especially his genius for friendship based on tolerance: as he wrote to John Skippe, 'we all have a some thing that is whimsical whem we come to consider ourselfs impartialy and a Mutual indulgence to that some thing in Each other constitutes real friendshipp.'[57]

The basis of Malchair's instruction is set out in his unpublished treatise, *Observations on Landskipp Drawing*. This is a volume of 117 pages bound in vellum, consisting of some 10,000 words of text, on 43 pages, and 32 pages of drawings, interspersed in four main groups between the sections of text. One page is missing (pp. 81-2). The text is unfinished, and any plan Malchair had to publish it was abandoned. Moreover, although it is dated 1791, it was based on the experience of thirty years, and a fragment of an earlier treatise

begun in 1776 begins in almost exactly the same words.[58] The surviving fragment of the *Observations* is no more than a working draught: there are major and minor deletions, three entire pages are crossed out (but still clearly legible), and there are symbols indicating that the order of the paragraphs was to be changed. The text is divided into sections which, even in the revised order, show no logical development and tail off without conclusion. The tone of the prose is also inconsistent, varying from admonitions to a child – 'It is not the practice of the Oxford school to put anny drawing tooles in the mouth' – to instructions to the master on the best means of teaching children. He also permits his pen to run away with itself in a 'Rodemantade' of florid prose on the beauty of trees. Further, the treatise stops short after the first few lessons, and deals hardly at all with the more advanced stages of composition and perspective. In spite of the irregularities and illogicalities, the treatise is an endearing and instructive document, revealing much about both Malchair's teaching methods and his own nature drawings, and going some way to explaining his success as a teacher.

The text of the *Observations* is divided into nine sections, of which five give details of materials, three of basic techniques, and the last, a brief and unfinished passage on 'the different branches of Landscape painting' Malchair begins at the beginning, with an extended discussion of the materials suitable for the landscape draughtsman. This is so closely based on his own experience as an artist that he scarcely mentions media he found unsympathetic, such as pen and ink. He selects the minimum, for this is essentially a practical manual. Chalk is suitable for drawing figures, but not landscapes, for already, Malchair taught the tonal drawing that did not require a sharp point. 'Red chalk is very unfit for Landskipp,' and, while soft black French chalk may be used with white on blue or grey paper, and 'fine effects may be produced from it by a skillful hand', yet 'this is a species of crayon work subject to smearing and not at all proper for the Portfolio'. The best medium is ordinary 'black lead pencil', which, in skilful hands, can be made to produce effects others achieve with chalk, is readily available, and 'yields more kiendly to the touch after Nature than anny other material'. It also mixes well with Indian ink and watercolours. The lead should be about $\frac{1}{8}$ of an inch thick, the point 'as blunt as a glazier's diamond' in order to make both a flat edge for broader strokes and larger areas of shading, and at the same time offers a corner for delicate lines and details. To the devotees of fine leads, Malchair retorts that 'verry nice work may bee produced by a broad nipp, when the management of it is well understood'. To remove pencil marks, either to obtain particular effects or simply to erase mistakes, Malchair recommends 'stale cleane bread' over the more recent discovery of Indian rubber or elastic gum, because the latter tends to spoil the surface of the drawing and damage the paper. He warns that 'young practitioners place rather too much confidence in it, which makes them careless,' and those who use chalk must do without it. Paper should be chosen carefully, but should not be one of the refined varieties manufactured for capricious artists who are fussy about their materials but not about their drawing. The best paper is yellowish and 'graniculated', 'thiese qualityes agreeing well with all the objects in a landskipp', for 'the multiplicity of rugged and rough objects in landskipp absolutely require [it]'.

Having selected the materials, Malchair begins his longest digression, on the duty of the drawing master not to discourage his pupil, either by pretending to knowledge he does not have and thus misleading him, or by showing him work far beyond his level, and thereby discouraging him. 'One who would teach a

Child must draw like a child to conceal his skill as much as possible, his stile must gradualy improve as the pupil advances; he must even seeme to learne the arte rather than to teach it.' Even when the master shows his pupil a finished drawing made at his own level, he must emphasise that 'he declared no labour in producing it.' From what we know of Malchair's pupils, it is surprising that he should write so much about teaching children, but the general principle, that the master should draw at the pupil's level, is one familiar in many treatises on education, from Rousseau's *Emile* to Reynolds's *Discourses*.

The first lessons should be taken up with drawing the outlines of simple objects. 'Natural objects have strictly speaking no outline', but the draughtsman is obliged to use outlines, 'before he discriminates the Mass by shaddow and complexion'. He should make them in such a way that they 'disappear in a greate measure when the discriminating powers of shade and complexion take place.' Complexion is defined as the colour of an object, which is conveyed even in monochrome media 'by the different degrees and strenght of the materials he draws with'. This should not be confused with light and shade.

When he has achieved some mastery in drawing simple objects, the pupil is ready to draw simple compositions of several objects together. The aim, however, is not to make the pupil mechanically perfect in copying, and 'the master must detain the scholar no longer in drawing after coppyes than is necessary for acquiring a propper grasp of the tule and a facility in making it produce all the various touches necessary for the purpose,' what Malchair calls 'the alphabet of a Languich'. Once he has learnt that alphabet, he is ready to draw from nature.

It is at this point that Malchair shows the greatest confusion in his thinking, for, having advocated drawing from nature, he contradicts himself completely, and, as a concession to contemporary practice in the drawing academies, advocates copying the works of the Old Masters. He names two volumes of engravings as providing suitable material for copying: *Jabach's Collection of Landscapes engraved after the Drawings of Carracci*, and *Carracci's School*, reproductions after the Carracci frescoes in the Palazzo Farnese; Malchair owned a late edition of the engravings by Carlo Cesio first published in 1657.[59] The Jabach collection includes etchings after landscape drawings by the Carracci and other Bolognese masters, which, though 'the representations are only general', are useful to copy, to give 'a flowing freedom of hand'. The second is included without comment, clearly because he had heard others recommend it: as a compendium of poses of the human body, it was invaluable, but as a repertoire of models for the landscape artist, it would have been useless. Having mentioned suitable works for copying, Malchair again enjoins the beginner 'not to dwell longer on this work than is necessary to form his hand and eye to a degree sufficient for the study of Nature in the field.'

Malchair's ideas on light and shade are more coherent. 'Shading by lines is subject to crudity, and repugnant to many objects in Landskipp.' The landscape draughtsman should rather use the tip of his finger, for 'the method of shading by means of rubbing, is by much the most expeditious and natural… for many of the most beautiful effects in nature are too momentary to allow the artist time to fumble in his pockets.' This form of shading, however, is liable to be 'tame and insipid' if overworked, and it should be used in conjunction with the more conventional means. Indeed, the point of the pencil 'is always at hand to correct the error. To that belongs the quickening and life-giving power, all is made brilliant by it and to spring from the paper. The point is the spirit of all.'

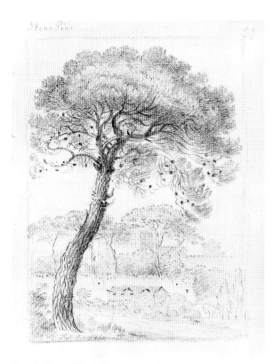

Fig. 8. 'Stone Pine', from *Observations*

The two fundamental forms are the cube and the convex or concave. 'The convex form is subject to a greater variety of lights and shade than the cubic form, and has besides a reflected light on its shadow side which relieves it in a most beautiful manner if that which is behind be dark.' 'Shadows are deepest in the recesses of objects, when the light has least access', and colours scarcely discernible, as in the darkness of vaults. 'By far the greater number of objects have shadows of recess: the bark and roots of trees, surface of old walls and rocks abound them.' 'If the fullest power of shade is bestowed on the exterior part of the objects, there will be nothing left to animate the work and all will be flat and lifeless without the shade of recess.' He goes on to recommend that his pupils take advantage of the different lights at different times of the day, not merely the conventionally picturesque morning and evening, for 'nature can paint at all seasons and hours, for she has an

inumerable variety of extraordinary ways to produce effects for painting, many of which are fully as sublime and awful as the rising or setting sun'. Among the effects he recommends are 'the shadows of clouds travelling on the surface of the earth', for the variety of light which they throw on objects on earth, He also takes a passing but revolutionary interest in objects painted between the sun and the draughtsman: 'Wonderful effects are observable when the objects are between the sun and spectator, but they are so little known that few would subscribe to the truth of them were they ever so well represented.' Malchair occasionally made such experiments himself (cat. no. 77), and it is clear that his interest in the transient phenomena of nature had developed over many years.

Malchair had a horror of systems and formulae for drawing natural objects, believing that they produced stiff and mechanical results which were wholly incapable of representing the infinite variety of natural forms: it is impossible to 'bend the beautiful wildness and fantastic irregularity of trees to stiff mechanic rules'. Working freehand may carry the artist a little wide of the mark, but this is greatly preferable to the 'miserable extreme of stiff and lameness.' In any case, with practice, the pupil will soon learn how to conceive form and draw it without resorting to excess. This passage is surely an attack on Alexander Cozens and his 'systems', the first of which, *The Shape, Skeleton and Foliage of Thirty-two Species of Trees for the Use of Painting and Drawing*, was published in 1771, and which contained etchings of trees as mechanical and regular as Malchair's drawings in his *Observations* are extravagant and individual. All three of Malchair's, the stone pine, spruce fir and cedar, were included in Cozens's treatise, and only the first is remotely comparable, because, like Cozens, he draws it not by itself, but in an idealised Italianate composition.

The final section of Malchair's treatise 'Of the different branches of Landskip Painting' must also have been a riposte to Cozens, who, in his *A New Method of Assisting the Invention in drawing original Compositions of Landscape* (1783) concludes with 'Descriptions of the various Kinds of Compositions of Landscape', a technical, rather than historical, compilation. For Malchair, landscape painting comprises three general types, 'The Sublime or Grande', the 'Orderly or regular', and the 'Accidental or mixed'. Each might be described as 'Pictoresque', but some would use this epithet only for the third, because it 'consists of a greater variety of objects, with a Capricious mixture of Arte and Nature, producing such fortuitous beauties as the reachest immagination and fancey cannot come up to'. To those who believe that some subjects are unsuitable for depiction, Malchair retorts that 'even a Pig-Staiy with a single Elder bush is a Landskipp, or, a punt, a man & a willow.'

The evidence provided by the *Observations* can be supplemented by that of the drawings made by both master and pupils during their lessons. When they had mastered the basic strokes and 'language', and acquired, through the copying of the Old Masters or exemplary contemporaries such as Richard Wilson, sufficient manual dexterity, they were taken out to draw from nature. At this stage, Malchair's most important principle was the careful choice of a vantage point: as William Crotch later wrote, 'Brother beginner – If thou hast *but* 20 minutes to spare – spend at least 5 in walking about your subject and take my word as well as Mr Malchair's that you will not spend it in vain.'[60] The comparison with photography is anachronistic but irresistible. Initially, the pupil should concentrate on drawing trees, being 'the most difficult part of his art', using a different technique and strokes to distinguish each species. Trees in the foreground also provide a strong framework through which distant objects may be composed, especially in woodland scenes, 'where we are frequently enchanted all rounde by Picture within Picture, all is like latice or Nettworke of an endless variety'. 'The tops of trees also make a fine Frame work to the Skye.' The spaces between the trees, which Malchair calls 'interstice', also create their own pattern, as though the composition is also made up of white shapes on black, like a photographic negative. Another means of ensuring a naturalistic composition was the practice of drawing through an open window. This no doubt had its origins in the landscapes seen through open windows in religious paintings of the fifteenth century, but the earliest reference I have found to painting the view directly from life through the open window is in a letter from Jonathan Skelton written in 1758, in which he wrote, 'I have half finished another picture in Oil from Nature, from the Window of my Bed Chamber.'[61] Later, the practice was adopted by other artists in Italy, most strikingly by Thomas Jones in 1782.[62] Incidentally, Jones must have known that this was a favourite device of Malchair's, for the two met at the home of Oldfield Bowles, North Aston, in 1773.[63] Several of Malchair's surviving drawings indicate that this was a common exercise during his lessons (e.g. cat. nos. 17, 32), from which the pupil learnt to seize atmospheric effects, quirky compositions, and complicated perspective. Finally, even the slightest of Malchair's drawings reveals a profound interest in light and climate, which he transmitted to his pupils. Unlike contemporary artists, who acknowledged that morning and evening were the most suitable times of day, Malchair asserts that the artist 'well knows that Nature can paint at all Seasons & howers for she has an innumerable variety of extraordinary ways to produce effects for Painting, many of which are full as sublime and awful as the rising or setting

sunn.' Not only do all hours of the day offer different effects, but light and the weather change constantly, and 'forty different pictures are produced from the same subject in an hour.' Unfortunately, neither Malchair nor his pupils explored the corollary to this belief, that forty different pictures could be made at a single sitting.

Parallel to his thriving teaching practice, which often required him to draw at the level of his pupils, Malchair continued to make numerous independent drawings, gaining in confidence and developing a broader style. Perhaps exhausted by the topographical drawings of 1776-7, he made comparatively few in the remaining years of the decade, but recovered momentum in 1780, and worked steadily until the 1790s. One feature that become increasingly common was retouching his own drawings: according to Crotch, 'poor old Malchair used to delight in improving his old sketches, he called it reforming the old sinners'.[64] The technique he used during the 1760s and early 1770s of combining both pencil and grey wash almost indiscriminately, using now one and now the other to create subtle textures and effects of light, was gradually modified, and, as the inscriptions on the backs of the drawings show, he came to draw first in pencil and later to rework the composition in brush and wash, while still using pencil to add definition to the foreground. Once, he worked on the same drawing on twelve different days over a period of exactly a month![65] Although he used sketchbooks for most of his career, he began habitually to draw on single sheets of large and often coarse paper, as his effects become bolder and the texture of the paper played an increasingly important role, even the close and even parallel lines of an ordinary sheet of laid paper played their part. He reached full maturity in monochrome by *c.*1775 (see cat. no. 23), but continued to experiment with colour until, in the 1780s, by

experimentation and perseverance, he had evolved a technique capable of incorporating watercolour as well as ink washes, and, although never a natural colourist, some of his most intense creations are coloured, most notably the extraordinary vision of the sun rising over Christ Church (cat. no. 56). His subject matter included not only the yards and alleys, gardens and colleges of Oxford, but also the occasional and ephemeral, such as fires (cat. no. 26), or a bower decorated with flowers to celebrate the completion of Dr Kennicot's polyglot bible in 1780 (Brown, no. 1247). These drawings were made more for pictorial effect than to record events, and Malchair left his pupil, James Roberts, to depict one of the most remarkable events of the 1780s in Oxford, Sadler's ascent in a balloon.[66] Details were, in any case, always subordinate to atmosphere and general effect, and astonishingly for so prolific a landscape artist, only a single plant study survives (Brown, no. 1002). As he grew older, he became accustomed to making drawings 'from recollection', and several drawings in the Ashmolean are thus inscribed (e.g. cat. nos. 74, 78, 95). The only documented instance of the lapse between experiencing the scene and recording it is given in a letter to Dr Luttrell Wynne of 5 May 1793 (Minn, 1957, p.102) when Malchair went out without his sketchbook, and, immediately on returning home, tried to recapture the beauty of the sunset from Cumnor Hill. The resulting drawing is regrettably not known. It is likely, however, that many of these 'recollections' were made years later: they are generally of familiar scenes, and, as with his recording of popular tunes, his memory, both aural and visual, was remarkably good. Finally, he copied the work of other artists: Claude and Carracci among the Old Masters, his own pupils and, above all, Richard Wilson among his contemporaries.

In the 1780s, Malchair was taken up by an

important new patron, the second Lord Clive, who had been at Eton and Christ Church with Beaumont, Rashleigh, and Frankland, and studied with Alexander Cozens. The association began in 1780, and was of such importance that, two years later, Malchair could write to John Skippe that he had 'for two years past dedicated all my leisure time' to Clive, and two years after that, he again referred to Clive's patronage: 'I have been a voyage to the Indies, or, in other words, to Lord Clive's, which turned out very well. It came in the nick of time, for I never was so completely broke down … My Lord's being just married has somewhat increased my employment.'[67] Lady Clive had also been a pupil of Alexander Cozens, and she and her husband were keen amateur draughtsmen, but Malchair may have been employed as a musician. Certainly, the Clives occupied much of his time, in their various houses: between 1780 and 1795, he is recorded at Oakley Park in 1780, 1786 and 1789; Walcot House in 1785 (see cat. no. 53); Clermount in 1782; and staying with Clive's brother-in-law, the Earl of Powis, at Lymes in 1789, and at Powis Castle in 1791 and 1795.

The Tours of Wales
While Malchair had lived at Bristol, he might easily have crossed the Severn into Wales, but apparently did not. His patron, Robert Price, made a tour to Barmouth and back in 1759, and Malchair no doubt saw the drawings and heard the anecdotes either that autumn, or on a subsequent visit to Foxley. In later years, many of his pupils went on tours of Wales: the Revd Dr Luttrell Wynne in 1770 and 1774; the Revd Peter Rashleigh in 1775; and Lord Aylesford several times, notably in 1784, when he made 52 drawings.[68] In general, by the time of Malchair's tours, Wales had become a commonplace destination for those in search of the sublime, the picturesque, or the

antiquarian. A whole host of artists and writers, noblemen and gentry had recorded, in words or drawings, published or unpublished, their impressions of this primeval landscape, untouched by human improvements, and inhabited by innocent peasants.[69]

To an artist accustomed to the peaceful waves of the hills at Foxley, or 'to Eyes that are only wont to contemplate the beauties of a rich farming country', as Malchair wrote of Oxford,[70] Wales came as a revelation, and it took some time to adjust his vision to the change of scale. In all, he made at least seventy drawings on three tours, in 1789, 1791 and 1795, which eventually passed to William Crotch, who numbered each on the *verso* in red chalk. The first tour, which, if we are to believe Crotch's numbering, produced only three drawings, was made during a visit to the Earl of Powis, in September 1789; the only surviving drawing is of Montgomery Castle (cat. no. 69). Two years later, he spent nearly two months exploring North Wales more thoroughly. He travelled from Powis Castle as far as Dinas Mawddwy, Beddgelert, Bangor and Conway. This tour was even less productive, and the seven surviving drawings still reflect his inability to come to terms with his experience.

On his last and most extensive tour, Malchair was accompanied by the Revd George Cooke, Fellow of Oriel, whose interest in geology communicated to Malchair some of the momentous movements behind the formation of the Welsh mountains. The weather was bad, as countless travellers to Wales had found, but this seemed to intensify Malchair's intense and exultant mood, and the rain, mist, storms and occasional gleams of sunlight were all translated into his drawings. His commentary records the excitement: 'flying clouds and much wind … the rock partly lost in mist … this drawing was beholden for its effects to the brewing of a thunderstorm … the

paper soaking wet with rain when drawing ... the first of these drawings was made in a shower of rain with some sun glancing through ... a sudden surprise! The sky happened to turn favourable during our drawing this scene; the clouds opening, a sun-beam glanced off the waters which gave a surprising effect to that simple landscape.' The great stylistic freedom shown by the Welsh drawings of 1795 may have been largely attributable to the onset of blindness: no longer was Malchair able to concentrate on countless irrelevant details, but only able to see the larger essentials, in darker ink and with unprecedented force of expression.

This last tour of Wales shows a fierce burst of creativity: in the fortnight beginning on 28 July, he produced 34 large drawings, with four each on 28 July, 3 August and 11 August. Dinas Mawddwy shows the first storm of emotions, and the first time Malchair realised that he could equate violent pencilling and brushwork with the cataclysms of nature. The pair travelled from Stinchcombe in Gloucestershire to Welshpool and then to Dinas Mawddwy, where they remained for nine days, making shorter excursions in the neighbouring hills. They set off for Barmouth on 6 August, reached Harlech on 11 August, and proceeded northwards to Caernarvon, stopping at the tourist spots of Beddgelert and Pont Aberglaslyn on the way. His last drawing, on 21 August (cat. no. 94), was also one of the most dramatic and violent, but his energies seem to have been exhausted in the last few days. Cooke and Malchair seem to have deliberately avoided many of the sites popular with tourists, Valle Crucis Abbey, for example, or the celebrated estate of Hafod and nearby Devil's Bridge, farther to the south. They were even content to draw Snowdon and Cader Idris only from a distance.

After his return to Oxford, Malchair compiled a list of the tour (see Appendix), and made copies of 32 of the Welsh drawings, including three from the earlier tours. To

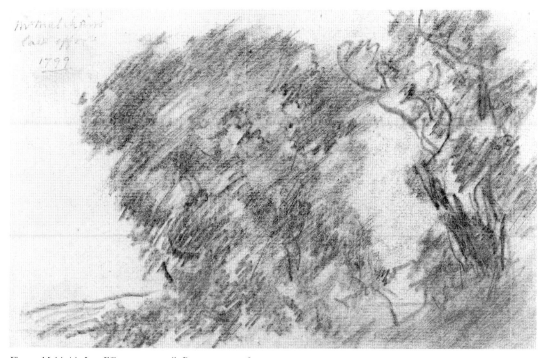

Fig. 9. *Malchair's Last Effort, 1799.* pencil. Brown, no. 1076

these, he attached another list, with fuller descriptions of each drawing (some of which are transcribed in the catalogue entries). The miniature versions are valuable not for their beauty – much of the force of the large drawings comes from their size – but as records of the original appearance of many compositions which have been either cut down or are lost. These copies, and the arrangement of the tunes he had collected on the journeys, occupied Malchair's last years before he went blind. He had retired from the Music Room in 1792, and, with the profits from the sale of prints and from teaching, he possessed 900 pounds invested in the Stocks, from which 700 were sold and, together with money subscribed by his friends, used to buy an annuity of 120 pounds.[71] Among the subscribers, Lord Aylesford was the most generous, paying £20, Dr Wynne £10, and the unexpected name of Sir Joseph Banks, five guineas. Gradually, he stopped drawing from nature, preferring scenes drawn from memory, in which particular details are subordinate to general atmospheric effects (e.g. cat. no. 95). His last drawing, of 1799, was made when he was almost blind, and depends entirely on his fluency with the pencil (fig. 9). In 1797, he officially handed over his practice as a drawing master to William Delamotte, who announced in *Jackson's Oxford Journal* on 21 October that:

> *Mr Wm Delamotte, late Pupil of B. West, Esq. President of the Royal Academy, takes the liberty of informing his Friends, that he has Permission of the Reverend the Vice Chancellor to teach DRAWING in the University of Oxford.*

Through the misery of his last years, Malchair was supported by his friends, most notably Dr Crotch. Yet, as Uvedale Price wrote to Sir George Beaumont, 'to take away poor Malchair's life, might in respect to its consequences to him, be almost considered as an act of mercy and kindness'.[72] He died on 12

December 1812, and his obituary appeared in *Jackson's Oxford Journal* a week later:

> *On Saturday last died in this city, in the 82nd year of his age, John Baptist Melchair; this venerable man was born at Cologne, in Germany, and came into this country at an early period of life. He was first introduced to this place by that magnificent patron of learning, and the fine arts, the present Bishop of Durham. Mr Melchair was a true Christian, and possessed a most enlightened mind. His savings, from a confined income, he never failed to give away in charity, to a few well chosen and deserving objects. From a peculiar suavity of manners, added to these excellent qualities, he deserved and obtained the esteem of a great number of friends, of the highest respectability and station. His great collection of drawings (from nature and of his own pencil), ancient music, and a few original paintings, will be highly appreciated by the true lovers of the polite arts.*[73]

He was buried in St Michael's Church on 19 December 1812.[74] By his will, which was signed on 7 November 1801, with codicils added on 21 April 1804, 23 February 1807, and 28 April 1809, he made monetary bequests to his sister in Germany and her surviving children, his godson, and his servants. He also bequeathed a portfolio of thirty-one drawings and one picture, print or drawing to his executor, Dr George Cooke, and a picture to his other executor, John Ireland, apothecary; and the residue to his wife's nephew, George Jenner.[75]

Posthumous Reputation

After his death in 1812, Malchair's influence survived in the camaraderie of the Great School, formed by his pupils and of which he had been elected President; and in the teachings of successive drawing masters at Oxford, James Roberts, William Delamotte, and William Crotch.[76] To the general public, however, he remained largely unknown. The

handsome tribute in Joseph Skelton's *Oxonia antiqua restaurata* of 1823 is as much to Malchair's antiquarian activities as to his artistic abilities, although, significantly, Skelton did not mention his teaching. In 1828, he was remembered as 'a teacher of drawing in the University of Oxford. A man of strong mind, correct taste and of the most agreeable conversation.'[77] His numerous drawings of Oxford elicited a spark of antiquarian interest in the middle of the nineteenth century, when the Revd Dr Henry Wellesley, Oxford's greatest collector, gave a lecture on Malchair, 'pointing out how much antiquaries were indebted to the zeal which was the means of handing down such accurate relics of the past.'[78] Wellesley's lecture was based largely on the Malchair drawings in his own collection, which comprised two albums and nine sketchbooks. These were sold after his death in 1866: the sketchbooks eventually passed to Corpus Christi College, while the albums were acquired by C.F. Bell for the Ashmolean in 1928. Bell had earlier acquired a large group of drawings from the Morrell sale, and his account of them in the *Annual Report* succinctly assesses Malchair's importance as a fashionable drawing master at Oxford.[79] It was not until the 1940s, however, that Malchair's name registered in the general art historical consciousness. Thanks to that great triumvirate of collectors, A.P. Oppé, Iolo Williams and L.G. Duke, Malchair and many other artists emerged from the gloom of ignorance, stimulated by the appearance on the market of large groups of drawings at such dealers as Appleby's and Walker's Galleries.[80] The entire series of Malchair's Welsh drawings, for example, appeared at Appleby's in 1942, and most were bought by Duke and Williams; three were later bought from Duke by the National Museum of Wales, and one by the British Museum. In 1942, the British Museum acquired an album of varied drawings at

Oppé's behest, some of which at least are by Malchair. Oppé's pioneering article, which remains the standard account of Malchair's life and work, was published in the *Burlington Magazine* in 1943, and Malchair occupies a worthy place in Iolo Williams's *Early English Watercolours* of 1952.

The most comprehensive account of Malchair's activities, however, is found in an unpublished manuscript by Ian Fleming-Williams (1914-1998).[81] He was ideally suited to examine Malchair and his teachings: after training at the Royal Academy Schools (1930-34), he was the art master at Charterhouse between 1947 and 1970, and therefore had practical experience of the trials and triumphs of teaching amateurs who often had more enthusiasm than skill. He was also well known among the circle of his elders, Duke, Oppé, and Williams – as early as 1953, he had effectively taken over from Oppé as the leading student of Malchair. Over the next fifteen years, he gathered material for his book, travelling widely, and collecting photographs of almost all Malchair's drawings, which he mounted on index cards and annotated. He also visited the sale rooms whenever drawings by Malchair or his pupils were to be sold, and acquired not only an unpublished and unrecorded drawing manual, from a book auction at Sotheby's in 1960, but also works representing each phase of Malchair's output, often by key drawings. Indeed, when the omnivorous Paul Mellon bought one of Malchair's best drawings, *Moel-y-ffrydd* (cat. 87), with many other works from the Duke collection in 1962, Fleming-Williams was so concerned that it should not leave England permanently that he persuaded Mellon to exchange it for a self portrait by Stubbs that he had found with a country dealer.[82] It is no surprise, therefore, that nearly a third of the works in this exhibition were at one time in Fleming-Williams's collection.

The resulting manuscript comprises four extended chapters, with only a summary synopsis of the first that was never written, perhaps because its scope and ambition, 'to show how a particular attitude towards landscape germinated, developed, and was disseminated over a period of a hundred years or so' were too daunting. Each chapter is based on an imaginative recreation of the circumstances of each drawing, and a close analysis of the artist's response. Fleming-Williams's sensitivity enabled him to dismiss Oppé's strictures of 'clumsy and fluffy', and rather to sympathise with an artist whose technique sometimes lagged behind his vision.

His failure to interest a publisher in his monograph did not cause Fleming-Williams to abandon Malchair, and he incorporated much of the material into his chapters on drawing masters and the amateurs in Martin Hardie's *Water-colour Painting in Britain* in 1968, which laid the foundations for all subsequent work on these subjects. In 1969, he wrote an account in *The Connoisseur* of a group of early drawings then for sale at Sanders of Oxford, which was followed by articles on Malchair's pupils, Dr William Crotch, John Skippe, and the Finches at Packington, who for generations perpetuated the lessons the fourth Earl had learnt from Malchair.[83] Gradually, however, he became increasingly taken up by the work of Constable. The path from one to the other, from the pure amateur draughtsman to the professional painter celebrated at the Royal Academy and in public, was not as tortuous as might first appear. Both artists documented their drawings meticulously, both concentrated on their own small part of England, for Constable, the Stour Valley and Salisbury, for Malchair, Oxford; and for both, drawing was essentially an experimental art, private and personal. Constable was, of course, a far greater artist, but the apprenticeship provided by Malchair stood Fleming-Williams in good stead.

In later years, Fleming-Williams encouraged several younger scholars to study Malchair, sharing his notes, photographs, and manuscripts. He gradually refined his collection of drawings by Malchair and his pupils, selling the lesser items, but buying a significant group from the Oppé collection in 1983 (cat. nos. 4, 71, 86, 94). He made a generous gift to the Ashmolean in 1996 of the drawing manual, a group of important documentary drawings, and his photographs and notes on Malchair, while in the previous year, he had presented perhaps his most prized possession, *Moel-y-ffrydd*, to the Tate Gallery.

In an unpublished lecture on Malchair, Fleming-Williams declared, no doubt to the surprise of his audience, that 'in my assessment, [Malchair] stands as one of the most original landscape artists of the eighteenth century.' Essentially self taught, working in a provincial centre independent of contemporary practices and of the demands of patrons, 'he had to discover his own problems and work out the solutions for himself'.[84] The success of his experiments may be judged in this exhibition, and, as our knowledge of his contemporaries increases, so may his position within the English School.

References

1. John Ruskin, *Lectures on Art delivered before the University of Oxford in Hilary Term, 1870* (Oxford, 1870), p. 3.
2. Personen Standarchiv Brühl, LK 202, ff. 236, 325 respectively. Fleming-Williams (MS, II, p. 1) assumes that Malchair would have been born in the last days of 1729, leaving 'the customary interval of several weeks' between birth and baptism. However, it is more likely that his parents would have rushed their eldest son to the font. Malchair had five sisters and two brothers, born between 4 February 1728 and 14 May 1747 (*idem*, LK 202, ff. 212, 272; LK 203, ff. 27, 56, 84, 100, 121); in the registers, the family surname is variously spelt Malcher, Malchere, Malschere, Mallscher, Malschaer, and Malscher, and there are numerous other variants.

3. according to an inscription on cat. no. 51.

4. See Klaus Wolfgang Niemüller, *Kirchenmusik und reichstadtische Musikpflege im Köln des 18. Jahrhunderts* (Cologne, 1960), pp. 68, 292.

5. *The Diary of Joseph Farington*, ed. Kenneth Garlick and Angus Macintyre, IV (New Haven & London, 1979), p. 1425, entry for 1 August 1800.

6. William Crotch in Bodleian Library, MS Mus. d. 32, here exhibited as cat. no. 110.

7. as noted on a drawing, *Lewes, 4th of February – 1755 – this date I found upon a piece of music of my own writing. Hence it follows that I must have come to that place in the year 1754 – for Gariod in Authumn* (CCC, II, fol. 33). According to a note of Ian Fleming-Williams, Oppé suggested that the soldier's name was Bampfylde; there is no Bonfield in the *Army Lists* of the period.

8. *The Life and Work of Benjamin Stillingfleet* (London, 1800), II, p. 123.

9. quoted by Beryl Hartley, 'Naturalism and Sketching: Robert Price at Foxley and on Tour', in *The Picturesque Landscape: Visions of Georgian Herefordshire*, ed. Stephen Daniels and Charles Watkins (exh. cat., University of Nottingham, 1994), p. 35.

10. see F.I. McCarthy, 'Some newly discovered Drawings by Robert Price of Foxley', *National Library of Wales Journal*, XIII (1964), pp. 289-94.

11. CCC, II, loosely inserted.

12. on a slip of paper formerly attached to a portrait by Worlidge in the Wellesley collection, now in Bodleian Library, MS Mus. d. 32.

13. Ashmolean Museum, 1996.495.

14. A Gentleman of Oxford, *The New Oxford Guide: or, a Companion through the University* (Oxford [1759]), p. 2

15. *Oxford in 1710 from the Travels of Zacharias Conrad von Uddenbach*, ed. W.H. & W.J.C. Quarrell (Oxford, 1928), p. 2.

16. Graham Midgley, *University Life in Eighteenth-Century Oxford* (New Haven & London, 1996), pp. 91-106.

17. Timothy Clayton, *The English Print, 1688-1802* (New Haven & London, 1997).

18. *Jackson's Oxford Journal*, 10 July 1784.

19. see E.K. Waterhouse, 'Paintings and Painted Glass', in *The History of the University of Oxford*, V, *The Eighteenth Century*, ed. L.S. Sutherland and L.G. Mitchell (Oxford, 1986), pp. 857-64.

20. C.F. Bell, *Pictures by the Old Masters from the Library of Christ Church Oxford* (Oxford, 1908), p. 4.

21. see Morris R. Brownell, 'William Gilpin's "Unfinished Business": The *Thames Tour* (1764)', *The Walpole Society*, LVII (1993-4), pp. 52-78 (64).

22. William Gilpin, *Observations on the River Wye*, 2nd edn (London, 1789), pp. 3-4.

23. Farington, *loc. cit.*

24. Brown, no. 1225.

25. drawing inscribed *J.M. ft. for E.M. 1^{st} of Nov^{br} 1768 – 1*, Bodleian Library, MS Top. Oxon. b. 93, no. 31.

26. she made only one plate, signed *E.M ft.*

27. e.g. Brown, nos. 923 (Oxford from Cumnor Hill, 19 October 1772); 925 (Headington, 19 May 1773).

28. *Jackson's Oxford Journal*, 21 August 1773. Her only sister, Patty Jenner, died three years later, 'of a lingering consumption, attended with most excruciating pains'; *Jackson's Oxford Journal*, 21 January 1776.

29. Fleming-Williams, MS, III, p. 11.

30. Bodleian Library, Vet. A5 c. 62.

31. David Alexander, *Amateurs and Printmaking in England 1750-1830* (exh. cat., Wolfson College, Oxford, 1993), no. 20.

32. Oxford University Press, Archives, 'Orders and Accounts of the Delegates of the Clarendon Press, 1758-1794'.

33. Joseph Skelton, *Oxonia antiqua restaurata*, 2 vols (Oxford, 1823), I, facing pl. 67.

34. see Petter, p. 15.

35. See John Sparrow, 'An Oxford Altar Piece', *The Burlington Magazine*, CII (1960), pp. 4-9 (5). Malchair's drawing has not been recorded since it was sent to Rome.

36. Gilpin knew of only one practitioner at Oxford, whom Barbier identified as the portrait painter, James Cole: see Carl Paul Barbier, *William Gilpin: His Drawings, Teaching, and the Theory of the Picturesque* (Oxford, 1963), p. 19.

37. The albums are now at the Yale Center for British Art; see Alexander, *op. cit.*, pp. 4-5.

38. *Woodforde at Oxford 1759-1776*, ed. W.N. Hargreaves-Mawdsley, Oxford Historical Society, n.s., XXI (Oxford, 1969), p. 188.

39. Bodleian Library, MS Top. Oxon. b. 93, no. 6a, dated 21 July 1771.

40. 4 June 1785, 18 June 1785, 19 March 1791; Brown nos. 1044, 1256, 1280.

41. compare his handwriting on the endpaper of the volume in the Royal College of Music, MS 2091.

42. Holland-Martin letters, no. 12.

43. One is exhibited here as cat. no. 48. The best view of Warwick is published by Charles Nugent, *From View to Vision: British Watercolours from Sandby to Turner in the Whitworth Art Gallery* (exh. cat., Whitworth Art Gallery, Manchester, 1993), no. 114; a further ten related drawings are in the same collection. There is also a view of Warwick Bridge of 1787 in the Ingram Family Collection.

44. *Jackson's Oxford Journal*, 13 February 1790.

45. *Jackson's Oxford Journal*, 28 February 1793 and 20 April 1793.

46. *Jackson's Oxford Journal*, February 1795.

47. The best published study of this theme is still Fleming-

Williams 1968; K.M. Sloan, 'The Teaching of Non-Professional Artists in Eighteenth Century England' (unpublished Ph.D. thesis, Westfield College, University of London, 1986) is also essential. See also *idem*, 'Drawing: a "Polite Recreation"', in *Studies in Eighteenth Century Culture*, II, ed. Harry C. Payne (Madison, 1982), pp. 217-40.

48. Clayton, *op. cit.*, p. 114.

49. *Jackson's Oxford Journal*, 15 July 1775.

50. *ibid*, 13 December 1760 and 30 August 1766.

51. *ibid*, 24 April 1784.

52. *ibid*, 5 February 1785.

53. see the advertisement in *Jackson's Oxford Journal*, 20 November 1784.

54. from the *Public Advertiser*, 1786, quoted in William T. Whitley, *Artists and their Friends in England 1700-1799*, 2 vols (London, 1928), II, pp. 69-70.

55. Holland-Martin letters, no. 6, 21 November 1782.

56. Holland-Martin letters, no. 9.

57. Holland-Martin letters, no. 10.

58. Bodleian Library, MS Top. Oxon. b. 222, no. 22 *verso*.

59. 'I have just no purchased for three guineas the Gallery of Carracci by Cessio, with lattin Explanation of all the pictures printed at Rome in 1753. the impressions are not remarkably strong, but they are not retuchet, and I think the boock a greate acquisitionas this prints are become exceedingly scarce, I never did see nor heare of this boock before', letter to John Skippe, 7 November 1782; Holland-Martin letters, no. 5.

60. quoted in Fleming-Williams, 1965, p. 30.

61. 'The Letters of Jonathan Skelton written from Rome and Tivoli in 1758', *The Walpole Society*, XXXVI (1960), p.

55. I am grateful to Prof. Luke Herrmann for this reference.

62. for examples, see Philip Conisbee *et al.*, *In the Light of Italy: Corot and early Open-Air Painting* (exh. cat., National Gallery of Art, Washington).

63. 'The Memoirs of Thomas Jones,' ed. A.P. Oppé, *Walpole Society*, XXXII (1946-8), pp. 26-9.

64. Norfolk Record Office, MS 11266, no. 27.

65. Brown, no. 1052.

66. *Jackson's Oxford Journal*, 20 November 1784, 4 December 1784. For Malchair's comments on the occasion, see Holland-Martin letters, no. 10.

67. Holland-Martin letters, no. 10.

68. For Wynne, see the sketchooks in the collection of Mr & Mrs E.A. Williams; for Rashleigh, two drawings in the National Library of Wales; for Aylesford, Fleming-Williams, 1971, I, fig. 3.

69. see Malcolm Andrews, *The Search for the Picturesque: Landscape Aesthetics and Tourism in Britain, 1760-1800* (Aldershot, 1980), chapter VI.

70. MS list in the album of reduced copies at Cardiff, no. 12.

71. Minn 1957, p. 101.

72. Uvedale Price to Sir George Beaumont, 11 November 1812 (original untraced).

73. *Jackson's Oxford Journal*, 19 December 1812.

74. Curiously, Crotch remembered Malchair's being buried at St Ebbe's: Norfolk Record Office, MS 11214, Letters I, letter of March 1845; and Delamotte put him in 'the churchyard opposite George Lane', that of his parish church, St Mary Magdalen (see cat. no. 51).

75. Public Record Office, Prob. 11/1542, ff. 376, 377 v. (formerly P.C.C., Heathfield, 147)

76. on Roberts, see *D.N.B.* Delamotte, J.C. Wood, 'William Delamotte, 1775-1863', *Apollo*, LXXXIII (1966), pp. 205-7; and on Crotch, Fleming-Williams 1965-2 and Fleming-Williams 1990, pp. 56-60.

77. [Henry Beste] *Italy as it is* (London, 1828), p.28.

78. *Proceedings of the Oxford Architectural and Archaeological Society* (1862), pp. 148-51.

79. *Annual Report of the Visitors*, 1925, pp. 18-19.

80. On Duke, see Judy Egerton, 'L.G. Duke and his Collection of English Drawings', *OWCS Club Journal*, XLIX (1974), 11-29; on Iolo Williams, see Paul Goldman, 'The unerring Eye of Iolo Williams', *Antique Collector*, 1984, on Oppé, see Anne Lyles and Robin Hamlyn, *British Watercolours from the Oppé Collection*, (Tate Gallery, London 1997) pp. 9-18.

81. on whom, see the obituary by Leslie Parris in *The Times*, 20 March 1998, p. 27.

82. I am grateful to Miss Anne Lyles for this information. The Stubbs was exhibited in *George Stubbs*, (Tate Gallery, London, 1990), no. 3.

83. see Select Bibliography.

84. MS in the Archives of the Department of Western Art, Ashmolean Museum.

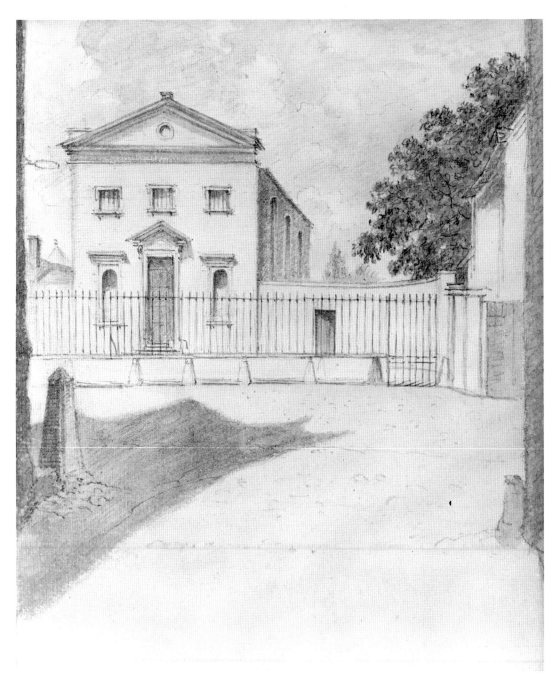

Malchair the Musician

by Susan Wollenberg

While this exhibition rightly celebrates Malchair's achievement as an artist, it was as a musician that he pursued his professional career in Oxford and elsewhere. Malchair's talents in this sphere were varied: he was active as violinist, composer, arranger and collector of folk tunes. An unusual manifestation of his musical invention survives in the form of the fourth chime still rung at Gloucester Cathedral. He took a scholarly interest in aspects of Oxford's musical heritage, paying special attention to the music collections in the Library at Christ Church; he transcribed numerous extracts from Italian cantatas in Dean Aldrich's manuscripts, and compiled catalogues of the manuscript and printed music formerly belonging to Aldrich and to Richard Goodson, now deposited in Christ Church Library (these items are preserved in the Royal College of Music, MS 1098 and MS 2125 respectively). Malchair combined an eclectic attitude towards a wide range of musical experience with an intense dedication to particular fields of interest. His qualities of humour, industry, a lively enquiring mind and a flair for discovering curiosities, are shown in his work as a musician; and his engaging personality, as well as his musical and artistic knowledge, must have contributed to the depth of his friendship with William Crotch (1775-1847). In his biographical notes on Malchair (contained in Bodleian MS Mus. d. 32), Crotch recalled how 'Malchair would call all his drawings and music *mere rubbish* when conversing on Holy subjects!'

Malchair first arrived on the Oxford musical scene well before Crotch was born.[1]

He had settled in the city by 1760 (the year in which he married Elizabeth Jenner). In 1759 he took part in a contest for the leadership of the Holywell Band. As Crotch related,

The Barrington family were always very kind to Malchair. When the present B[isho]p of Durham was Steward of ye Music Room, Hellendael (afterwards leader at Cambridge) and Malchair were Candidates to be leader of ye Band. Malchair played Geminiani's Concerto in D. Hellendael played a solo Concerto of his own. Mr Barrington persuaded the Stewards to Elect Malchair as more useful than a Solo player. Hellendael was handsome and renowned for his beauty – poor Malchair tho' a fine figure was ugly; both were German, and both excellent musicians.[2]

In fact, Pieter Hellendael was a Dutchman, but it is certainly true that Malchair won the post against distinguished competition. Malchair evidently continued to give satisfaction, retaining the leadership until the early 1790s, when, as Crotch described in the memoirs, the 'fine Cremona violin' on which Malchair led the orchestra was 'broken by an Orange thrown… during a tumult of ye young men about ye year 1792 after w[hi]ch he never lead'.[3]

Malchair's association with the band began at a time when the Holywell Music Room was still a relatively novel feature of Oxford's cultural life. 'Music meetings' can be traced back in Oxford to the period of the Commonwealth.[4] After the Restoration, various gatherings for the cultivation of chamber music – instrumental and vocal – flourished in colleges and taverns. The Musical

Club documented in the late seventeenth and early eighteenth centuries, to which many of Oxford's leading musicians and social luminaries belonged, met regularly to enjoy performances of Corelli, Carissimi, Purcell and other Italian and English composers; the club also owned and maintained instruments, and lent out printed music from its collection.[5] William Hayes (Heather Professor of Music, 1741-77) described in his history of the Music Room the difficulties of fitting instruments and performers among the audience in a typically low-ceilinged, crowded room.[6] The need for a purpose-built concert room to accommodate the club's activities was recognized, and an appeal was launched in the 1740s. After a false start (with a different site – the Racket Court) and a hiatus when the money raised by subscription scheme ran out, the work on the building proceeded 'with Chearfulness' and in July 1748 the Holywell Music Room, reputedly the first concert hall of its kind in Europe, was opened.

The design, attributed to Thomas Camplin, Vice-Principal of St Edmund Hall, blended elegance and simplicity with functionality. The room was noted for its ideal acoustical properties; one observer remarked that 'there is not one pillar to deaden the sound'.[7] The performing area was arranged to house orchestra and singers, while the benches for the audience were reportedly 'calculated for 400 persons commodiously' (in its present form it seats about 250). With its own premises, and the nucleus of a resident orchestra and chorus, the Musical Society (as it was now officially named) embarked on a series of weekly subscription concerts and special events which set the pattern for the remainder of the century, and the early decades of the next century. The Holywell concerts united 'town and gown' in a spirit of enterprise; their organization on a democratic basis chimed with the progressive growth of concert life away from the courts in the eighteenth century, presenting a challenge to the aristocratic tradition of resident musicians subject to the whims of their patrons and performing for socially exclusive audiences in often artificial conditions.

The resident performers at Holywell were governed by the regulations drawn up for the Musical Society: the 1757 Articles stipulated that all members of the band were required to reside in Oxford as a condition of their appointment, and to abide by the Society's rules, whereby 'all Performers who receive Pay are expected to attend all Rehearsals'.[8] Committee members were fined for non-attendance at meetings, and borrowers similarly penalized for failing to return books and instruments. Members of the band typically supplemented their income by teaching, writing and other profitable ventures: the violinist Philippe Jung (probably principal second violin, 1781-1808) also gave French and German tuition, opened a series of music shops in Oxford, and published a tourist guide to the locality, the *Guide d'Oxford*; while Malchair taught drawing. A regular source of extra income was provided by the opportunities for 'benefit concerts' permitted under the Society's rules. These were established under Malchair's predecessor as leader of the band, Joseph Jackson. On 24 March 1759 an advertisement in *Jackson's Oxford Journal* announced a 'Concert of Vocal and Instrumental Musick' at the 'Musick-Room' on Thursday 29 March 'for the Benefit of Mr. Jackson', featuring particularly 'a concerto and solo on the Violin, by Mr. Jackson', as well as a harpist from London, 'the celebrated Mr. Parry' (tickets were half a crown each). Poignantly, the *Journal* for 24 November 1759 advertised a Benefit, by permission of the Vice-Chancellor, consisting of a performance of Handel's *Alexander's Feast* at the Music Room for Mrs Jackson (widow of the late Mr Jackson, first Violin) and her

family. By March 1760 the Journal carried an advertisement for 'a CONCERT of Vocal and Instrumental MUSIC' at 'the Music Room in Holywell' on Thursday 13th of that month, 'for the Benefit of Mr. MALCHAIR', the 'vocal' part of the programme consisting of four songs by 'the most celebrated Italian Composers', to be sung by Signor Kottowsky from London, who would also perform a concerto 'on the German Flute'. (He was perhaps an acquaintance from Malchair's violin-playing days in London; Crotch in his biographical notes on Malchair mentioned that he 'previously [before he lived at Bristol] played a Ripieno Violin at London on his first arrival'.)[9]

In the early decades of his leadership of the Holywell Band, Malchair's name was often coupled with that of James Lates (?c.1740-1777), who seems to have led the second violins. Advertisements for the Holywell performances during this period typically featured 'Messrs. Malchair, Lates, & c.' providing the instrumental parts (together with the singers Norris and Matthews in the leading vocal parts). Working so closely with Lates over many years, Malchair presumably came to know this interesting musician more than casually. James Lates, active as violinist and composer, was the son of the Hebrew scholar David Francisco Lates, who taught in the University (David Lewis has described the younger Lates as 'the first Oxford Jewish composer').[10] He published several collections of string music: his Op. 5 sonatas were dedicated to the Duke of Marlborough, in whose service he performed as violinist at Blenheim. Lates's idiomatic and stylish compositions probably reflect the kind of string style that he helped to promote at Holywell in the 1760s and 1770s. Malchair is listed among the (well over 200) subscribers to Lates's Six Sonatas Op. 4 for 'Two Violins, or a German Flute and Violin, with a Thorough Bass for the Harpsichord' (1768).

Malchair, Lates, and their colleagues in the Holywell band, under the direction of the Heather Professor of Music – first William Hayes, then, from 1777, his son Philip – were involved regularly in rehearsing and presenting miscellaneous programmes of vocal and instrumental music for the Monday evening subscription concerts or for the occasional benefit performances; they played in the termly Choral Music, when complete works were offered, particular favourites being the Handel oratorios: from at least 1754, *Messiah* received annual performances in Oxford, either at the Sheldonian Theatre or at the Holywell Music Room (Malchair also played in *Joshua*, November 1768 and *Acis and Galatea*, November 1771, among others); and in the summer festivities, when concerts in the Theatre, with distinguished visiting performers, formed part of Encaenia week, the most celebrated being those of 1791, for Haydn's honorary doctorate of music. There were opportunities for performing outside Oxford; Malchair (among other Oxford musicians) retained a connection with the Three Choirs Festival, which he had formed before his appointment at Holywell. At Hereford Cathedral in 1759, the first performance of *Messiah* as part of the Three Choirs Festival – which was also the first performance of *Messiah* complete, in a cathedral – included Malchair among the principal instrumentalists.[11] He was also in demand for the annual entertainment at Oakley Wood House during the Cirencester Races; for example, in August 1773 the *Journal* announced that *Acis and Galatea* would be performed there, 'First Violin, with a Solo, by Mr. Malchair' (vocal parts by Norris, Matthews and others). The performance was scheduled for 11 a.m., followed by a 'Cold Collation for the Company' at 2 p.m. and 'Tea in the Afternoon' (tickets quarter of a guinea each). The day was rounded off with a ball at the

Assembly Rooms: the Oxford musicians may have participated in this too.

Within Oxford, the performers attached to the Holywell Music Room seem to have created a close, mutually supportive and generally well regulated community (although tempers sometimes flared, especially incited by the corpulent and quarrelsome Dr Philip Hayes). The Musical Society's *Articles of Subscription* for 1775-6 (about half way through Malchair's tenure as leader) give a detailed impression of the pattern of events and the operation of the subscription scheme, together with hints of trouble: 'In Compliance with the earnest Request of a very considerable Number of Subscribers, it is hoped, that for the future, Gentlemen will not suffer Dogs to follow them to the Room, which are a great Annoyance to the Company'. Concerts of vocal and instrumental music were to take place every Monday except in September and Passion week; the 'Oratorio of the Messiah' would be performed 'as usual in Lent Term', and another oratorio, or other choral piece, in Act Term (summer), while in Easter and Michaelmas Terms in place of the choral performance, at the subscribers' request, Grand Miscellaneous Concerts would be offered 'in which will be engaged at least one capital Vocal Performer, and one capital Instrumental Performer'. Not only were subscribers to be entitled to two tickets, one for themselves and one for a lady, with 'the Lady to be admitted gratis' to the regular concerts and for 2s 6d to Choral or Grand Miscellaneous events, but also it was stated that 'several Ladies having expressed their Desire of contributing annually to the Musical Society, their Subscriptions will be thankfully received' on very favourable terms.[12]

Jung, in his *Guide d'Oxford*, noted Malchair's particular penchant for the music of the 'celebrated Handel', Geminiani, Corelli, and other 'old authors'.[13] While in a sense this

Fig. 10. Publicity ticket for Malchair's last benefit concert, 1792. *Verso* of Brown, no. 1101

reflected a conservative attitude, it also represented a modern current of thought which placed a special emphasis on 'ancient music' – the beginnings of the 'canon'. The Holywell programmes gave plentiful scope for the satisfying of Malchair's taste for old music. But alongside the *concerti grossi* and choral works of the 'ancients' they included up-to-date operatic and symphonic music – J.C. Bach, Abel, Stamitz, Gluck and Cimarosa appeared, among others, on the 'modern' side. The programmes, divided into two 'Acts' (and with perhaps a brief entr'acte such as a glee or madrigal) characteristically alternated vocal and instrumental items totalling about 10 (2 × 5) in the Monday evening concerts, expanded to about 12 (2 × 6) in the Grand Miscellaneous Concerts at the Theatre. The pattern of each half generally began with an overture, followed by a solo song or operatic ensemble, a symphony, a further vocal piece, and a concerto or chamber work; the concluding item might be a popular oratorio chorus, such as Handel's Sing unto God, 'With Trumpets and Drums'. Works by Oxford composers

were featured, in which the composer might perform as soloist. Within a concert at Holywell the musicians were generally required to command a wide range of musical styles. The demands on the performers were evidently increased by requests for encores; responding to this, the concert programmes warned that 'by the ARTICLES OF SUBSCRIPTION no Performance, whether Vocal or Instrumental, is to be repeated'.[14]

The regular band had opportunities to play alongside star performers visiting from outside Oxford, many of them associated with the fashionable London concerts and the grand annual music festivals. Oxford's position en route back to London probably fitted in well with their touring circuit. The Holywell Music Room was also the scene of several prodigy appearances: this too – the cult of the child musical genius – was a particular fashion at the time. The most remarkable was William Crotch, who, as 'a Child in a Frock on his Mother's Knee, performed on the organ in the Music Room, to the great astonishment of a large Audience', on 3 July 1779 – aged three![15] (He must have been the only Oxford Professor of Music to have made his first appearance in the city in such sensational style!) Although the documented evidence for Malchair's friendship with Crotch, which formed such an important element in the last decades of Malchair's life, relates only to the later period from the 1790s on, Crotch's earlier association with the city would have enabled him to encounter Malchair, especially at the Holywell Music Room. Following his tour of 1778-9, and after the visit to Oxford in 1783 when he met his future patron, the Reverend Alexander Schomberg, Crotch returned in 1788 to reside in Oxford, lodging with the singer and music-seller William Matthews – an associate of Malchair. His increasing involvement in the Oxford musical scene (which included regular engagements as soloist at Holywell) was

strengthened by his appointment as the organist of Christ Church in 1790, and as Heather Professor of Music in the University in 1797, at the age of 21.

'About this time [1797],' Crotch recalled,

I became more intimately acquainted with Malchair and he paid me a daily visit at 4 o'clock staying till 10 min[utes] before 5 when I was obliged to go to Christ Church prayers. He brought a music book for me to play to him under his arm and sometimes brought a new tune for me to write down as his eyes became too dim to see even his large notes any longer – He continued these daily visits till breaking his shin against a Wheelbarrow in Trinity Court where he used to take a few turns, he never again ventured out ... I used to call on him every Sunday after morning sermon.[16]

Crotch's annotations to the music volume in which he wrote down and arranged Malchair's compositions refer admiringly to Malchair's ingenuity, including his reaction to incipient blindness:

When Mr. Malchair (long about 40 years ... leader of the band at ye Oxford Music Room & drawing Master) became dim sighted ... he contrived various methods of amusing himself without using his eyes ... repeating Poetry – walking a certain number of times round the room and playing on the Violin National Airs w[hi]ch he had learnt by memory – and thus he parcelled out his time so completely that unless he was unwell he never found solitude an inconvenience, and the call of a friend rather discomposed than obliged him.[17]

Malchair's compositions (surviving in Crotch's lovingly assembled copy) are mainly in the style of folk tunes. Some may be reminiscences, but in general the implication seems to be that most were newly composed by Malchair (several include his variations on the tunes). The titles – Crotch noted that 'the

names were given by their author' – partly reflect Malchair's German background, as in 'The Waits of Coblentz on ye Rhine';[18] under the tune 'The Waits of Cologne' Crotch remarked that this was 'the birthplace of our Author where he was a Chorister'.[19] Other titles relate to Malchair's travels after he had settled in England, as with the tune 'Mrs Lloyd of Caernarvon', glossed by Crotch as 'a reputable Lady of Caernarvon who was very hospitable to our author'.[20]

Malchair's interest in folk music is well documented in autograph manuscript sources as well as printed form (in Crotch's *Specimens of Various Styles of Music referred to in a Course of Lectures, read at Oxford & London …*, I, *c*.1808). Although the contents of the autograph manuscript collections (exhibited here as cat. nos. 109-10) are extensive, containing several hundreds of pages of music carefully assembled in Malchair's neat, clear hand, these two volumes represent only a fraction of his activity in this sphere. The manuscript at Cecil Sharp House bears the original inscription 'Vol. 3. The Third Collection', which, together with internal references to, for example, 'Coll. 2 d.', strongly suggests that vols. 1 and 2 were prepared previously; these are not now known to exist. The manuscript in the Royal College of Music is inscribed on the cover:

> The Arrangement
> Being an Extract of the Welsh, Irish and Scotch Tunes, contain'd in the foregoing Vols, &
> placed in seperate Classes

while its title page announces 'A Collection of Welsh, Irish and Scotch Tunes. Part the First', selected and arranged 'by J.B. Malchair / Oxon. 1795'. 'Part the Second', with further Welsh, Irish and Scotch tunes, begins a little over halfway through. Possibly, further volumes were envisaged for this series, while its parent volumes (which may relate to the other

series) already existed. The two surviving manuscripts contain some duplicated items. Together, these sources convey an impression of long and thorough labour.

'Folk music' would not in fact have been a term likely to be used by Malchair or his disciple Crotch. What they collected and documented so painstakingly was regarded, and described, as 'national music', the concept of folk music being a later nineteenth century development in England. From what survives, Malchair's energy and enthusiasm as a collector are very clearly evident. The detail that he provides regarding sources, associations of the tunes, and comparison of different versions, testifies to the care and the intense scrutiny he applied to the objects of his collection. What emerges is his love of these tunes, and the degree of enjoyment he derived from collecting them.

The scholarly side of this activity was of particular significance for its time in two respects. First, Malchair recognized the importance of John Playford's *Dancing Master* and studied and gathered tunes from the various editions, some of them very rare, in which he took a bibliographical interest. Both Malchair and, following him, Crotch in the *Specimens*, noted that a copy of the 1652 edition of this 'very curious work', as Crotch dubbed it, was deposited in Wood's Library in the Ashmolean Museum.[21] (Malchair's advice on acquiring copies of *The Dancing Master* was to alert your bookseller, and look on the stalls in the London streets!)[22] As Margaret Dean-Smith has observed, of Malchair's work on Playford's collections, this was 'probably the first time that The *Dancing Master* had been used in this way, and the first time the tunes it contains had been scrutinized, compared and generally subjected to musical examination and study'.[23] Part of the task Malchair undertook was the transmission of the tunes in more easily readable form through transcription into

Malchair

Fig. 11. A Blind Irish Piper; *From this man I noted some beautiful Irish Tunes as he played them on the Bag-Pipe.*
15 May 1785. Brown, no. 1037

modern notation. He acknowledged the difficulties of reading the old notation 'in these days, when all things are become easy by the assistance of Rule and Methode'.[24]

To all these efforts Crotch undoubtedly owed the impetus for the prominent role he assigned to 'national music' in his *Specimens*. He admitted that 'some of the most eminent writers on the art have been inclined to disregard this species of music, because it was preserved by tradition' (this of course was the very reason why the later folk song movement placed special value on it) but under Malchair's influence Crotch elevated it explicitly to important status.[25] In terms of appreciating the music's qualities, he would have absorbed Malchair's view that many of these melodies of 'great antiquity and of Various Nations' were 'uncommonly beautyful' and deserved to be saved from oblivion.[26] Malchair found a depth in the tunes themselves as well as interest in their associations. He expressed a sense of regaining past culture, contrasting it to modern times.

Besides his general debt, constantly acknowledged in the Preface to the *Specimens*, to the example of 'Mr. Malchair, who has made National Music his study',[27] Crotch derived some 30 tunes from Malchair's collections for his English 'specimens', and further tunes for the Scottish section, as well as more exotic items including two 'from Mr Malchair's collection' among his examples of 'Jewish Music'.[28] In addition, he mentions in the preface that the accompaniments supplied for various tunes were either furnished entirely by Malchair or strongly based on models he provided. Discussing the problems of 'adapting accompaniments' to these traditional melodies, Crotch credits Malchair with possessing, and demonstrating, the special skill required 'in putting most ingenious and natural harmonies to a great number of Old National Tunes'.[29] Crotch's *Specimens* thus add an extra dimension

to Malchair's originals, which in the MS collections are presented in a single melody line, unaccompanied, following the style of Playford's *Dancing Master*. (The 1652 edition, and subsequent issues, bore the subtitle 'to be played on the Treble Violin'.) Crotch documented Malchair's experiments with a three-stringed violin for his own compositions in folk style: apart from the Cremona instrument, Malchair possessed another violin which 'remained unused for sometime with its 4th. [i.e. G] string broken. And having read in Anty Wood that he first played on a Violin of 3 strings tuned in 4ths it suggested to him the idea of making this use of his neglected Violin' (for which Malchair created a special notation, transcribed by Crotch).[30]

Secondly, Malchair developed the idea of collecting tunes 'on location'. Interspersed with the many items from Playford and other published sources were his own discoveries. Numerous annotations to melodies in the collections, both in manuscript form and when taken over by Crotch for the printed *Specimens*, show Malchair's eagerness in this regard. Beyond the academic and the musical aspects of his work are the pure 'collector's instinct' and delight in acquisition. As Malchair remarked in his vivid English, the 'leasure howers of many years were employed in forming this collection, ney, necessary busness was at times incrotched uppon when the fitt of collecting Grew Violent'.[31] Thus when Crotch describes how No. 156 of his *Specimens* was 'written down by Mr. Malchair, who heard it sung in Harlech Castle',[32] or when Malchair himself notes that his version of 'The Grand Duke of Tuscanys March' is 'as played by a Savoyard on a barrill Organ in the Streets at Oxford. November 30 – 1784',[33] they conjure up a picture of Malchair the active collector of tunes, as well as editor. The streets of Oxford were evidently a fertile source. Among the items gathered in the Cecil Sharp House

volume they yielded, besides the March already mentioned, such gems as La Rochelle, 'played by a Piedmontese Girl on a Cymbal in Oxford Streets December 22. 1784' (and recorded together with Malchair's instructions for reproducing the effect on the violin); an untitled tune resembling 'Early One Morning' transcribed 'from the Singing of a Poor Woman and two femal Children Oxford May 18. 1784'; a topical item, 'The Budget for 1785. Sung in the Streete July 21 – 1785 – Oxon A Political Balad on Mr. Pit's Taxes'; a tune for 'flute a bec [recorder] and Tambour' which Malchair heard 'play'd in the Streets at Oxford Ash Wednesday Feb: 25, 1789'; and, most evocatively, the lively 'Magpie Lane' tune: 'I heard a Man whistle this tune in Magpey Lane Oxon Dbr. 22, 1789. came home and noted it down directely'.[34]

The music of the military bands also attracted Malchair's attention. He later acquired 'an Irish tune noted down [in shakier handwriting than previously] from the playing of ye Oxford Militia Band ... March 1800'.[35] (Malchair composed Marches for the Oxford Loyal Volunteers, included in Crotch's manuscript volume of his compositions; these were rejected by the band 'on account of the Rhythm'!)[36] Annotations to the manuscript in the Royal College of Music include a number of Oxford college sources: 'Rothemurches Rant. a Strathspey' was derived from 'the Honble Mr Linsey of Baliol Coll: Oxon: Noted down from his singing the Tune'; 'Killekranky' came from 'the Singing of Mr. Cunningham, of Christ Ch: Oxon'; and 'Pen Rhaw' was taken from 'the old M.S. Book of Mr. Jones of Jesus Oxon...'[37] Malchair adds some personal comments: to a tune marked *amoroso* from Jones, he puts the remark 'Very little of the amoroso in this, my Master Jones'.[38] The long habit of collecting, and Malchair's enquiring interest in these tunes (and in the culture they represented) generated numerous offers of items for his collection from friends and correspondents. Among the donations were the five tunes 'recievd ... by a letter from the Revd Mr. Samuel Riall, signed Upham June 13 – 1786. Ireland', included in the R.C.M. manuscript and excerpted by Crotch for his *Specimens*.[39] Crotch, in the Preface to the *Specimens*, identifies various tunes given to Malchair, for example 'No. 249 ... brought from Spain, and presented to Mr. Malchair by Mr. Vyse, of All-Souls' College, Oxford'.[40] Several of Crotch's entries headed 'Music of North America' were 'given to Mr. Malchair, by a French gentleman ... resident in ... Canada'.[41]

In his introduction to 'The Arrangement', Malchair reflected on the music of the different nationalities, expressing his conclusions in typically idiosyncratic style: the Scottish tunes he had gathered were more numerous – 225, together with 123 Welsh and 107 Irish – 'becose, more than half of the tunes that are playd in Scotland are originally Irish',[42] and further into the manuscript he elaborated on the many Irish tunes 'which the Scottish Nation have formerly adopted, and are now tought to look upon as theire ohn'.[43] Notwithstanding this well intentioned effort to understand and classify the different national types, Malchair's work later attracted censure from the publisher William Chappell, editor of *Popular Music of the Olden Time*, 1855-9, who in a letter of 8 December 1856 to the music scholar and librarian W.H. Husk[44] objected to the muddling of categories represented, for example, by Malchair's inclusion of the tune 'Roast Beef' in his Irish group (Chappell, or some other commentator, has pencilled in at the relevant point in the manuscript: 'Placed here among Irish tunes!!').[45]

With twentieth century developments in folk song and dance studies, the value of Malchair's work has been duly recognised by specialists in the field; and with the

establishment of dedicated performing groups, the attractions of the music Malchair collected are more accessible to the modern listener.[46] The trace that Malchair left in this area of musical culture is impressive and distinctive. Before he died, he would no doubt have been aware of the warm recommendations with which his work had been promoted by Crotch, who presented Malchair's tunes to the public with his own affirmation – very much in the spirit of Malchair – that this was a subject 'wherein much remains to be discovered'.

References

1. For biographical information on Malchair see *The New Grove Dictionary of Music and Musicians*, ed. Stanley Sadie (London, 1980), XI, pp. 567-8; I am grateful to the author of that article, Robert Bruce, for his advice.

2. Bodleian, MS. Mus. d. 32, p. 51.

3. *Ibid.*, title page, *verso*.

4. See *The History of the University of Oxford*, IV, *Seventeenth-Century Oxford*, ed. N. Tyacke (Oxford, 1997), pp. 632-4.

5. Margaret Crum, 'An Oxford Music Club, 1690-1719', *The Bodleian Library Record*, IX (1974), pp. 83-99.

6. Bodleian, MS. Top. Oxon. d. 337.

7. J.H. Mee, *The Oldest Music Room in Europe* (London, 1911), p. 34.

8. Oxford, Music Faculty Library, Rare Books; reprinted in Mee, *op. cit.*, pp. 45-53.

9. Bodleian, MS. Mus. d. 32, title page, *verso*.

10. D.M. Lewis, *The Jews of Oxford* (Oxford, 1992), p. 5.

11. D. Lysons, *History of the Origin and Progress of the Meeting of the Three Choirs of Gloucester, Worcester, and Hereford …* (Gloucester, 1812), p. 189.

12. *Articles of Subscription*, 1775-6, printed in *Jackson's Oxford Journal*, *passim*, for example on 16 March 1776.

13. Mee, *op. cit.*, p. 79.

14. Programmes are extant in the Bodleian Library, MS Mus. 1 d. 64, MS Top. Oxon. d. 281, and MS Gough Oxf. 90.

15. See Bodleian Library, MS Top. Oxon. d. 247, p. 147.

16. Bodleian Library, MS Mus. d. 32, p. 21.

17. *Ibid.*, title page, *verso*.

18. *Ibid.*, Part II, No. 7, p. 15.

19. *Ibid.*, Part I, No. 6, p. 2.

20. *Ibid.*, Part II, No. 14, p. 19.

21. R.C.M., MS. 2091, fol. 4v; Crotch, *Specimens*, Preface, p. 5.

22. R.C.M., MS. 2091, fol. 7v.

23. Margaret Dean-Smith, 'The Preservation of English Folk Song and Popular Music: Mr. Malchair's Collection and Dr. Crotch's Specimens', *Journal of the English Folk Dance and Song Society*, VII (1953), pp. 106-111 (110).

24. R.C.M., MS. 2091, fol. 4v.

25. Crotch, *Specimens*, Preface, p. 2.

26. R.C.M., MS. 2091, fol. 4r.

27. *Specimens*, Preface, p. 3.

28. Nos. 17-18.

29. *Specimens*, Preface p. 4.

30. Bodleian Library, MS Mus. d. 32, title page, *verso*.

31. R.C.M., MS. 2091, fol. 3r.

32. *Specimens*, Preface, p. 8.

33. Cecil Sharp House Library, Malchair MS (QM), p. 58.

34. *Ibid.*, pp. 60, 42, 73, 82 and 88.

35. *Ibid.*, p. 119.

36. Bodleian Library, MS Mus. d. 32, Part III, p. 49.

37. R.C.M., MS. 2091, pp. 105, 98, 13.

38. *Ibid.*, p. 8.

39. *Ibid.*, p. 75; Crotch, *Specimens*, Preface, p. 5.

40. *Specimens*, Preface, p. 10.

41. *Ibid.*, p. 13.

42. R.C.M., MS. 2091, fol. 2v.

43. *Ibid.*, fol. 65 (between pp. 88-9).

44. Loosely inserted in R.C.M., MS. 2091.

45. R.C.M., MS. 2091, p. 71.

46. For example through the concerts and recordings of the Oxford-based group 'Magpie Lane'.

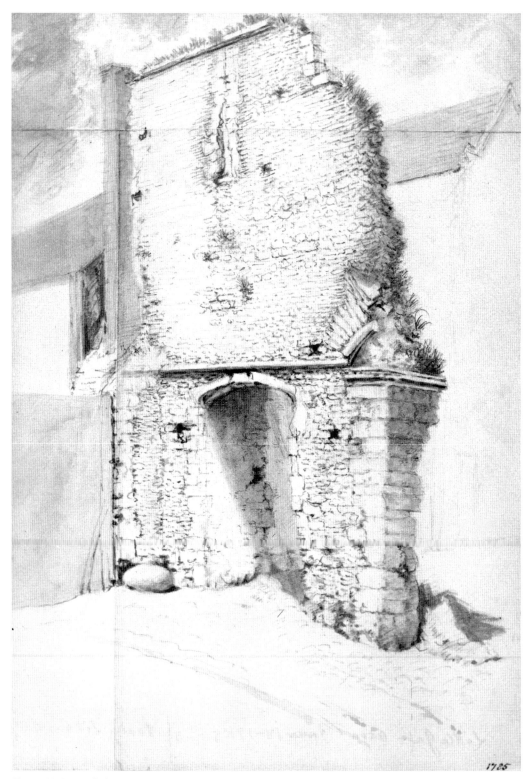

Fig. 12. Littlegate, Oxford by Malchair

Malchair and the Oxford Topographical Tradition

by Julian Munby

*Look upon its buildings, and the lofty pinnacles
and turrets thereon, and what structure in Oxford
or elsewhere doth more delight the eye?
administering a pleasant sight to strangers at their
entrance into the east part of the City…: Go
without it, and you'll find it a College sweetly and
pleasantly situated, whose Grove and Gardens…
are emulous with the gardens of Hippolitus
Cardinal d'Este…. Go into the Water-walks, and
at some times in the year you will find them as
delectable as the banks of Eurotas… Such
pleasant meanders also shadowed with trees were
there, before the civil distempers broke forth…*[1]

Introduction

Anthony Wood's encomium of Magdalen
College at once demonstrates the
aesthetic motivation, and ready nostalgia of
antiquarian concerns in the seventeenth
century. Oxford's topographical tradition has
its origins in antiquarian pursuits of that age,
but was to became something more in the
following century, and images of the city and
colleges were made both to record the
buildings, possessions and territory of
individual institutions and generally to
celebrate the city and university. From earliest
times engraved reproductions have been sold
to nostalgic alumni, and to provide visual
momentoes for visitors. Moreover, the Thames
valley landscapes have often inspired artists,
and if Oxford never rose to the heights of the
Norwich School, at least the century of
Malchair and Turner of Oxford (1760s-1860s)
produced some significant contributions to the
English landscape movement.[2]

Like many early views of Oxford,
Malchair's drawings are important to us now,
at least in part, for their topographical
information about vanished parts of Oxford,
and the appearance of the city before the
changes in the 1770s swept away so much of
the medieval character of the city. It may,
however, be questioned to what extent
Malchair was guided by an antiquarian
impulse, though in retrospect he clearly
realised the value of this aspect of his work in
the fact that he chose vanished buildings as the
subjects for published engravings. Nevertheless,
his work must be considered in the light of the
long tradition of the pictorial representation of
Oxford, which may be unusually rich in its
products but is in many ways an unexceptional
manifestation of national trends. That the
great quantity of topographical drawings of
Oxford is so little known is partly the result (as
often happens) of their being treated as
manuscripts in libraries or archives and also, of
course, the desirability of protecting
watercolour drawings from too much light.
However, the two major collections of the
Bodleian Library and Ashmolean Museum are
well indexed, and there are guides to the even
greater numbers of prints.[3]

The origins of the topographical tradition

The iconography of the medieval town of
Oxford was established early with the image of
the walls and towers (fig. 13) shown on the
municipal seal of 1191 (which is incidentally the
first known in England).[4] This can be
compared with other images of towns such as
the view of Constantinople/Lincoln in the
14th-century Luttrell Psalter, and the classical
tradition of a compact icon or 'ideogram' such

Fig. 13. The Oxford Seal of 1191

as the tutelary deities with mural crowns, or medieval patron saints clasping models of a church or city.[5] Despite the familiarity of the image, surprisingly few towns employed the walled city on their seals, though London, York and Worcester were all to do so.[6] In 1191 there were as yet no spires in Oxford, but they are shown in *c.*1400 on the finest medieval depiction, a wood carving on a misericord at New College, illustrating in miniature the entire academic process of students entering the City and being sent out with the benefit of a Wykehamical education.[7]

The distant view
The geography of Oxford to some extent governs her topographical image, for at a time when the main east and west approach roads descended from the hilltops, the towers and spires were the most obvious feature, and no single view or image inside the walls could provide a summation of the character of the University. Thus the first international image of Oxford, that of Braun and Hogenburg published in the atlas *Civitates Orbis Terrarum,*

(Vol. I, 1575) was a view from the London road that can still be appreciated from South Park in Headington.[8] Despite William Smith's less usual view from the south, albeit from one who may never have visited Oxford,[9] the skyline of towers and spires was perhaps an obvious choice as icon for coins of Charles I's Oxford mint in the Civil Wars, while the 'Prospect of Oxforde from the East' also appears on the Hollar's map of the royalist garrison town (1643) as it did later on Loggan's map of 1675.[10]

Mapping the city
Oxford and Cambridge both had birdseye maps prepared in the 16th century, unusually for English provincial towns. The European background of such enterprises was a series of maps of famous cities, that of Venice in 1500 remaining one of the earliest and most spectacular, while equally impressive were those produced in Flanders and the Netherlands, such as the multi-sheet pictorial plans of Antwerp (1565) and Bruges (1562). These views were often in the form of true scale maps with buildings added in pictorial form (as isometric projections, not perspective).[11] London of course has its (now incomplete) copper plate map of *c.*1560, and Oxford followed in 1578 with the birdseye map prepared by the Suffolk land surveyor Ralph Agas.[12] As he explained in an introductory verse:

> *Meane time the measure, forme & Sight I bringe*
> *of antient Oxford, noble Nurse of skill*
> *a Citie seated ritch in everye thinge*
> *girte with woode & water, Pasture, corne & hill*
> *he tooke the vewe from North, & soe he leaves it still*
> *for there the buildinges make the bravest showe*
> *and from those walkes the Scholers best it knowe.*

Agas's Oxford was published in 1588 (followed by Cambridge in 1592), and now only survives

in a badly damaged single copy but is also known from the version re-engraved by Robert Whittlesey in 1728.[13] It does indeed convey the impression of a well-watered and rather leafy city, which probably over-emphasises the amount of unbuilt space in the centre of the town, despite the late-medieval contraction of Oxford.[14] The general appearance of Oxford was made familiar by Agas' map, and more so from derivative views like that published on the map of Oxfordshire in Speed's Atlas in 1611, while the selection of the view from the north set a precedent for birdseye maps that was to be followed by Hollar and then Loggan in the next century.[15] Maps, and especially these pictorial projections, were akin to topographical painting, and could afford equal pleasure and information to the attentive viewer; Burton indeed famously recommended the perusal of such maps as a cure for melancholy.

Illustrating the Antiquaries

Topographical views, in the form of maps or perspective drawings were often the result of direct patronage with a didactic purpose. It is indeed remarkable the extent to which the images of Oxford in the seventeenth and early eighteenth century are the product of directions given by the antiquaries, especially Anthony Wood (1632-95) and Thomas Hearne (1678-1735). It was Wood who effectively commissioned Loggan to undertake his Oxford map and views, and encouraged Aubrey in his studies, while Hearne employed Michael Burghers to illustrate his learned papers, in a manner so distinctive as to be made the subject of parody.

Wood and Aubrey

The antiquary and scientist John Aubrey (1626-97) figures as a sometime colleague of Wood's, enthusiastically exchanging information with him, like providing him with

a view of the great castle tower drawn from his memory of Oxford in the 1640s. Aubrey's early antiquarian concerns had been manifested by his commission in 1643, when still an undergraduate, of Hesketh's drawing of the ruins of Oseney Abbey, later engraved by Hollar (fig. 14) for William Dugdale's *Monasticon* (1661).[16] But his most intriguing enterprise was his history of medieval architecture, the *Chronologia Architectonica*, forming part of his unpublished *Monumenta Britannica*, which contained many Oxford examples in the illustrations of architectural details.[17] Aubrey's sequence of buildings must partly have depended on information from Anthony Wood about the date of college and church buildings, since Wood's writing often shows knowledge of changing styles in his description of colleges, derived from his experience of sources for building history.[18]

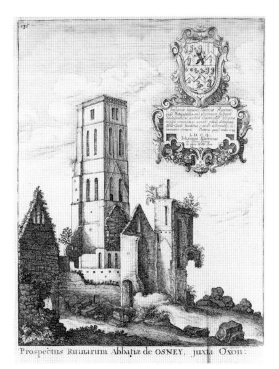

Fig. 14. Wenceslaus Hollar, The Ruins of Oseney, engraving from Sir William Dugdale, *Monasticon*, II (London, 1661)

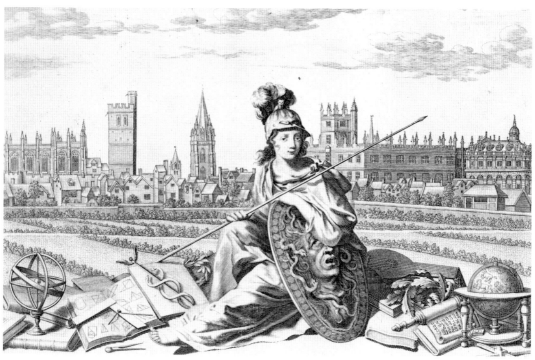

Fig. 15. Frontispiece to David Loggan, *Oxonia Illustrata* (Oxford, 1675), detail

Wood and Loggan

In 1665 Anthony Wood began his collections
for his *History of the University*, published in 1674,
and decided early that the work would be
illustrated, perhaps encouraged by the sight of
William Dugdale's *Antiquities of Warwickshire* in
1656, a work by whose reading he was
'ravish'd and melted downe', and which also
contained numerous illustrations. In the same
year Wood first met the young artist and
engraver David Loggan (1635-92);[19] in the story
preserved by George Vertue, Loggan was first
'taken Notice of in delineating the Front of All
Souls College for himself and was perswaded
to undertake Oxford'.[20] Certainly, within a
short time Loggan was living in Oxford and
preparing the celebrated series of forty views of
the university with the extraordinary birdseye
map of the city. These were published
separately by Loggan in 1675 as *Oxonia Illustrata*
(fig. 15), but were always intended to

accompany Wood's History as a prestigious
advertisement for the revived University Press.
In addition to the map there were two
prospects of the city from the east and south,
and precise portraits of all the colleges, halls
and university buildings.[21]

The college views are exacting depictions
of the details of architecture, replete with
circumstantial detail of texture and variation,
that can be used today as an authoritative
source for lost buildings. Gardens are shown
with as much loving care as buildings,
preserving the groves and parterres long after
their disappearance, while they are peopled by
scholars at work and play. Likewise the streets
are enlivened by figures and vehicles: pedlars,
flower-sellers and gentry, and a comprehensive
staffage of transport from pack-horses and
water carts to waggons and coaches. These
were at once contemporary images and
historical records of the architectural history of

the colleges. Wood himself was inspired to draw, in the manner of Loggan, a view of the old buildings of University College prior to their demolition, and Loggan set a high standard for his followers.[22]

For Loggan's birdseye view of Oxford, Wood reported lending Loggan an ancient map, undoubtedly that of Ralph Agas, but while Hollar had freely plagiarised the information on Agas for his birdseye view, it was an entirely 'new and most accurate' survey that formed the base for Loggan's 'Scenographia'. Wood noted on his copy that *'this map or platforme of the University and Citie of Oxon was mostly drawn by the hand, with a pencill, of David Loggan, the University engraver, anno 1673: engraven on a copper plate anno 1674: and published with the book of maps of colleges and halls anno 1675. The said David Loggan using my direction in the matter and an old map of Oxon which I have in my hands'.*[23] Loggan's celebrated view of Oxford is of astonishing accuracy, and demonstrable mistakes are few (it omits the medieval kitchen of Lincoln College). It represents every building and garden throughout the city and suburbs in great detail, with representations of land-use (nursery gardens and arable land), antiquities (the castle and civil-war bastions), water (fish-ponds and holy wells) and street furniture (maypole and pillory). With the exception of a lone bargeman the map is notable for containing representations of cattle, but no people, and even the apparent figure of a fisherman in St Ebbe's turns out to be the bucket and pole for watering the Paradise Gardens, to be illustrated by Malchair a century later. This is not the only instance where Loggan's map, used in conjunction with later drawings, is an importance source for elucidating vanished topographical details. The map was in turn used by William Williams as the base for his map of 1733, and it was not until 1750 that a new survey was made for Isaac Taylor's map.

Hearne and Burghers

Thomas Hearne's career as self-publishing antiquary is notable both for the number of editions of historical texts he produced, and also for the learned appendices attached to them, which are often accompanied by informative illustrations by Michael Burghers (1653?-1727), a pupil of Loggan's.[24] These include important views made around 1720s of the castle, and of all the monastic remains on the outskirts of Oxford (Oseney, Rewley, Godstow, Sandford and Littlemore).[25] In a manner following that of Loggan, Burghers' portraits of buildings are drawn with care and understanding, and no doubt he was guided by Hearne in what was relevant to depict. The views are peopled with inquiring scholars (at Oseney Abbey a group of antiquaries are following the ploughman in time-honoured fashion),[26] there are ordinary folk at leisure, and the margins are well supplied with informative captions flagged by signal letters scattered over the plate. As privileged engraver to the University since Loggan's death, Burghers was available for illustrating other works, such as White Kennett's *Parochial Antiquities* (1695), which contains views of Oxfordshire (and Bucks) churches and country houses.[27] The style of antiquarian illustration, with descriptive annotations, was distinctive enough to invite a parody by George Vertue in his satirical plate of Hearne's alehouse 'Antiquity Hall' (1723), peopled with drunken scholars and preposterous captions, much to the annoyance of Thomas Hearne.[28]

Later antiquaries

Despite the recession of the first wave of learned enterprise in the years after 1700, throughout the eighteenth century much learned endeavour went into the production of collections of parochial antiquities, and there was necessarily a visual aspect to the copying of church monuments and inscriptions, but

usually little prospect of publication.[29] Richard Rawlinson (1690-1755) made some progress with materials for a county history (to include Wood's account of Oxford), and went as far as collecting plates, but in the event Oxfordshire never boasted a county history until the twentieth century.[30] In Oxford the first stirrings of change in the historic fabric of the town led to the tradition of drawing ruins or buildings prior to their demolition. James Green, who we shall meet again as an engraver, was employed by Edward Rowe Mores of Queen's College in 1750 to make drawings of the medieval buildings that had been demolished earlier, and seems to have been commissioned to make a series of views of medieval halls, many of which have now disappeared. Included in these was a record of the thirteenth-century gildhall of Oxford, which was demolished in 1750.[31] While innocent of the gothic fervour of the nineteenth century, or indeed the exactness of Loggan or Burghers, Green's drawings are nevertheless an informative record of significant lost antiquities.

Marketing the image: the Oxford Almanacks

The most obvious source of images of Oxford in the eighteenth century was the annual series of engraved almanacks produced by the University Press, which from 1674 had included a picture above the calendar.[32] Down to 1722 these were mostly allegorical scenes (by Burghers), though they frequently included the spires of Oxford as a backdrop to an improbable landscape peopled by gods and heroes, or occasionally important new buildings such as the Clarendon Building. Between 1723 and 1762 the almanacks featured a long run of College portraits (many by George Vertue), often including historical scenes of the founder or notable college alumni, against a background of the

architectural views of college buildings as they were or were hoped to be; generally these college portraits float in a celestial landscape rather than being located in the mundane streets of Oxford. The colleges were also fully illustrated in the 65 plates of William Williams' *Oxonia Depicta* (1733), which brought Loggan up to date for the Georgian era, if rather in the manner of an architectural textbook. While his college views are less accomplished than Loggan's, Williams does preserve some valuable evidence for college gardens as well as new building, and his plans of lost buildings (e.g. Christ Church, Canterbury Quadrangle) are an important record.

Outside of illustrated books, the appearance of subscription plates and single sheet engravings reflects a growing market for Oxford views for both alumni and the first tourists, and enormously increased the currency of images of the city in circulation. Loggan's views were reissued in miniature on the continent in 1707, and impressions continued to be made from his original plates.[33] The brothers Buck issued their 'South West Prospect of the University, and City of Oxford' in 1731, a detailed view of the skyline of Oxford viewed from North Hinksey Hill, and to this they added the 'South – East Prospect' in 1753.[34] Their style is somewhat naive (and sadly the engraving lacked the lightness of their pen), but these are an expressive reworking of standard views in eighteenth-century mode, the latter boasting the Radcliffe Camera to complete the Oxford skyline, and scholars disporting in female company.

Green, Donowell and Malchair
The changes in landscape painting apparent from the middle of the century have their counterpart in townscape, signalled in Oxford with the appearance of a young artist James Green as university engraver in the place of

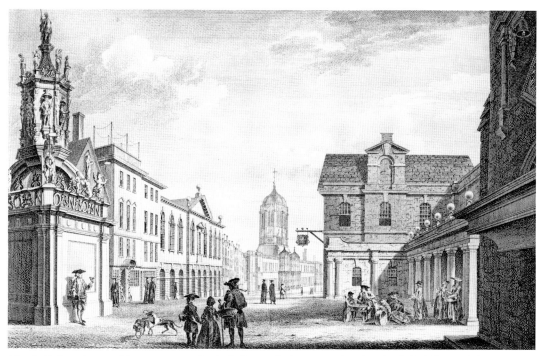

Fig. 16. *Carfax as it appeared in 1775*, an engraving by J. Donowell of 1755 reproduced as the Oxford Almanack for 1894

George Vertue. It was his first Almanack (for 1752) that introduced a perspective 'townscape' view of the university buildings in Radcliffe Square, in contrast with all those that had gone before.[35] Sadly his early death in 1759 prevented the development of Green's skills, but others were taking a similar interest in opening out the traditional college portrait.

John Donowell, in a series of *Perspective Views of the Colleges and other Public Buildings of Oxford* published in 1755 (with titles in English and French) showed the principal City and University buildings in their townscape setting and was a pioneer in establishing what were to become some of the standard Oxford views: Broad Street looking towards the Sheldonian Theatre, the curve in the High Street looking west from Queen's College, and Christ Church from Carfax.[36] This last (fig. 16) was carefully arranged to include the Carfax Conduit, the Buttermarket, and the new Town and County Hall to frame the striking view of

Tom Tower that is alas no more; Donowell's view of Trinity and Balliol Colleges was yet more bold, for half the scene is obscured by the trees in front of Balliol, and the most prominent feature is a horse and cart.[37] The success of these views is proved by their reworking by later artists, and their pirating for the foreign print trade, such as Daumont's reversed vue d'optique of Donowell's High Street, *c*.1775.[38]

Thus it was perhaps no coincidence that Malchair's drawings for the Almanack of 1767 and 1768 mark the initiation of a series of general Oxford views, following on from a brief reappearance of allegorical views after 1755 that had been the staple fare of the early almanacks. They are both landscapes and clearly owe more to contemporary trends and to Dutch painting than they do to any previous views of Oxford. The first view perhaps consciously reverts to the subject of the Bucks' 1731 prospect of Oxford from the

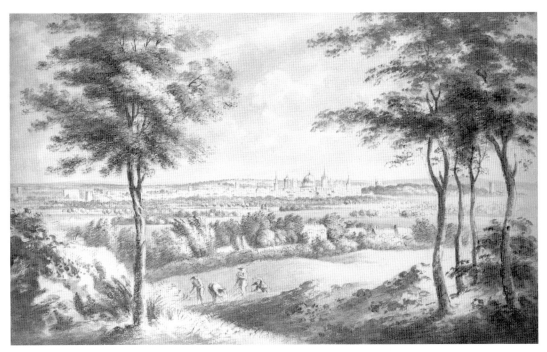

Fig. 17. Malchair, *Oxford from Hinksey.* Brown, no. 1283

south west, and if the engraving is a little coarse it is perhaps owing to the failure to relay the lightness of Malchair's style, to be seen in his study of the same view (fig. 17). The second is rather better engraved, and according to the contemporary explanation shows

> 'A *view of Merton College, with the ground descending from the Garden towards the River taken from the Meadow to the East of the Cherwell; Together with both the Towers of Christ Church, discovered through an Opening in the Trees at the East End of Christ Church Walk'.*[39]

Thus the rural landscape is to be as carefully chosen as Donowell's townscape, to achieve a satisfactory pictorial composition.

Michael Angelo Rooker
Malchair only performed these two almanacks, and the series continued with two decades of Michael Angelo Rooker (1769-88), then Harris, Dixon and Dayes in the 1790s, and J.M.W. Turner between 1799 and 1811. If Donowell suggested the new view of Oxford it was Rooker who made it his own. Rooker's views of college and university buildings are strong and detailed perspective views of the exteriors of buildings (usually groups of buildings), almost as if of colossal Roman ruins, or rather a medieval abbey. From the first (All Souls College, 1769) the standard is set with the contrast between the smooth ashlar stonework of Hawksmoor's building and a busy foreground of rough masonry and garden plants, competently drawn and expertly engraved (by the artist's father Edward Rooker). In 1770 there is a 'most elegant Perspective View' of Oriel, in 1771 Magdalen Tower as it should be, dominating the narrow approach road to the city, then Merton Chapel College framed by a street scene (1772), New College, towers and spires rising above a rural idyll of harvest in the Holywell fields

(1773). The selection of just the right viewpoint for townscape effect is perfectly judged: The Schools Tower peeps from behind the Clarendon building (1775), and the Radcliffe Camera is seen from All Souls from the only possible angle (1777). In Christ Church Meadow (1776) and St Giles's (1779) the marked perspective allows the roadway and trees to dominate, while in the 1780s college gardens often steal the scene. All are provided with an authentic staffage of scholars, workers and idlers, dogs and vehicles, and everyday scenes of road-mending, gardening, and carpet-beating, while a bull worries the hapless dog in the Meadows.[40] All are classic compositions, most of them unprecedented in previous views of Oxford, and they were to be copied by numerous and less skilled hands in later years. Only one secular (and antiquarian) scene makes its appearance: the view of Friar Bacon's Study on Folly Bridge in 1780, the year after its removal, a view that was sufficiently striking for the juvenile J.M.W. Turner to make a copy of it.[41] Apart from the Almanacks, which were engraved from watercolour drawings, Rooker also painted some antiquities in oils: the view of Folly Bridge just mentioned, also Hythe Bridge (now in the Museum of Oxford), and a view of the Castle.[42]

Rooker's successor is not without interest: Daniel Harris, who drew the four Almanacks between 1789 and 1793. As jailor of the County Prison he used convict labour to build prisons and river locks, and to conduct archaeological explorations in Oxford Castle.[43] Not much is known otherwise of his artistic endeavours, but his views are more than merely competent, if based on the Rooker model, and the drawing for the 1792 Almanack is very fine (fig. 18).

Malchair's Oxford

Rooker established a new canon for the Oxford topographical view with a robust picturesque, and there could hardly be a greater contrast with the contemporary work of Malchair, with his delight in the soft and minimal images of back streets, waterways and trees. But what was the nature of the city they both studied so attentively?

Urban improvement
The Oxford of Malchair and Rooker was a changing city, indeed they witnessed the most profound changes to the urban fabric that had taken place since the Reformation. This can be clearly seen from the series of eighteenth-century maps, starting with the new survey made for Isaac Taylor in 1750 (which itself formed the basis of its successors until the mid nineteenth century). Taylor's map shows Oxford as first known by Malchair, while the reworkings of the plate by William Faden (1789) and Richard Davis (1797) reflect the transformations that took place to the city centre in this time. Oxford in 1750 was little different in appearance from Loggan's Oxford in 1675. The most obvious changes were new buildings like the grand frontage of the Queen's College on the High, and the transformation of the university zone with the Radcliffe Camera and the Clarendon Building. Other arrivals such as the Magdalen New Building, or the Peckwater Quad of Christ Church were less obvious. The gradual expansion of Oxford had not yet taken the form of growth into new suburbs and needs were still met by infilling in the existing suburbs, so little change was visible there. The city was still defended with walls and gates, approached by narrow bridges and surrounded by countless streams and leafy walks.

The Age of Improvement affected the towns as much as the countryside in the middle decades of the eighteenth century, and among many parliamentary acts for urban improvement was Oxford's own 'Mileways Act' of 1771:

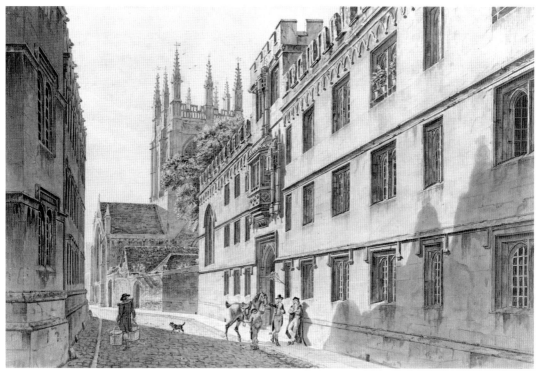

Fig. 18. Daniel Harris, *Corpus Christi College from the Back Gate of Christ Church: Design for the Oxford Almanack, 1792.*
Ashmolean Museum (Brown, no. 824)

An Act for amending certain of the Mile-ways
leading to Oxford; *for making a commodious*
Entrance through the Parish of Saint Clement;
for rebuilding or repairing Magdalen Bridge;
for making commodious Roads from the said
Bridge, through the University and City, and the
Avenues leading thereto; for cleansing and lighting
the Streets, Lanes and Places, within the said
University and City, and the Suburbs thereof, and
the said Parish of Saint Clement; *for removing*
Nuisances and Annoyances therefrom, and
preventing the like for the future.[44]

The act provided for the repaving of the two
main routes through Oxford, together with
Broad and Catte streets, the widening and
rebuilding of Magdalen Bridge, the removal of
the Eastgate, the Carfax conduit, the shambles
in Butcher Row (Queen St), the Northgate,
and obstructions in Broad Street and the

houses by St Mary Magdalen Church. In
addition, the street markets were suspended,
and all fresh produce was to be sold in a new
covered market, which still survives. The Act
did not specifically include Folly Bridge, and
Friar Bacon's Study was actually demolished
for the Hinksey Turnpike Trustees under a
special act of parliament, in 1779.[45]

Similarly, the New Road to the west of
Oxford passing through the middle of the
castle had already been made for the Botley
Turnpike, under provision of a special
amending act, in 1769.[46]

The artist's view
The combined effect of these turnpike and
paving acts was to remove some of the City's
most interesting and picturesque antiquities,
and with little apparent protest (though the
castle mound was protected by Christ Church

from destruction when building New Road). Posterity is indebted to Malchair for recording the appearance of these monuments, and others such as Canterbury College that he drew during the course of demolition and those, like parts of the castle and Beaumont Palace, that no longer survive. Malchair himself appreciated the importance of these records, and selected his views of Magdalen Bridge and the Northgate for publication as aquatints in 1789/90 while the appearance of Canterbury College was engraved in 1793. But what is rather more striking in examining the overall content of the Oxford sketchbooks is that, while they are very informative to the present age for their record of Georgian Oxford, they are not predominantly of antiquarian subjects, and show little interest in the details of ancient architecture. Indeed, the frequent representation of new buildings like the Radcliffe Infirmary and the Observatory suggests an interest in the picturesque quality of the environs of Oxford unencumbered by antiquarian sentiment. One of Malchair's favourite Oxford subjects, the gatehouse on Folly Bridge known as 'Friar Bacon's Study', was perhaps of as much interest for its shape and the compositional potential of its relationship to nearby water and trees, than for any historical association (and the Observatory would of course be a parallel for this).

Malchair's Oxford is indeed a city of trees and water, viewed in different lights, or seen by moonlight, sunset or firelight (he drew several fires in buildings). He sees the spires of Oxford, fringed by hills and trees. The river was a constant theme: bridges, eel traps and weirs, seen from the houseboat he used for drawing expeditions. Fields are preferred to streets, and Merton College, Magdalen and Christ Church are seen from the walks and meadows. The spectacle of the Observatory being constructed in the fields, or the Infirmary rising above fields and hedges were

frequent subjects. Perhaps the most delightful discovery is his seeing the potential in lanes and back yards for a picturesque composition. Malchair's own back garden, looking towards the back of Ship Street, makes for an interesting roofscape, and there were innumerable hovels, stables and barns in the back yards of St Giles and elsewhere that, duly composed with a bush, tree or gate, formed an excellent subject. It is clear that Malchair practised his precept as reported by William Crotch 'always to walk about my subject before I begin to draw'.[47]

A view of the Holywell cockpit, the tannery bridge in St Ebbe's, or the drawing of a collapsed timber barn in Jericho are for us a magical insight into the appearance of Oxford in the century before the camera, and a wonderful contrast with the Oxford of Rooker and Turner. But apart from Malchair's careful annotation of date, time and place on most drawings, we might suspect that these were primarily regarded by him as essays in picturesque composition. He was certainly not amongst the antiquaries in the last decades of the century, like Daniel Harris (mentioned above), John Carter who began to record gothic architecture, or John Buckler who with his son John Chessell has preserved for us the exact portraits of streets and buildings of late Georgian Oxford.[48] But, uniquely among his predecessors and contemporaries, Malchair saw in Oxford and its environs a picturesque, indeed romantic potential and was able to convey in a disarmingly easy manner his own vision of her topography.

Oxford in Aquatint
Malchair's aquatint publications of Northgate and Magdalen Bridge were among the first of a series of similar productions by other artists. John Buckler was to produce a run of stately aquatint views of Magdalen College and the church of St Peter in the East between 1799

and 1802;[49] Thomas Malton's *Views of Oxford* appeared as a part work from 1802 with 24 aquatints; John Claude Nattes' *Graphic and Descriptive Tour* was also issued in parts from 1805 with 14 aquatints, while the culmination of this phase was Rudolph Ackermann's *History of the University of Oxford* of 1814.[50] With the increasing use of colour, a variety of artists, and professional publication in London, these take us into another era, and the explosion of popular views in lithography and steel engraving in the early nineteenth century. Their very popularity, and continuing domination of the print market has nevertheless distracted attention away from the wealth of alternative views of Oxford, and the unpublished drawings of the eighteenth-century city and university, amongst which Malchair's must have first place.

References

1. A. Wood, *Historia et antiquitates Universitatis Oxoniensis* (Oxford, 1674), II, p. 211; English translation ed. J. Gutch (Oxford, 1792), pp. 350-2.

2. Timothy Wilcox and Christopher Titterington, *William Turner of Oxford (1789-1862)* (exh. cat., Woodstock, 1984).

3. The Bodleian has a card-index of Oxford views in the Arts End of the Old Library, and the Ashmolean has some topographical indexes. For an extensive listing of printed illustrations of Oxford, see Appendix III to Aymer Vallance, *The Old Colleges of Oxford* (London, 1912); while the Brian Kentish, *Antique Maps and Prints of Oxford and Oxfordshire* (exh. cat., Magna Gallery, Oxford, 1987), lists over 700 items.

4. R.H.C. Davis, 'A Oxford Charter of 1191 and the Beginnings of Municipal Freedom', *Oxoniensia*, XXXIII (1968), pp. 53-65, pls vi-vii.

5. P.D.A. Harvey, *The History of Topographical Maps* (London, 1980), pp. 66-70; J. Backhouse, *The Luttrell Psalter* (London, 1989), fig. 68; Chiara Frugoni, *A Distant City. Images of Urban Experience in the Medieval World* (Princeton, 1991), pp. 108-9, e.g. fig. 37.

6. Gale Pedrick, *Borough Seals of the Gothic Period* (London 1904), nos. 22 (London), 28 (Worcester), and 41 (Bristol).

7. *New College Oxford 1379-1979*, ed. John Buxton and Penry Williams (Oxford, 1979), pl. 15.

8. Most recently reproduced in John Goss, *Braun & Hogenberg's The City Maps of Europe* (London, 1991); see the final preparatory drawing at Windsor by Joris Hoefnagel in Christopher White and Charlotte Crawley, *The Dutch and Flemish Drawings ... in the Collection of Her Majesty the Queen at Windsor Castle* (Cambridge, 1994), no. 54.

9. W. Smith, *Particuler Description of England* (1588, printed 1879); see Paul Harvey, *Maps in Tudor England* (London, 1993), pp. 75-7.

10. F.J. Varley, *The Siege of Oxford* (Oxford, 1932), pl. II; Hollar's view is reproduced in the Oxford Historical Society portfolio, *Old Plans of Oxford*, O[xford] H[istorical] S[ociety], XXXVIII (1899).

11. Harvey, *Topographical Maps*, pp. 74-5, 180.

12. Martin Holmes, 'An Unrecorded Map of London', *Archaeologia*, C (1966), pp. 105 ff.; Harvey, *Tudor England*, pp. 73-7.

13. The surviving copy of Agas is in the Bodleian Library; both versions were reproduced in 1899 in *Old Plans of Oxford*.

14. See the redrawn version by John Blair, in *The History of the University of Oxford*, III, *The Collegiate University* ed. James McConica (Oxford, 1986), p. 642.

15. John Speed, *The Theatre of the Empire of Great Britain*, reproduced as *The Counties of Britain. A Tudor Atlas by John Speed* (London, 1988).

16. The castle view is reproduced in T.W. Squires, *In West Oxford* (Oxford, 1928); the Oseney view was published in W. Dugdale, *Monasticon Anglicanum*, II (London, 1661), pl. facing p. 136; see Michael Hunter, *John Aubrey and the Realm of Learning* (London, 1975), p. 68 and note, p. 149 and pl. 10 for Dugdale.

17. Hunter, *op. cit.*; H.M. Colvin, 'Aubrey's *Chronologia Architectonica*' in *Concerning Architecture: Essays… to Nikolaus Pevsner*, ed. John Summerson (London, 1968), pp. 1 ff.

18. Wood, *Historia Universitatis*, II, pp. 65, 350; Gutch edn, pp. 56, 648-9.

19. For Loggan, see *Dictionary of National Biography*; C.F. Bell and R. Poole, 'English Seventeenth-century Portrait Drawings in Oxford Collections', *Walpole Society*, XIV (1926), pp. 55-64; E. Croft-Murray and P. Hulton, *Catalogue of British Drawings*, I, *XVI & XVII Centuries* (London, 1960), I, pp. 428-34.

20. A. Clark, *Wood's Life and Times*, I, O.H.S. XIX (1891), p. 209 and II, O.H.S. XXI (1892), pp. 47, 49; for Vertue's notebooks (the source of the account in Walpole's *Anecdotes of Painting*), see *Walpole Society*, XVIII (1930), p. 98.

21. Falconer Madan, *Oxford Books III. Oxford Literature 1651-1680* (Oxford, 1931), pp. 304-8 gives a full description of the plates.

22. *Victoria County History, Oxon.* III, *The University of Oxford*, ed. H.E. Salter and M.D. Lobel (Oxford, 1954), pl. facing p. 69.

23. Clark, *op. cit.*, II, pp. 49, 313.

24. D.C. Douglas, *English Scholars* (1939) cap. ix; I.G. Philip, 'Thomas Hearne as a Publisher', *Bodleian Library Record*, III (1951), pp. 146-55.

25. Those of the Castle and Rewley are reproduced in Squires, *op. cit.*, pls. XXXVII, LXV-VI.

26. J. Sharpe, 'Oseney Abbey, Oxford', *Oxoniensia*, L (1985), 113, pl. 5.

27. H. Carter, *A History of the University Press* (Oxford, 1975), pp. 129, and 426.

28. Reprinted by Joseph Skelton, *Oxonia Antiqua Restaurata* (Oxford, 1823), II, pl. 67-8, with informative notes; see also *Remarks and Collections of Thomas Hearne, VIII*, (O.H.S. L, 1907), p. 92 (29 June 1723).

29. On decline, see Stuart Piggott, *Ruins in a Landscape* (Edinburgh, 1976), pp. 21, 117, and *idem*, 'Antiquarian Studies' in *The History of the University of Oxford*, V, *The Eighteenth Century*, ed. L.S. Sutherland and L.G. Mitchell, (Oxford, 1986), pp. 757-77.

30. B.J. Enright, 'Rawlinson's Proposed History of Oxfordshire', *Oxoniensia*, XVI (1951), pp. 57-78, esp. p. 73; A. Crossley, 'Oxfordshire', in C.R.J. Currie and C.P. Lewis (eds), *English County Histories: A Guide* (London, 1994), pp. 323 ff.

31. Bodleian, MS Gough Oxon. 50; for Green, see below.

32. For a full descriptive and illustrated list, see H.M. Petter, *The Oxford Almanacks* (Oxford, 1974).

33. E.H. Cordeaux and D.H. Merry, *A Bibliography of Printed Works Relating to the University of Oxford* (Oxford, 1968), nos. 289, 292.

34. Ralph Hyde, *A Prospect of Britain: The Town Panoramas of Samuel and Nathaniel Buck* (London 1994), pp. 49-50, pls. 53-4.

35. J. Munby, 'James (not John) Green (1729-1759), Engraver to the University', *Oxoniensia*, LXII (1977), pp. 319-21.

36. These and other views are listed in the works cited in n. 3.

37. These engravings were reproduced as the Oxford Almanack for 1894 and 1871 respectively; see Petter, pp. .

38. Kentish, no. 374.

39. Petter, pp. 72-3; explanatory label attached to the example in the Almanack volumes deposited in the Ashmolean Museum.

40. Patrick Conner, *Michael Angelo Rooker (1746-1801)* (London, 1984), pp. 106-12; all are illustrated in Petter, pp. 73-8.

41. Petter, pp. 75-6.

42. Conner, p. 109; L. Gilmour, 'A painting by Michael Angelo Rooker', *Oxoniensia*, LIX (1994), pp. 473-6.

43. E. King, *Vestiges of Oxford Castle* (London, 1796), pp. 6-8; for Harris as a builder, see H.M. Colvin, *A Biographical Dictionary of British Architects 1600-1840*, 3rd edn (London, 1995), pp. 461-2.

44. Mileways Act: 11 Geo. III, c.xix; L.L. Shadwell, *Enactments in Parliament II*, O.H.S. LIX (1912), pp. 102-36; John West, *Town Records* (Chichester, 1983), table at p. 183.

45. See amending act for Hinksey Turnpike, Shadwell, *Enactments II*, 161 (18 Geo. III, c.99, 1778-9); M.G. Hobson, *Oxford Council Acts 1752-1801*, O.H.S. XV (1962) pp. 132-3.

46. J. Munby and H. Walton, 'The Building of New Road', *Oxoniensia* LV (1990), p. 124.

47. Jonathan Rennert, *William Crotch (1775-1847) Composer, Artist, Teacher* (Lavenham, 1975), p. 94.

48. A small selection is reproduced in *Drawings of Oxford by J.C. Buckler 1811-27*, Bodleian Picture Book 3 (Oxford, 1951).

49. Kentish, nos. 280, 289, 291, 295, and 389.

50. Cordeaux and Merry, nos. 304, 305, and 25; *Scenery of Great Britain and Ireland in Aquatint and Lithography, 1770-1860 from the Library of J.R. Abbey: A Bibliographical Catalogue* (London, 1952 & 1972), nos. 272, 274, and 278.

Catalogue

Catalogue 1-110

Note on the provenance

The drawings in the Ashmolean derive principally from two sources. Most of those registered in 1928 came from the collection of the Revd Dr Henry Wellesley; sold, Sotheby's, 29 June 1866, lot 742, 'A Portfolio, with leaves, containing 80 sketches in Pencil, Sepia and Colours; Views in England, by J.B. Malchair; the Frontispiece by Lord Guernsey'; 9 July 1866, lot 2235, 'Sketches in Oxford, from Nature, by J.B. Malchair, *fifty-two in a volume*', sold for £10 to Messrs Colnaghi; they passed to C.F. Wyatt of Forest Hill, Oxford, and thence to the Revd B.W. Bradford, Broughton Rectory, Banbury, sold Sotheby's, 22 October 1928, lot 133, where they were bought by the Ashmolean. By this time, there were 179 drawings in the collection, and it has been impossible to trace the source of the additional 47 sheets.

The second group, of 278 drawings, was bought from the Magdalen College Fund at the sale of the redoubtable Mrs Harriette Anne Morrell (1843-1924), Black Hall, 1925. There is a summary listing in Brown, nos. 306-12 (Aylesford), 313 (Bampfylde), 318-23 (Barnard), 373 (Beaumont), 372 (Lady Beaumont), 390 (Blandford), 912-36, 938-49, 951-61, 963-1329 (Malchair), 1473-5 (Pigot), 1672 (Sikes), 1916-18 (Wynne), taken almost entirely from Bell's transcriptions of the inscriptions. Both Bell and Brown excluded a small group of drawings, now contained in a folder loosely inserted in Album I, marked 'Jenner; *Nothing to do with Oxford or Malchair*', two of which are clearly signed *G. Jenner*, and therefore the work of Malchair's pupil and nephew, George Jenner. Although crude and slight, they do at least give some indication of his ability.

The Morrell album was evidently formed by a pupil or admirer of Malchair, probably during his lifetime. The only clue to the collector's identity is given in inscriptions on the backs of eleven drawings, *J.B. Malchair given me by Sir T.F. Frankland* (Brown, nos. 1121-31).

Brown assumed that the first part of the inscription is a signature of the artist, but this seems unlikely. However, all these drawings are firmly glued to the album pages, and it is therefore not possible to identify the handwriting.

There is a collection of eleven sketchbooks by or associated with Malchair in Corpus Christi College Library, of which seven are exhibited here (cat. nos. 1, 8, 10, 14, 16, 19, 81). Nine had belonged to Wellesley, who had probably acquired them by 1839: an inscription in MS CCC 443 (VII), fol. 32v. is dated 1839 and may very well be in his handwriting. They were sold at Sotheby's, 3 August, 1866, lot 204, 'Sketch-Books of J. Malchair from 1755 to 1791, containing many interesting Drawings of Oxford and the neighborhood, also of other parts of England during his Travels; 9 vols', which were bought by Messrs Colnaghi for £25. Their next owner was John Griffiths (1806-1885), Warden of Wadham College and Keeper of the University Archives, who also acquired the volumes of drawings and proof engravings for the Oxford Almanacks from the Wellesley sale at Sotheby's, 9 July 1866, lot 2209, 'a most curious and valuable collection of Oxford Almanacks…'; these he bequeathed to Wadham and they were deposited in the Ashmolean in 1955. Minn, p. 159, erroneously assumes that the collection of Malchair sketchbooks was formed by Griffiths, but it was surely assembled by one of Malchair's pupils, probably the author of the drawings in vols. VI and XI. Fol. 17 of vol. VI is signed *TS*, initials which also appear on drawings in the Ashmolean and which C.F. Bell identified as those of Thomas Sikes, but without any obvious evidence. Griffiths did add two further volumes to the collection. They passed on his death to Thomas M. Crowder, Bursar of Corpus Christi College, by 1885, and thence to his nephew, Sir Matthew Dodsworth, Bart,

who presented them to Corpus in *c.*1903, the date of his gift to the college of Crowder's copious manuscript diaries, among them *Sunday Walks near Oxford 1877-1903* (MS CCC 456).

From the account of Dr Wellesley's lecture in 1862, it is clear that he had seen almost all Malchair's drawings, including not only those in his own albums and sketchbooks now in Oxford, but also the views of *Kenilworth* at Manchester and elsewhere (see cat. no. 48); *Millbank* at Temple Newsam, Leeds; *Rochester Castle*, recently given to the Ashmolean and probably not by Malchair; and untraced drawings of *Gravesend* and *Powis Castle* (though surprisingly, he did not know of the drawings made on the Welsh tours). Wellesley noted that 'His drawings have unfortunately been much scattered. Mr Skelton, however, had obtained a good many; also Lord Barrington, and there were smaller collections in the hands of his former pupils.' The dispersal of these collections has not been documented.

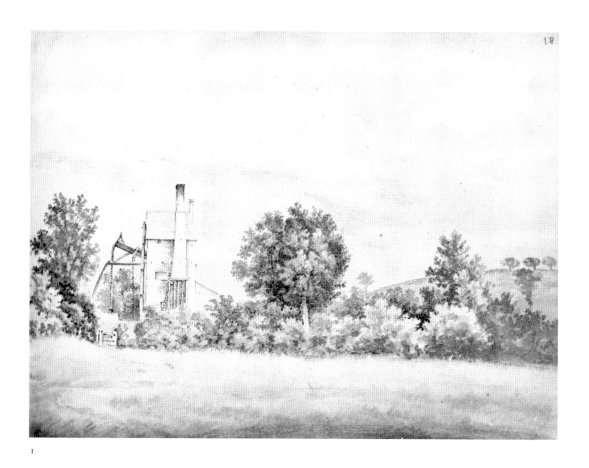

I

I

Fire Engine at Bedminster Boydwell
pencil and grey and green washes
inscribed in ink on *verso, yᵉ Fier Ingen Near
Bedminster Boydwell yᵉ 1ˢᵗ of August*
Fol. 18 of a sketchbook of 42 ff. of drawings,
measuring 190 × 250
Prov.: Revd Dr Henry Wellesley; John Griffith;
Thomas Crowder; Sir Matthew Dodsworth, by
whom presented to the Library of Corpus
Christi College, *c.*1903
Lit.: Minn 1943-4; Fleming-Williams, 1969, pp.
170-1, fig. 1
Lent by the President and Fellows of Corpus
Christi College [MS CCC 443 (II)]
¶ The earliest of Malchair's sketchbooks
contains drawings dated between 7 April and
14 July 1757, and shows scenes at Bristol and
the surrounding area, including one of the
artist's lodgings on Stock Bishop (fol. 17), save
that the two final leaves, of scenes in London,
were used in 1759. Together with the drawings
of similar subjects in the Ashmolean (Brown,
nos. 1210-22), these effectively show Malchair's
beginnings as an artist, for, although he had
made studies from nature before his arrival in
England, and probably continued while at
Lewes, none survives, and several sheets in this
sketchbook show Malchair venturing on the
most basic problems of representation.

In this drawing, the technique of dabs of
wash over explorations in pencil is still
unsophisticated, but Malchair has produced a
charming representation of an industrial
machine viewed as a curious part of the
agricultural landscape. The machine itself, in

62

the downs to the south of Bristol, is a Newcomen engine, the original form of the steam engine, used to pump water out of mines.[1]

It was only on his visits to the West Country that Malchair made studies of the machinery of the Industrial Revolution: in 1792, for example, he made an atmospheric and gloomy drawing of the foundry at Canon.[2]

1. I am grateful to A.V. Simcock of the Museum of the History of Science for identifying the machine.
2. sold Christie's, 17 November 1981, lot 5; and again, Bonham's, 18 March 1998, lot 106.

2-3
Two Pages from a Sketchbook
pencil, 184 × 207, 224 × 205
the sketches on the first page dated in pencil, *y 2ᵈ of May. 1758, 5 of May – 1758*, and *ye 6 of M.*
Prov.: purchased, 1928 [1928.117-8]
Lit.: Brown, nos. 1210-11
¶ Although of different sizes, these sheets together with others in the Ashmolean (Brown, nos. 1212-13) probably come from a sketchbook Malchair used at Bristol in spring, 1758. The subjects are urban scenes and shipping, drawn in pencil in a surprisingly rapid and fluent style, with brief annotations of a kind that Malchair did not make later in his career. The

3

arrangement of several compositions on one page is also unusual, and was soon replaced by the more extravagant use of one page for each new composition, however quickly abandoned.

4
Bristol Hot Wells
pencil and grey wash and watercolours, 204 × 323 (the corners cut off)
inscribed on the *verso, of the hotwell and Lodging Houses on the Banckes of the river Avon near Bristol*
Prov.: Sotheby's, 15 October 1947, part of lot 21; A.P. Oppé (no. 2340a), and by descent; Sotheby's, 30 March 1983, part of lot 31; Ian Fleming-Williams
Lent from a private collection
¶ This is the only drawing from Malchair's early years to survive outside the sketchbooks and albums in Oxford, and originally came from an album including two works by Paul Sandby now in the Royal Collection,[1] and two other drawings by Malchair or a pupil, which was probably formed in *c.*1760. He treated the same subject from farther down stream in the earliest sketchbook (CCC, II, fol. 2, dated 7

2

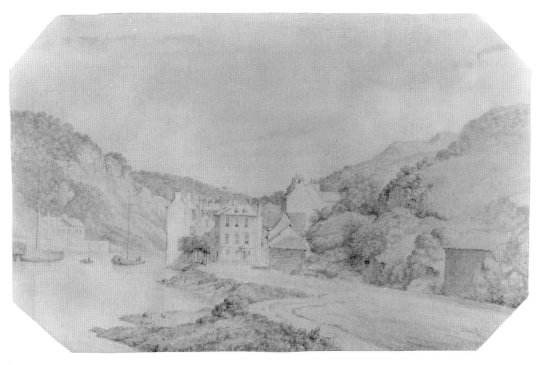

4

April [1757]), and the comparatively elaborate finish, with touches of colour in the buildings and elsewhere, might suggest that the later drawing was worked up at home for presentation to an unknown admirer or pupil.

1. A.P. Oppé, *English Drawings, Stuart and Georgian Periods in the Collection of His Majesty the King at Windsor Castle* (London, 1950), p. 114, nos. S424-5, where dated to 1760.

5

Shotover Hill
pencil and grey wash, 115 × 255
inscribed in pencil, lower left, *Calcott* and dated on *verso*, *July 1764*
Prov.: Sanders of Oxford, 1969; Ian Fleming-Williams
Lit.: Fleming-Williams 1969, p. 171, fig. 3
Lent from a private collection
¶ Shotover Hill, to the east of Oxford, and from which most travellers on the old London road would have approached the city, was a favourite viewpoint from which the whole

plain of Oxford could be seen (cf. cat. no. 77). This is a variant on a composition that Malchair drew several times in his early years at Oxford (e.g. Brown, no. 1233, dated 12 June 1765), but only once in his maturity (Brown, no. 1253, dated 12 August 1784). It comes from a group of eighteen drawings of the 1760s published by Fleming-Williams, many of which are inscribed *C* or *Calcott*. This refers to a previous owner, probably William Calcott, a pupil and copyist of Malchair.[1]

1. There are copies of Malchair drawings, some signed *W. Calcott* and dated in the 1770s, in the Bodleian Library, MS Top. Oxon. c. 299.

6

Friar Bacon's Study
grey wash over pencil, 198 × 244
inscribed on *verso*, *16th of August 1765. Friar Bacon's Studdy, Oxon*
Purchased, 1928 [1928.98]
Lit.: Brown, no. 914

64

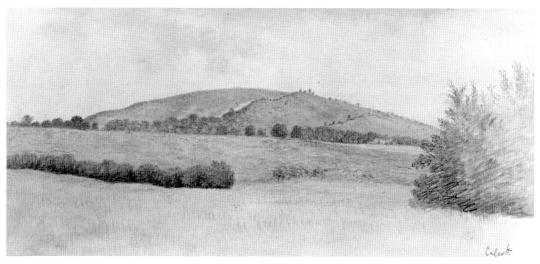

5

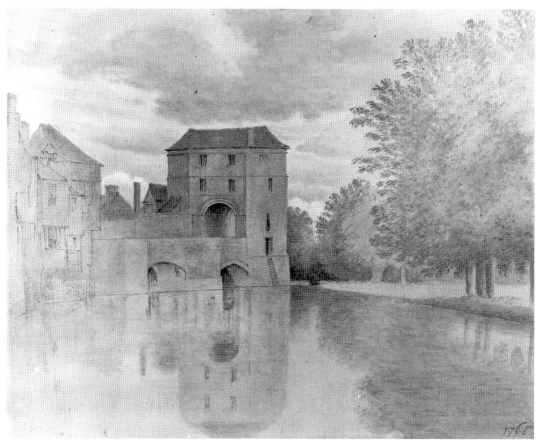

6

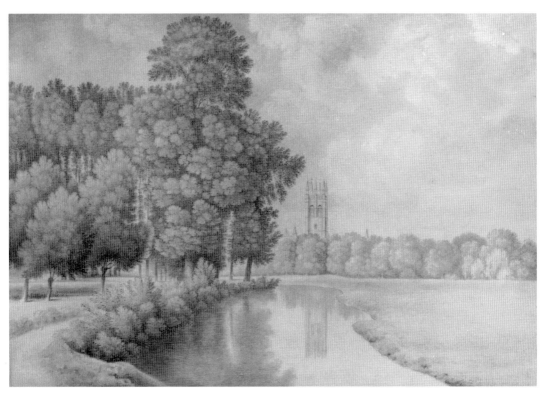

7

¶ The defensive gate at the southern end of the main bridge over the Thames was linked by a drawbridge to the great causeway known as Grandpont which continued as far as South Hinksey. The gatehouse, which in the Middle Ages was kept by a hermit who lived outside the city wall, was commonly known as Bachelor's Tower, or Friar Bacon's Study, because the philosopher and scientist, Roger Bacon (1214-1294), was believed to have used it as an observatory. It was heightened soon after 1611 by Thomas Waltham, and became known as Welcome's Folly.

This was Malchair's favourite monument in Oxford, and he drew it from every possible angle. Part of its fascination seems to have lain in the hexagonal shape of the tower, which posed intriguing problems of lighting for the artist. Fleming-Williams has written of this drawing that its success –

is the fruit of the experiment he made while sketching his lodgings eight years before at Bristol, when, in attempting to give a sense of unity to the whole, he had painted a pale wash over all but the sky. Then he had lacked experience and had been unaware of the degree of subordination which was required of the lesser parts for the maintenance of that unity. But now, with an understanding of the subtleties of tone balance, and, through his fusion of techniques, with a grasp of the finest shades of gradation and texture, he was at last able not only to achieve unity, but to do so within the limits imposed by a certain quality of light at a particular time of day. (Fleming-Williams, MS, II, p. 12)

Magdalen Tower from Christ Church Meadows

pencil and grey wash, 324 × 472 (sight)
Prov.: Ian Fleming-Williams
Lent from a private collection

¶ This is the largest of Malchair's early drawings, and the most elaborate in technique. It may be related to the two drawings Malchair made for the Oxford Almanack for 1767 and 1768, both of which show a comparable subordination of architecture to landscape. The focus of the drawing is Magdalen Tower, carefully and precisely drawn with a ruler, its pinnacles peeping over the abundant summer foliage of the trees in Christ Church Meadows. The whole might be a lesson in varied drawing: for example, the foliage at the edge of the trees, where the sunlight shines through, is made up of dots of pencil joined with grey wash, while the more substantial areas towards the centre are outlined with the brush, giving a feeling of density and substance; while the reflection of the pinnacles of Magdalen Tower is drawn in short horizontal strokes of the pencil, creating a shimmering effect. This is also one of the best examples in Malchair's work of what he described in the *Observations on Landskipp Drawing* as 'interstices', the areas between objects, usually trees, which are left blank and create a pattern of their own.

8

In Longford Park, near Salisbury

pencil and grey wash
inscribed in grey ink on *verso*, *At Longford in Lord Rhadnors Park near Salisbury 29 of Sep: 1768:*
Fol. 7 of a sketchbook of drawings measuring 280 × 185
Prov.: as cat. no. 1
Lit.: Minn, 1943-4
Lent by the President and Fellows of Corpus Christi College [MS CCC 443 (V)]

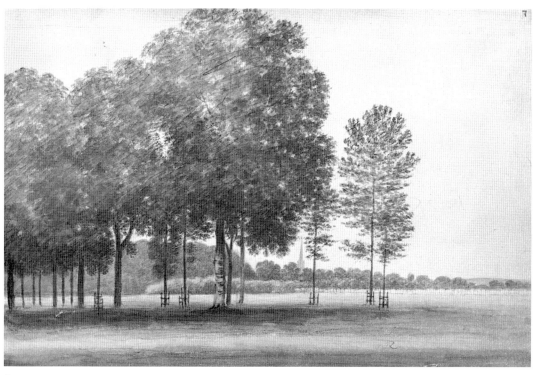

8

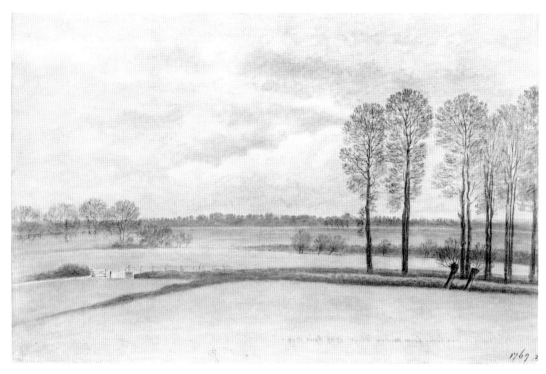

9

¶ Malchair made short tours of Wiltshire in two successive years, 1768 and 1769. Fleming-Williams (MS, III, p. 21) suggests that they may have been caused by the flourishing musical society at Salisbury, but it is just as likely that he had taken up with one of the Bouveries, several of whom were at Oxford, and at least one of whom must have been known to Malchair, for he was a great friend of Peter Rashleigh (see cat. no. 103). In 1768, Malchair made three drawings of Salisbury Cathedral on successive days, from the north, from Milford Hill, and here, from the grounds of Longford Park. The last, and most distant, view is also the most successful, for Malchair was probably alone, with the freedom to find the exact view, and the time to draw it fully. Hence, the composition is delicately balanced, the precise spot carefully chosen, and the asymmetrical disposition of the trees is designed to lead the eye gently from left to right in a zigzag towards the spire at the centre of the composition.

The last drawing of Wiltshire in this tour, made on 1 October, is a rather awkward study in pen and ink of the facade of Wilton House, and in the following year, Malchair made an equally dutiful study of Stonehenge. This was as near as Malchair ever came to making a picturesque tour in the manner of William Gilpin or his successors.

9
Merton Fields from Merton College
watercolours and pencil, 255 × 386
inscribed on *verso, A View of Merton fields from Merton College. 15 of April 1769 11/*
Purchased, 1925 [1925.20]
Lit.: Brown, no. 917
¶ On 3 December 1768, Malchair had made a drawing of a very similar view, taken from slightly farther to the right, of Merton Fields in flood (CCC, V, fol. 10). By the following April, the waters had receded. The composition is

based on the conventional formula of the receding zigzag, and drawn using tricks such as hard and soft outlines, and a variety of accents, but, through its lack of topographical features and human interest, the overall appearance is radically different from contemporary landscape drawings.

10

From the Water near Hythe Bridge at the Approach of a Thunder Storm

pencil and grey wash

inscribed in pencil on *verso*, *Aproach of a Thunder Storme*; and in ink, *from the water Near High Bridge Oxford. July 21. 1769. /2*

Fol. 6 of a sketchbook of 43 ff., measuring 240 × 165

Prov.: as cat. no. 1

Lent by the President and Fellows of Corpus Christi College [MS CCC 443 (I)]

¶ The sketchbook contains drawings dated between 1 July 1769 and 17 April 1772, and

therefore used alternately with sketchbooks III and V. This is the most evocative of those to survive intact, containing a high proportion of the sketches made on the amusingly christened expeditions with his pupils, the 'House Boat Expeditions' (ff. 5, 27), 'Bacon and Eggs Expedition' to Beckley (ff. 21, 41-3) and Hinksey (fol. 31), and a 'House Boat Concert' (fol. 34), a summary pencil drawing recording a trip by the Music Room band. The drawing of the thunderstorm approaching Hythe Bridge is the most atmospheric and highly worked, and Malchair's most convincing depiction of a stormy sky before 1789.

11

Friar Bacon's Study

grey wash over pencil, 189 × 274

inscribed in ink on *recto, 1770*; inscribed on *verso, A View of fryer Bacon, Oxford the first Drawing of this unpropitious Summer July 17. 1770 /7 From the Meaddow on the West Side of the Cosway*

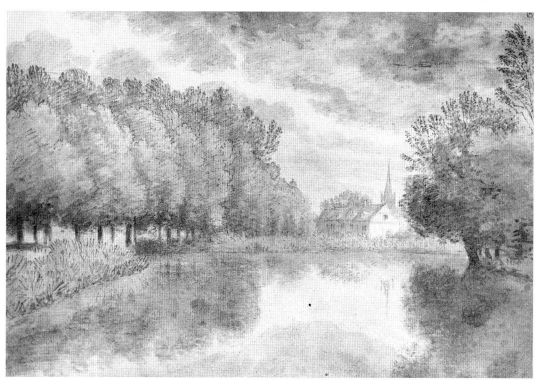

10

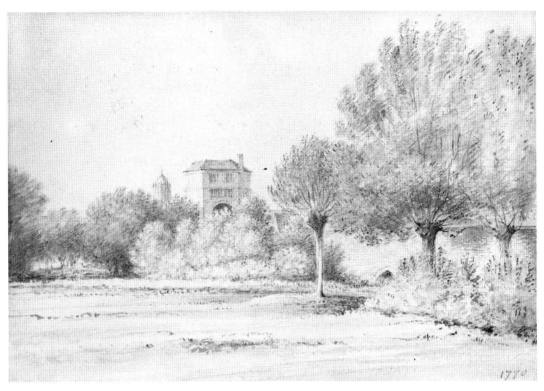

11

Purchased, 1928 [1928.99]

Lit.: Brown, no. 920

¶ The inscription is baffling, as there is a drawing dated 23 June in one of the sketchbooks (CCC, III, fol. 16). Apart from this drawing, however, it is true that Malchair was remarkably unproductive in 1770: the same sketchbook contains only seven isolated drawings, dated at wide intervals between 23 June and 30 August, and probably represents his total output for the summer. Even the drawing season closed early: he seems to have made none in September, before or after the Three Choirs Festival. This is in striking contrast to the rest of the decade, when he was extremely prolific.

The view of Friar Bacon's Study is taken from the west side of the long causeway, with Tom Tower visible over the shrubbery.

12

Friar Bacon's Study and Folly Bridge

pencil, grey wash and watercolours, 220 × 306

Prov.: Messrs Appleby, 1968, no. 48; Sotheby's, 14 April 1994, lot 325; Messrs Abbott and Holder

Lent by Julian Munby, F.S.A.

¶ A similar view to that in cat. no. 11, but taken from the opposite bank of the Cherwell, rather than the far end of the causeway. The style and pretty colouring of this charming view indicates a date of c.1775. The assurance of the pencil work contrasts with the rather clumsy handling of the wash and suggests that the drawing was begun by Malchair and finished by a pupil.

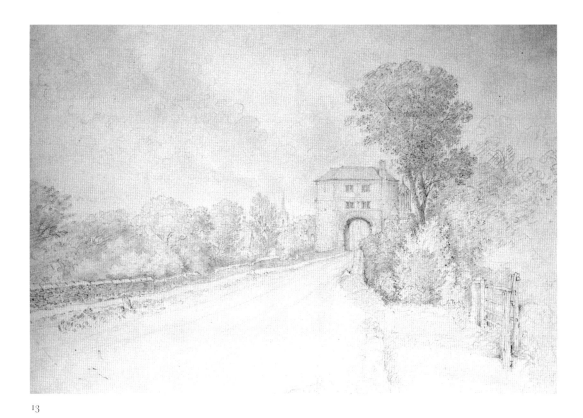

13

13

Friar Bacon's Study

pencil, 311 × 439

inscribed on *verso, 23d of August 1771 / 1 Fryer Bacon's Studdy . . . alias Folly Gate Oxford 23d of August – 1771*

Purchased (Magdalen College Fund), 1925 [1925.23]

Lit.: Brown, no. 921

¶ The dramatic narrowing of the road underneath the gateway explains why Friar Bacon's study was demolished, and Malchair has emphasised the perspective with the wide expanse of blank road in the foreground. The drawing is unusually large to be entirely in pencil, and was perhaps intended primarily as a record of this aspect of Folly Bridge.

14

Christ Church Walk from the Meadows

pencil, grey and coloured washes

inscribed in pencil on *verso, Round the Ch. Ch. Meddow – May the 4th 1772. A prodigious fine Evning 15 / a Cessation of a Dry Cold North Wind*; further inscribed in ink, *Ch. Church Walck from Ch: Ch: meddow. Oxford 4 of May. 1772. /6*

Fol. 24 of a sketchbook of 52 ff. of drawings, measuring 290 × 180

Prov.: as cat. no. 1

Lent by the President and Fellows of Corpus Christi College [MS CCC 443 (III)]

¶ The drawings in this sketchbook are dated between 8 June 1767 and 1 October 1772, and include the work of three summer campaigns, in 1767, 1770 and 1772, the last and most extensive taking Malchair to Ledbury and Foxley to visit John Skippe and the Price family.

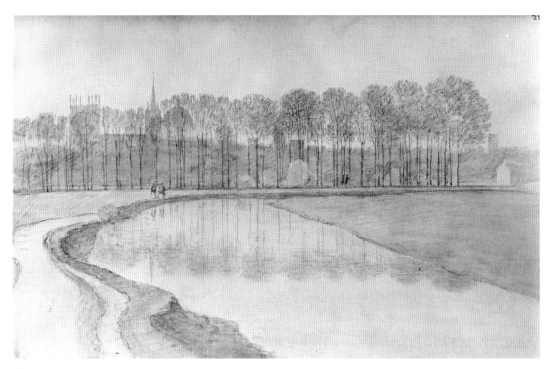

14

In this unusual view of Christ Church Walk, the composition is divided into three broad horizontal bands, the sky and river separated by the dominant and regular forms of the elms and their reflections.

15
Godstow Abbey
etching, 210 × 267 (plate)
inscribed, *Godstow Abbey* and signed, *John Malchair fecit 1772*.
Prov.: C. Hamilton, from whom purchased, 1866
Lent by the Trustees of the British Museum [1866-11-10-1034]
¶ Godstow Abbey was a Benedictine house founded in *c.*1131 after Dame Ediva of Winchester had a vision to build a new house near Oxford. This most aristocratic of nunneries enjoyed many celebrated residents, notably, according to legend, 'the fair Rosamund', later mistress of Henry II, murdered by Queen

Eleanor in 1176 and buried at Godstow. The house was dissolved in 1539, and fell into ruin during the Civil War. The tower and some of the walls survived until the late eighteenth century, but only a ruined enclosure stands today, and this etching therefore constitutes an important archaeological record.

This is the largest of Malchair's etchings, and the only one with a recognisably antiquarian subject. This is all but subsumed, however, in the careful and deliberately amusing composition of haycocks at the base of the tower, the three men in a boat on the canal, and the trees and bushes reflected in the water. What may be a preparatory drawing, in pen and brown ink and brush, is smaller and of a slightly different composition (Brown, no. 1090).

Malchair often walked over Port Meadow to Godstow, attracted by the romantic legend of Fair Rosamund, whose chapel he drew in 1774 (CCC, VII, fol. 24); by the texture of the

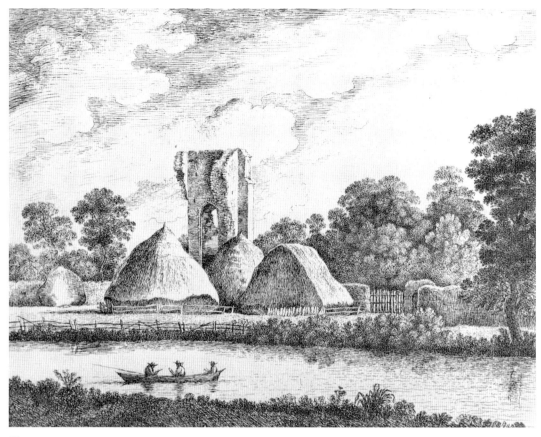

15

crumbling walls, of which he made a closely
observed study in 1784 (cat. no. 46); and by the
neighbouring bridge, a stiff geometrical shape
in the undulating countryside (Brown, nos.
1042, 1063, 1100).

16
Rycote
pencil and watercolours
inscribed in grey ink on *verso*, *Rycote. The Seat of
the Earle of Abingdon, Feb: 18. 1773 – 1/2*
Fol. 5 of a sketchbook of 36 ff. of drawings,
each measuring 283 × 185
Prov.: as cat. no. 1
Lent by the President and Fellows of Corpus
Christi College [MS CCC 443 (VII)]
¶ The first leaf of this sketchbook, which

contains drawings dated between 31 December
1772 and 12 August 1774, shows Beckett Park
near Shrivenham, the seat of Lord Barrington,
brother of Malchair's first patron at Oxford.
Malchair may have made the house his base
while exploring Berkshire on successive visits.
He was generally accompanied by the Revd
Samuel Swire, Fellow of University College
and Vicar of Coleshill, and the Revd
Nathaniel Booth of Merton.

Johannes Kip's engraving of Rycote,
published in *Britannia illustrata* in 1709, shows
the full extent of this great Tudor mansion,
which stood some ten miles east of Oxford. In
a disastrous fire in 1745, much of the house
was destroyed and James Bertie, the eldest
grandson and heir to the third Earl of

73

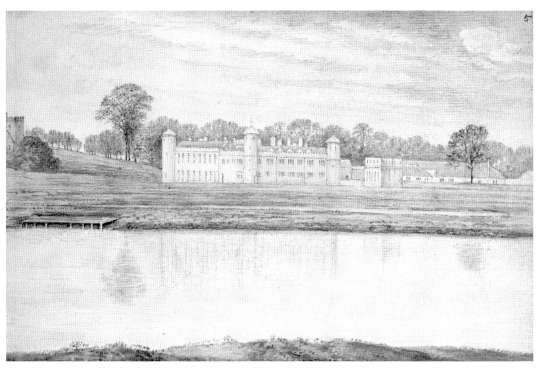

16

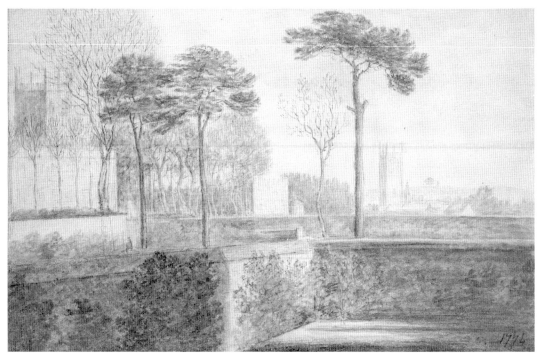

17

Abingdon, was killed. The south front and some of the east remained until they were demolished at the beginning of the nineteenth century; the chapel still stands. Malchair's drawing is taken from the south-east, a viewpoint carefully chosen to show the house at its best, for the main facade on the north side was in ruins. It is his most successful early view of a country house, topographically meticulous despite the faulty perspective of the central tower, and composed in horizontal bands to maximum effect.

17

View from Fell's Building, Christ Church

watercolour over pencil, 237 × 370
inscribed in brush in grey ink over pencil, *A View of Corpus, Merton and Magdalen Tower / from Fells Building Christ Church Oxon: 12 of Feb: 1774 – J.M. 10/-*, the signature in pencil only
Purchased, 1925 [1925.28]
Lit.: Brown, no. 928; Timothy Wilcox, *Francis Towne* (exh. cat., Tate Gallery, London, 1997-8), no. 74
¶ Fell's Building, on the south side of Christ Church, was erected in 1669 by Dean Fell, and pulled down in the 1860s to make way for the Meadows Building. This drawing was apparently made from a first floor room on the east side inhabited by one of Malchair's pupils: the most likely candidates are George Legge, Lord Lewisham (later third Earl of Dartmouth), a cousin to Lord Guernsey, who was at Christ Church between 1771 and 1775, and taking lessons with Malchair in 1773;[1] or the Revd Clayton Mordaunt Cracherode, who may have changed rooms since Malchair made a drawing from his window at Christ Church in 1772 (CCC, III, fol. 13, dated 9 June 1772) The window from which the drawing was made is visible in a much later drawing of Fell's Building from Merton Fields (10 November 1792; CCC, IV, fol. 26).

Like the view for Mrs Oglander (cat. no. 55), this drawing served as an lesson in perspective. The complicated disposition of the garden walls in the foreground are complemented by the two contrasting towers of Merton and Magdalen, and the careful distinction of pine and elm, provide technical difficulties for even the most advanced pupil.

1. Bodleian Library, MS Top. Oxon. b. 93, no. 8b.

18

Worcester Cathedral

watercolours over pencil, 458 × 329
inscribed in ink, lower right, *1774*
Purchased, 1928 [1928.102]
Lit.: Brown, no. 929
¶ Malchair played in the Three Choirs Festival, held annually in rotation at Worcester, Hereford, and Gloucester, between 1759 and 1776, but rehearsals and

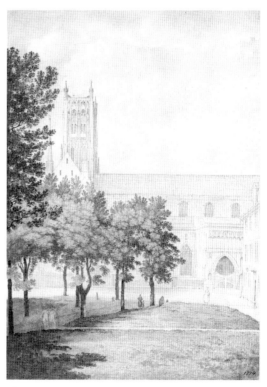

18

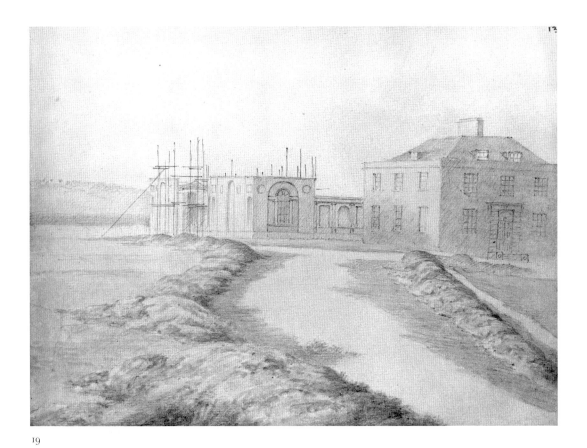

19

performances left him little time for recreation, and this is the only drawing he made in all these years.

The cathedral was begun by St Wulstan, Bishop of Worcester, in 1084, and largely built in the 13th and 14th centuries. This view from the north is untypically careful and mechanical, each straight line drawn with a ruler, and the colours, pink, red, and blue, applied in flat and unmodulated washes. Only the slightly acidic green dabs of watercolour in the trees and shrubbery relieve the general stiffness.

There is a comparably dry study, in similar colouring, of St Giles's Church, dated 15 July 1774 (CCC, VII, fol. 25). This would suggest that, although the date on the drawing of Worcester is not in Malchair's hand, it may be accurate.

19
The Beginning of the Observatory
pencil and grey and coloured washes
inscribed in grey ink on *verso, The beginning of the Observatory Oxford – Oct-17-1774-/4*
Fol. 13 of a sketchbook of 14 ff. of drawings, measuring 275 × 210
Prov.: as cat. no. 1
Lent by the President and Fellows of Corpus Christi College [MS CCC 443 (X)]
¶ The Radcliffe Observatory was the brainchild of the Savilian Professor of Astronomy, Thomas Hornsby, who was one of Malchair's closest friends. He suggested the project to the Radcliffe Trustees in 1768, and the foundation stone, on land given to the University by the Duke of Marlborough, was laid in 1772. The original design of the

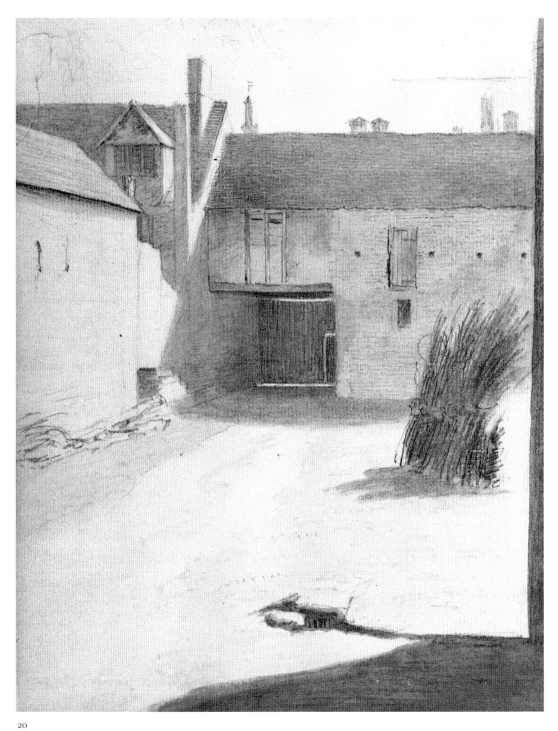

20

building was by the popular Oxford architect, Henry Keene, but in 1773, the Trustees accepted a new elevation, probably by James Wyatt, and Keene's son was instructed to work to this new design. The observatory was only completed in 1797, but the astronomical instruments were delivered in 1773.[1]

This is the earliest of Malchair's drawings of the Observatory in progress, and already shows the astronomer's house completed – the Hornsbys had moved in in 1773 – and the ground floor of the observatory itself nearing completion.

1. Ivor Guest, *Dr John Radcliffe and his Trustees* (London, 1991), pp. 224-303.

20

The Stable Yard at Merton College

grey washes over pencil, 226 × 180
inscribed in brush in grey ink over pencil on *verso, April 10 – 1775. /1* and in grey ink only,

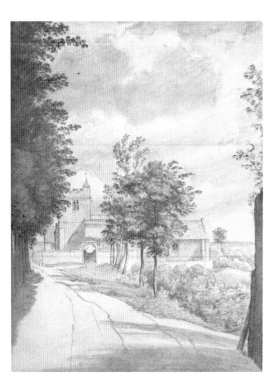

21

Merton Stable yarde. Oxon:
Purchased (Magdalen College Fund), 1925 [1925.29]
Lit.: Brown, no. 930
¶ The stone house on the left, one of the oldest in Oxford, was bought by the Warden of Merton College in 1270 and after 1290 became the college stable. It has not significantly altered over the centuries, as Malchair no doubt appreciated.

This drawing is described by Fleming-Williams as,

> *one of the most intimate and perfect of Malchair's studies ... technically faultless in its blending of pencil and wash ... Everything in it tells: the brushwood, the drain in the foreground, the row of four delicately stressed square ventilation holes, the empty sunlit yard, the sensitively modulated soft and sharp accents. Without moving further into abstraction, more could hardly be made from less.* (Fleming-Williams, MS, V, pp. 4-5)

21

Holywell Church

watercolours over pencil, 297 × 222
inscribed in brush in grey ink over pencil on *verso, May 12 – 1775 . 9/ Holywell Church. Oxford.*
Purchased (Magdalen College Fund), 1925 [1925.30]
Lit.: Brown, no. 931
¶ A charming drawing of the suburban church in the village setting of manor house, farmyard, and cockpit, with the fields of Holywell and the bowling green beyond.

22

Christ Church Cathedral from the Dean's Garden

pencil and watercolours, 245 × 383
inscribed in ink lower right, *1775*
inscribed on *verso, Christ Church Cathedral from the Dean's Gearden. Oxford 10 of June 1775. 10/*
Purchased, 1928 [1928.145]

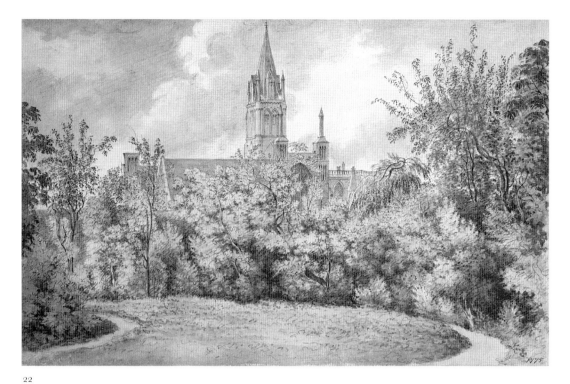

22

Lit.: Brown, no. 1238

¶ The combination of lush garden vegetation and a distinctive architectural element fascinated Malchair, and he made several drawings of this particular view. This is the second of three finished drawings: the earliest, now ruined, was probably made for Shute Barrington in the 1760s (British Museum), and another, vertical, composition was begun at much the same time as this and retouched 'on the spote' in 1784 (Whitworth Art Gallery, Manchester). Here, all parts are treated with equal care, from the mixture of rapid pencil hatching and billowing grey wash in the sky, to the carefully distinguished foliage of each species of tree.

23
Near Wadham College
pencil and grey wash, 243 × 170
inscribed in grey ink on *verso, 30 of June 1775. /7 Near Wadham Coll: Oxon.*
Purchased (Magdalen College Fund), 1925 [1925.31]
Lit.: Brown, no. 932
¶ A pastoral idyll in the fields to the north of Wadham College.

24
High Street, Oxford
pencil and brush in Indian ink, 243 × 192 (sight)
inscribed in ink on the old mount, *View of the High Street Oxford from the Corner of Queens College / Feb.y 19.th 1776 1/2*
Prov.: bequeathed by the artist to the Revd Dr George Cooke; and by descent to Grace Cooke, Mrs Rees-Jones; Ian Fleming-Williams
Lent from a private collection

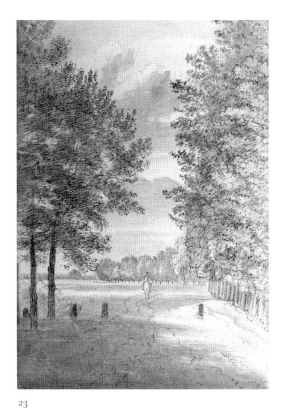

23

25
Merton Tower from Magpie Lane
pencil and grey wash, 253 × 200
inscribed on *verso*, *The Tower of Merton College Chapel Oxford from Magpie Lane, July 24. 1776. 5/*
Prov.: as cat. no. 24; presented to the Bodleian Library by Mrs Grace Rees-Jones, 1951
Lent by the Curators of the Bodleian Library (MS Top. Oxon. b. 222, fol. 16)
¶ For Malchair, the picturesque assortment of mediaeval houses on the east (left) side of Magpie Lane was irresistible, and the view was later to become a favourite with Oxford topographers. Even the construction in 1788 of Wyatt's new library at Oriel on the west side did not destroy the charm. The view shows the stately sixteenth century tower of Merton College chapel perched above mediaeval and later houses and halls, and is one of the most successful of Malchair's 'topographical series' of 1776.

¶ This is a refugee (no. 5) from the set of 31 topographical drawings Malchair bequeathed to the Revd Dr George Cooke, of which 28 are now in the Bodleian Library (see cat. nos. 25, 27, 29, 30), and was retained by Mrs Rees-Jones until her death. A rather feeble view of the High Street, taken from the level of Brasenose College looking towards All Saints' Church, is no. 33 in the series, a late and perfunctory addition. The view lower down, including the magisterial facade of the Queen's College and the elegant spire of the University Church, had been drawn by earlier artists, such as James Donowell, and was later to become the most hackneyed view of Oxford. Malchair's drawing was etched by his nephew, George Jenner, and published on 17 May 1795.

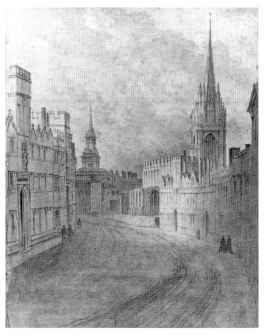

24

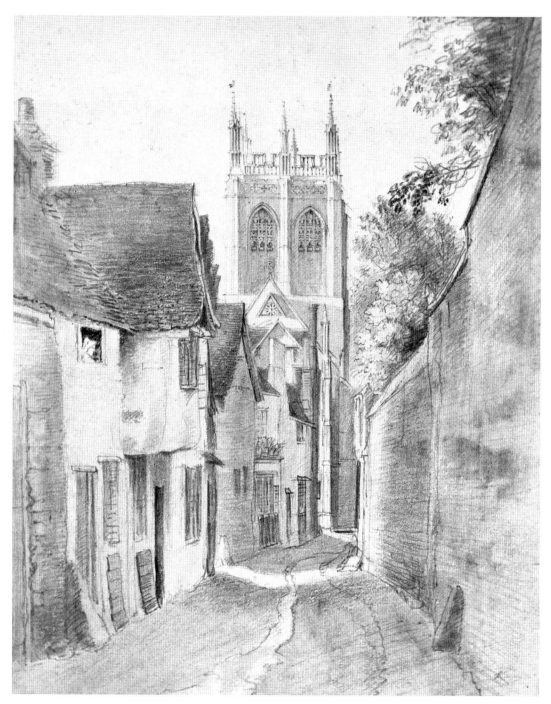

25

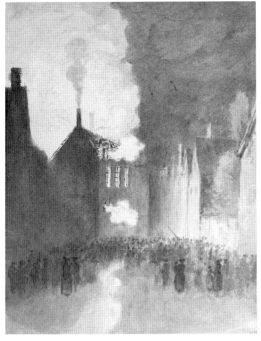

26

26

Fire in New Inn Hall

pencil and brush in blackish brown ink,
239 × 187
inscribed in pen and ink over pencil on *verso*,
The fire in Newin hall Oxon: Oct: 21. 1776. /9
Purchased (Magdalen College Fund), 1925
[1925.34]
Lit.: Brown, no. 935
¶ The fire, reported in *Jackson's Oxford Journal*
on 26 October 1776, destroyed much of the
mediaeval hall, which stood on the southern
part of the site now occupied by St Peter's
College. This is the earliest of Malchair's many
drawings of fires (for the last, see cat. no. 83),
and the most atmospheric. It is first lightly
sketched in pencil, then entirely reworked in
wash, using a darker ink and finer brush to
outline the windows. Malchair has cleverly
exploited the white paper to depict the flames
and the light they throw onto the nearby
buildings.

27

St Peter's in the East from New College Garden

pencil and grey wash, 256 × 201
inscr. verso, *St: Peters in ye.. East from New Coll:
Garden Oxford Novr5.th 1776. /1*
Prov.: as cat. no. 25
Lent by the Curators of the Bodleian Library
(MS Top. Oxon. b. 222, fol. 19)
¶ St Peter's in the East, the most noble parish
church in Oxford, was begun in the twelfth
century and mostly completed by 1500. The
only satisfactory place to view it is Malchair's,
from New College garden, now much tamed.
The drawing once again displays mild
perversity of the 'topographical' series in its
concentration on the garden to the detriment
of architecture. As a study in foliage, however,
it is the most extravagant and varied he
produced in the grey wash.

 The church is now the library of St
Edmund Hall.

28

Radcliffe Infirmary

grey washes over pencil, 60 × 198
inscribed in brush and grey ink on *verso*, *June
28 – 1777 – /8.* and in pencil, *The Infermery –
from the Nort of the Parck. Oxon.*
Purchased (Magdalen College Fund), 1925
[1925.35]
Lit.: Brown, no. 936
¶ One of the smallest and most exquisitely
finished of Malchair's drawings, this shows the
Radcliffe Infirmary, built at the expense of the
Radcliffe Trustees in 1759-70 to a simple but
dignified design by Stiff Leadbetter, seen across
the fields of St Giles. This view was quickly
destroyed by additions to the infirmary, and
the enclosure of the fields in the 1820s.

27

28

29 (illustrated page 32)
The Music Room
pencil and watercolours, 204 × 165
inscribed on *verso*, *The Musick Room at Oxford.*
1777.
Prov.: as cat. no. 25
Lent by the Curators of the Bodleian Library
(MS Top. Oxon. b. 222, fol. 26)
¶ The Music Room in Holywell is widely
believed to be the first purpose-built concert
room in Europe. It was built to a design by

Thomas Camplin for Wadham College in
1742-8. Its austere front, faithfully recorded by
Malchair from Bath Place opposite, was then
approached by flanking curved paths – here,
the door on the right is open. Apart from a
curious view of the back of the music room,[1]
this rather rough and rudimentary drawing is
the only record Malchair made of the building
where he spent most of his working life.

1. dated 6 February 1787; Bodleian Library, MS Top.
Oxon. b. 93, no. 16.

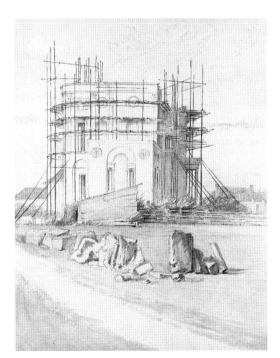

30

30
The Observatory under Construction
pencil and watercolours, 203 × 162
inscribed on *verso*, *The Observatory at Oxford while
abuilding 1777.*
Prov.: as cat. no. 25
Lent by the Curators of the Bodleian Library
(MS Top. Oxon. b. 222, fol. 24)
¶ The work on the Observatory has
progressed little since Malchair's last drawing
(cat. no. 19), no doubt as a result of the
decision of the Radcliffe Trustees to limit their
annual expenditure on it to £1,000.

31
The Radcliffe Infirmary
pencil and yellow-brown, green and grey
washes, 204 × 330
inscribed in pencil, lower right, *1778*; inscribed

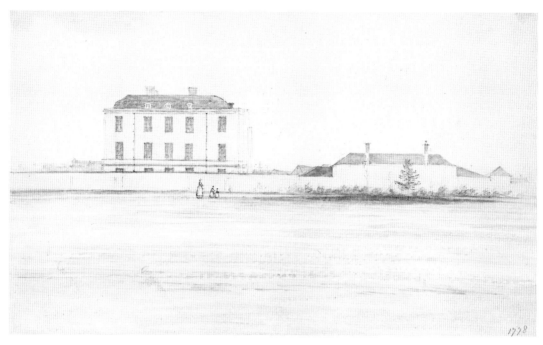

31

31 verso

in brush in grey ink over pencil on *verso*, *The Infermery at Oxford / from Professor Hornsbys house / at the Observatory / January the 9^th 1778. /1*, with a supplementary sketch inscribed *Miss Anne Hornsby*.
Prov.: Messrs Appleby, 1944; Iolo Williams
Lent by Mr & Mrs E.A. Williams
¶ Anne is not recorded among the numerous progeny of Thomas Hornsby baptized at St Giles's Church, but was married to George Frank Blakiston on 18 May 1801, and may be assumed to have been born *c*.1774. This

drawing, unique in Malchair's *oeuvre* in its naivety and extreme simplification, may therefore have been made as a lesson or amusement for the little girl, whose thumbnail portrait is drawn on the *verso*.

32
From Mr Jackson's Window, Christ Church
pencil, 293 × 218
inscribed in brush and grey ink over pencil on *verso*, *May 22. 1778 – from M^r: Jackson's window Fell's Buildings. / Ch: Ch: Oxon: 10/*
Prov.: Iolo Williams
Lent by Mr & Mrs E.A. Williams
¶ Presumably another drawing made with a pupil, from the north side of Fell's Building (see cat. no. 17), looking towards the cathedral, with a wide expanse of garden in the foreground. The technique, of pencil without wash, is unusual in such lessons, but allows for accurate delineation of the architecture and a variety of strokes in the foliage.

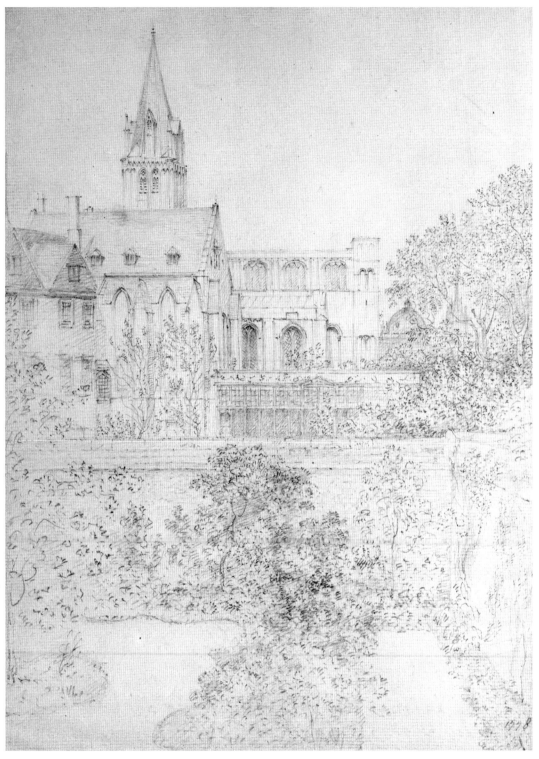

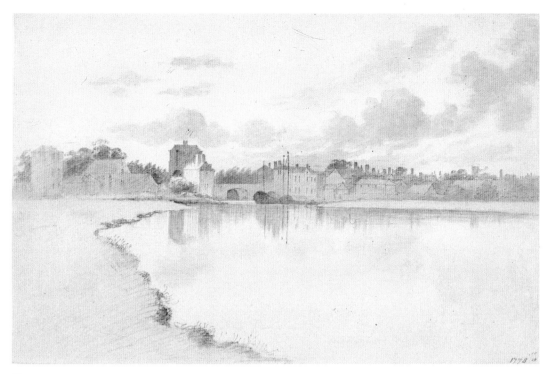

33

The pupil, Mr Jackson of Christ Church, has not been conclusively identified. The most likely candidate is William Jackson (1751-1815), who matriculated in 1768, was admitted M.A. in 1775 and D.D. in 1799, and was consecrated Bishop of Oxford in 1812. The other possibility is Thomas Jackson (1745-1797), who matriculated in 1763 and was later the minister of St Botolph's, Aldgate.

33
Folly Bridge from the River
pencil and grey wash, 242 × 375 (sight)
inscribed on *verso*, *July 30 1778 – The Warfe – Folly Bridge and Friar Bacons Studdy Oxford*;
inscribed in ink on *recto*, *1778* $\frac{10}{10}$
Prov.: Messrs Appleby, 1968, no. 35; Ian Fleming-Williams
Lent by David Thomson
¶ This unusual view of Folly Bridge shows the wharf, bridge and Friar Bacon's study from

downstream, to the south east. It is one of Malchair's most magical and economical creations: Fleming-Williams called it:

the finest of [Malchair's] many studies of this last of the ancient entrances to the city, a drawing that with its gentle light resting on only the one spot, the house by the bridge, and that with its subtlety of tone, anticipates by some thirty years Thomas Girtin's greater watercolour, the White House at Chelsea [Tate Gallery]. (Fleming-Williams, MS, V, p. 14)

34
Friar Bacon's Study
watercolours over pencil, 240 × 302
inscribed in grey wash on *verso*, *April 15 – 1779 – / 2 Bacons Studdy Oxon*
inscribed in pencil on *recto*, *1779*
Prov.: A.B. Emden, Principal of St Edmund Hall

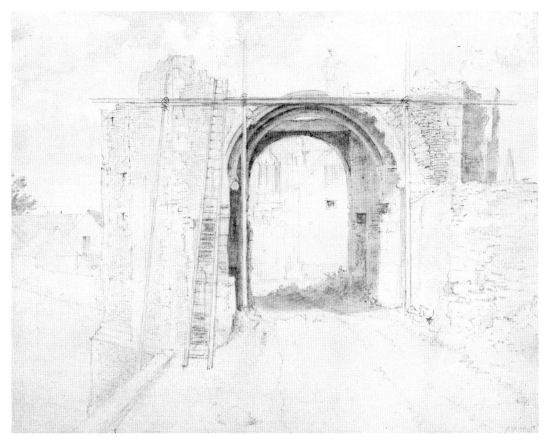

34

Presented by J.H.H. Minn, 1960 [1960.71.2]

Lit.: Brown, no. 937

¶ Having withstood the first wave of
destruction consequent on the Mileways Act of
1771, Friar Bacon's study was eventually
demolished in 1779 for the Hinksey Turnpike.
Malchair had real feeling for the strange
edifice, and drew both the north and south
sides while the demolition was progressing.
The companion drawing, made a day earlier,
on 14 April 1779, is inscribed with the pathetic
lines, *Ah poor Friar, you might have stude to see
manny generations to comme Pass under you had not
you stoped one time Jackson's load of Hay*.[1]

1. sold Sotheby's, 23 January 1963, lot 20, bought by
Messrs Appleby.

35 (illustrated page 90)

**View from the Window of Malchair's
Parlour**

watercolours over pencil, 268 x 346

inscribed in ink, lower right, *1782*

inscribed in pencil on *verso*, *[S]t Barnabas – June
11 – 1782. /6. From the back window of My Parlour
– opposit. Baliol Oxon – in this Drawing is traced the
Meridional Altitude of the Sun at the Winter Solstice*

Purchased, 1928 [1928.103]

Lit.: Williams, p. 91, pl. 155; Brown, no. 938;
David Blayney Brown, *Early English Drawings
from the Ashmolean Museum* (exh. cat., Morton
Morris & Co., London, 1983), no. 39; David
Blayney Brown, *Original Eyes: Progressive Vision in
British Watercolour, 1750-1850* (exh. cat., Tate
Gallery, Liverpool, 1991), pp. 6, 55 ; Timothy

Wilcox, *Francis Towne* (exh. cat., Tate Gallery, London, 1997-8), no. 75

¶ Both Williams and Wilcox identify the scene as showing St Barnabas, a parish founded in the new suburb of Jericho in the late nineteenth century. In fact, the inscription indicates that the drawing was made on the Feast of St Barnabas, 11 June. The view is taken from Malchair's lodgings at 12, Broad Street, where he had lived since at least 1772, looking over the gardens and onto the backs of the houses in Ship Lane; some of the same buildings may still be seen from the back of Thornton's Bookshop.

While this drawing may have begun as a lesson in perspective (cf. cat. no. 55), the warm, velvety finish and seductive mingling of pencil and wash create one of Malchair's most distinctive scenes.

Malchair made another, slighter sketch of a similar view on 8 October 1786 (Brown, no. 1049), and in the 1790s, it was drawn by several of his pupils: W.H. Barnard in 1795 (formerly collection of Ian Fleming-Williams), and William Crotch.

36
Cock Pit, Holywell
pencil and grey wash, 252 × 337
inscribed on *verso*, *[C]ock Pitt – Holywell Oxon.*
June 22 – 1782 – /7 by Napier's Bridge
Purchased, 1928 [1928.104]
Lit.: Brown, no. 940
¶ The cockpit was to the north-east of Holywell Manor, on land now part of Balliol College, but belonging to Merton in Malchair's time. Cockfighting was a popular sport among both town and gown, and sustained two cockpits and occasional matches elsewhere.[1] The distinctive shape of the cockpit, with an

36

apparently hexagonal ground plan, provided another challenge in perspective to Malchair and his pupils, and he made several drawings of the building, the first, in 1770, from behind, with only the roof visible above the trees (CCC, III, fol. 20), two drawings of 1774 and 1777 in which it is subordinate to its surroundings (CCC, VII, fol. 29; IV, fol. 40), and a final view very similar to this one (cf. cat. no. 58).

1. Graham Midgley, *University Life in Eighteenth Century Oxford* (New Haven and London, 1997), pp. 117-8.

37
Canterbury Building, Christ Church
pencil and grey washes, 300 × 479
inscribed in pencil, lower right, *1783*
inscribed on *verso*, *Canterbury Building Christ Church Feb. 26 – 1783 – / 1*
Purchased, 1928 [1928.154]
Lit.: Brown, no. 1250
¶ The mediaeval buildings of Canterbury College (founded in 1363), incorporated into Christ Church, were finally demolished in 1783 to make way for a new quadrangle, designed by James Wyatt and paid for by Richard Robinson, Archbishop of Armagh. Perhaps knowing that the gateway was to be demolished, Malchair made two drawings of the old gateway in 1774-5,[1] and a third in 1783 during its destruction (Brown, no. 1093). At the

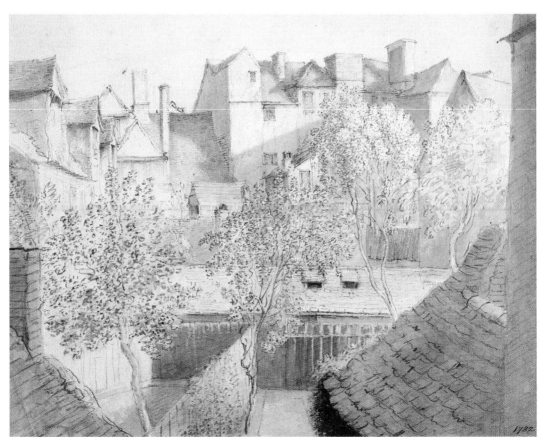

35

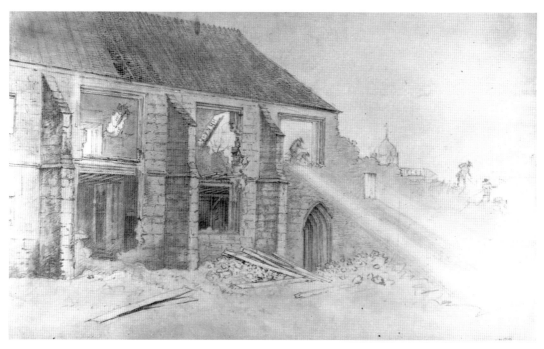

37

same time, he recorded the demolition of the
north range of the quad, and, although of
importance for recording the appearance of
the mediaeval buildings, the antiquarian detail
in this drawing is entirely subsumed in the
artist's interest in depicting the sun shining
through the ruins and the dust, a feat achieved
with a combination of blank paper and careful
rubbing of the soft pencil with the finger.

1. CCC, VII, fol. 10, dated 4 May 1774; and fig. 5.

38
The Remains of Beaumont Palace

grey washes over pencil, 222 × 286
inscribed in pencil, lower right, *1783 1788*
inscribed on *verso*, *Remains of King Johns Palace.
Near Gloucester Green Oxford. June 7 1783/1. The
Wall with the Arch is the only part which seemes to
have a clame to such Antiquity*
Purchased, 1928 [1928.105]
Lit.: Brown, no. 941

39
The Remains of Beaumont Palace

grey washes over pencil, 239 × 319
inscribed on *verso*, *[J]ohns Palace Oxford June 12
– 1783 – /1*
Purchased, 1928 [1928.106]
Lit.: Brown, no. 942
¶ Henry I's palace at Oxford was built at the
western end of what is now Beaumont Street,
outside the city walls, early in the twelfth
century. In its heyday, it was a substantial
building protected by a wall and entered
through a 'great gate'. By the late 13th
century, however, it had fallen into disuse,
and was ceded to Carmelite friars in 1318.
After the Dissolution of the Monasteries, the
buildings fell into disrepair, partly removed by
St John's College and were eventually swept
away when Beaumont Street was laid out in
the 1820s. This medieval vaulted building, with
a pointed arch and round window, was the
only remnant that could be studied by Oxford

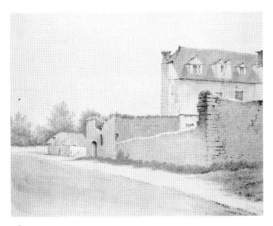

38

antiquaries, but Malchair was equally interested in the combination of houses, ruins and barn.

40
Behind the Tanners' Yard by Little Gate, Oxford

pencil and brush in grey wash, 265 × 405 inscribed in brush and grey ink over pencil on *verso*, *Behinde the Tanne yeard by Little Gate Oxford, August 2d. 1783. /4*, with a similar inscription in pencil erased. Further inscribed by C.F. Bell in pencil, *Malchair's handwriting*
Prov.: Walker's Galleries, 1947, no. 103; Ian Fleming-Williams
Presented by Ian Fleming-Williams, 1996.490
¶ The tannery was at the bottom of Littlegate Street, where the road crossed over the Trill Mill Stream. This elaborate study of masonry and water is one of a group Malchair made of the buildings and streams in St Aldate's and St Thomas's parishes, where the streams offer many such views. There is a much slighter

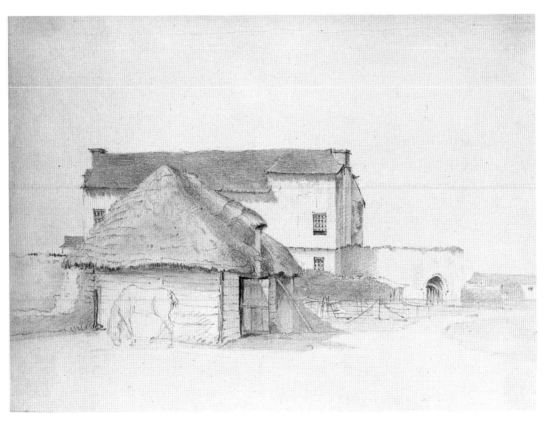

39

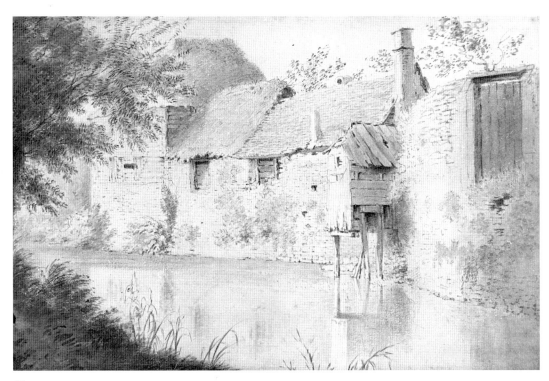

40

sketch of the same tannery, with Tom Tower and the spire of Christ Church Cathedral in the distance, dated 7 May 1787 (Brown, no. I, 1054).

41
Balliol Chapel and Library
pencil and grey wash, 243 × 308
inscribed in brush in grey ink over pencil, *lol Chapple and Library Oxford. from the Grove Aug: 2.d 1783 –*
Purchased, 1928 [1928.107]
Lit.: Brown, no. 944
¶ The chapel of 1522-9 was swept away by Butterfield's new chapel in 1856, in one of the most famous acts of Victorian barbarism. Here, the building serves as the backdrop to an extraordinary study in light and shade, the huge shadow of the oak tree occupying much of the foreground.

42
Kirtlington Park
pencil and watercolours, 288 × 472
inscribed on *verso*, *Kirtlington October 9 – 1783 – 1/2*
Purchased (Magdalen College Fund), 1925 [1925.39]
Lit.: Brown, no. 946

43
Kirtlington Park
grey wash over pencil, 297 × 460
inscribed on *verso*, *Kirtlington October 10 – 1783 – 1/2*
Purchased (Magdalen College Fund), 1925 [1925.40]
Lit.: Brown, no. 947
¶ The seat of Sir James Dashwood, second baronet (1715-79), Kirtlington Park was designed by William Smith and John Sanderson following earlier proposals by James

41

Gibbs in 1742-6, and completed with a particularly elaborate series of interiors. Horace Walpole remarked in 1753 that 'Sir James Dashwood's […] vast new house situated so high that it seems to stand from the county as well as himself.'[1] The grounds were landscaped by Capability Brown.

Malchair first visited Kirtlington on 10 March 1765, when he drew the church (Brown, no. 1230). His visit in 1783 may have come at the invitation of Sir James's younger son, Thomas (1749-1825), whom Malchair probably taught at Oxford (he matriculated from University College on 21 April 1765). Their association is now only recorded in a clumsy etching of *Philips an Oxford Musician, & Anet a Violin Player*.[2] Equally, the eldest surviving son,

Henry, was elected Steward to the Music Room in 1776, together with Oldfield Bowles, and he may have been Malchair's host in 1783.[3]

The two contrasting views, made on successive days, show the house from the park and a view in the park. The second is in Malchair's economical style, but the first, one of his grandest works, with a wide variety of pencil work characterising each species of tree, the restrained washes evoking the colours of early autumn.

1. quoted in James Townsend, *The Oxfordshire Dashwoods* (Oxford, 1922), p. 25.
2. signed in the plate, *T.D delin: JM. F*, British Museum, 1867-3-9-573.
3. *Jackson's Oxford Journal*, 15 June 1776.

42

43

44

44
Balliol College
grey wash over pencil, 238 × 295
inscribed in pencil, lower right, *1783*
inscribed in brush and ink over pencil on *verso*,
Baliol – Oxon: October 18 – 1783 -10/
Purchased, 1928 [1928.108]
Lit.: Brown, no. 948

45
Oxford Castle
grey wash over pencil, 294 × 467
inscribed in ink, lower right, *1784 / 21*
inscribed in brush in grey ink over pencil on
*verso, Oxford Castle and Castle Hill May 27 – 1784
– /5.*
Purchased, 1939 [1939.129]

Lit.: Brown, no. 950
¶ St George's Tower and Chapel are seen from the north-east, probably from the New Road built in 1769. The castle was built by Robert d'Oilly for William I in 1071, and later owned by Christ Church. It was replaced as a royal residence by Beaumont Palace (see cat. nos. 38-9), and, after various vicissitudes, was largely demolished during the Civil War; surviving buildings, including St George's Tower, were used as a gaol. This is the most fully worked of Malchair's numerous drawings of the castle, and the view of the apse of the Norman chapel shortly before its removal to be replaced by the Debtor's Prison, is a valuable record for historians.[1]

The builders of New Road offered to buy

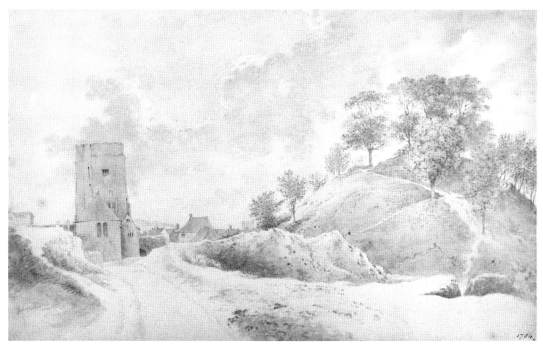

45

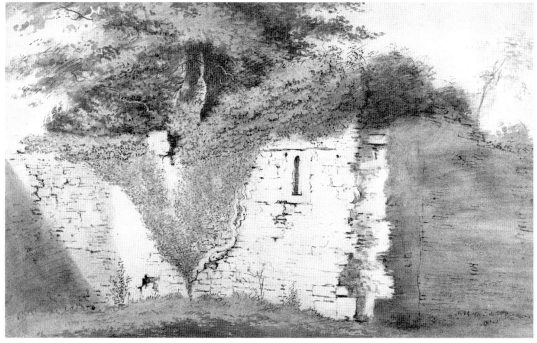

46

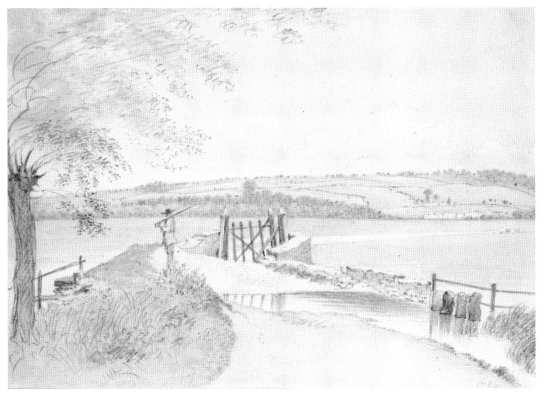

47

the castle mound for its soil, but were refused by Christ Church on the grounds that the antiquity should be preserved.[2]

1. CCC, V, ff. 21, 29; VII, ff. 26, 30; Brown, nos. 1252, 1257, 1263, and 1284.
2. Julian Munby and Hugh Walton, 'The Building of New Road', *Oxoniensia*, LV (1990), pp. 123-30.

46
Part of the Old Walls of Godstow Nunnery
pencil and grey wash, 297 × 469
inscribed on *verso*, *A Par[t] of the Old Walls of Godstow Nunnery near Oxford July 13 – 1784 – /6*
Purchased (Magdalen College Fund), 1925 [1925.126]
Lit.: Brown, no. 1041
¶ The crumbling walls of the East Gate, Little Gate, castle, and other ruins enabled Malchair to experiment in creating textures with

calligraphic strokes of the chalk, using his fingers to rub the chalk smooth, and combining wash and chalk in unorthodox but effective ways (cf. Brown, nos. 1044, 1256, 1280). This is the most closely observed and fully worked of these drawings, an atmospheric study of an old wall in a field made while the artist was alone.

47
The Gate into Port Meadow
grey washes over pencil, 210 × 300
inscribed in pencil, *1784*
inscribed in brush in grey in over pencil on *verso*, *Port Meadow Gate Oxford. August 12 – 1784 – 1/2*
Purchased (Magdalen College Fund), 1925 [1925.42]
Lit.: Brown, no. 951; Fleming-Williams, 1994-5, pp. 63-4, fig. 46

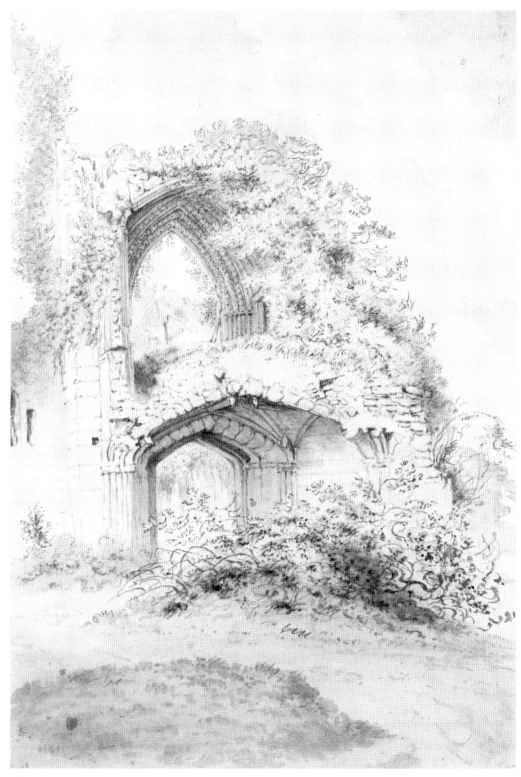

48

¶ Port Meadow, the ancient common land of the freemen of Oxford mentioned in the Domesday Book and often described as the city's oldest monument, is an area of 350 acres of grass and mud, frequently flooded, to the north-west of the city. The entrance shown in Malchair's drawing is now at the bottom of Walton Well Road, and the landscape happily little changed.

48
The Entrance of the Grand Hall at Kenilworth
pencil and stump and brush in grey wash, 443 × 308
inscribed in brush and grey ink over pencil on *verso*, *The Entrance of the Grande Hall at Kenilworth .. with the Servants Hall underneath – May 18 – 1785 – 10/*
Presented by Ian Fleming-Williams, 1996 [1996.496]
¶ The castle at Kenilworth was a favourite with antiquaries and tourists in search of the picturesque, and this is one of a series of six drawings Malchair made of the ruins between 17 and 20 May 1785; he made two further drawings, together with others of Warwick Castle in 1787 (most now at the Whitworth Art Gallery, Manchester). They are all unusually large and may have been intended for publication, though the strange viewpoints would scarcely have appealed to contemporaries. This is the most conventional, and typically combines close attention to the crumbling masonry and the vegetation gradually taking over.

49
Magdalen Grove
pencil and grey wash, 269 × 189
inscribed in brush and grey ink over pencil on *verso*, *A Sappling Elme / in Magdalen Grove June 29 – 1785 – /4 / Oxon.*
Purchased, 1925 [1925.44]

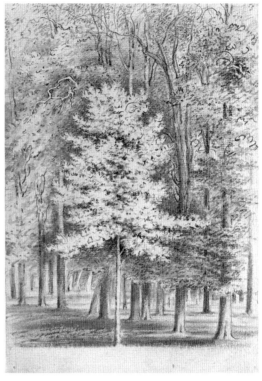

49

Lit.: Brown, no. 953
¶ Despite the emphasis on studying trees in his teaching, Malchair made only a handful of drawings of individual species, and only one of the grove behind Magdalen College.

50
Tenbury on the River Teme from the Swan
pencil and stump and grey wash on white laid paper, 292 × 445
inscribed in pencil along lower margin, *Tenbury on the River Teame – from the Swan / Sep 16 1785 – 8/*
inscribed in pencil on *verso*, *From the Swan on the Shropshire Side of Tenbury …Sept … /7*; further inscribed in brush and ink: *Tenbury Church from the Swan – Shropshire side of the Bridge – Saturday Sep: 17 – 1785 – /7*

Presented by Ian Fleming-Williams, 1996
[1996.491]

¶ Probably made on an overnight stop on the way to Walcot House in Shropshire (see cat. no. 53), the drawing is one of Malchair's rare failures at this date.[1] In his enthusiasm to use a wide variety of pencil marks and combine them with wash applied in different strokes, he has lost the power of synthesis essential for unity. This may have been exacerbated by working on the drawing at several different times, as seems to be indicated by the fragmentary inscription on the *verso*. The extensive inscription on the *recto* is unusual.

1. A drawing of Walcot House itself is dated Sunday 18 September 1785; Bodleian Library, MS Top. Oxon. b. 93, no. 37.

51
Near Little London, Berkshire

pencil and Indian ink, 296 × 446
signed in ink, lower left, *J.B. Malchair. 1786. Oxford*
inscribed on *verso*, *J.B. Melchair. Del^t. In the lane at Kennington in Berkshire leading upp to little London / May the 9^{th} 1786 – betwee Six and ten o'clock in the Evning / tutched again July 19 – same yeare – 1788. Oxford.*
Further inscribed by William Delamotte: *Given me by my dear old Friend Malchair; he was born at Cologne next house to Rubens. I took his place as drawing master at Oxford (after I left Mr West (PRA)) he became blind, his Pupils. Sir George Beaumont. &c &c procured him an Annuity for life – was buried in the Church Yard opposite George Lane Oxford. Will^m DelaMotte.*
Prov.: Messrs Spencer, August 1933, sold for 10 shillings to L.G. Duke (no. D 917); sold for £2 to H.C. Green (no. G 255); Ian Fleming-Williams

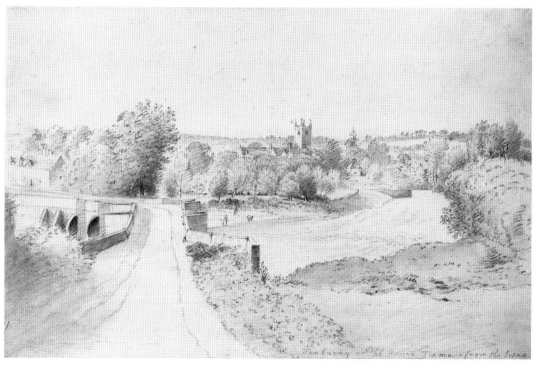

50

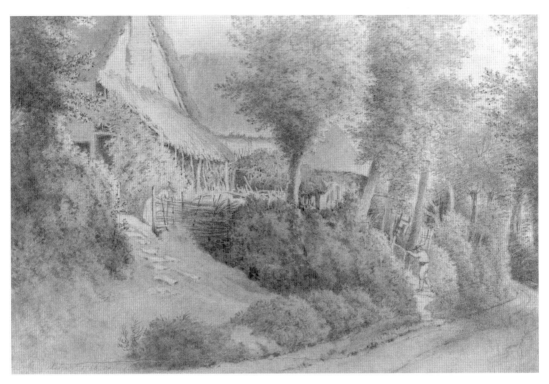

51

Lent from a private collection

¶ In the eighteenth century, Kennington was a small village south of Oxford, and Little London, probably a jocular name for an empty spot, was just to its south, on the eastern side of Bagley Wood. This is one of the most sophisticated drawings of Malchair's maturity, finely detailed in the initial pencil drawing and closely reworked two years later. The long inscription by Delamotte provides valuable biographical material not otherwise documented.

52
The Observatory from the Banbury Road

watercolours over pencil, 291 × 444

inscribed on *verso, John Baptist Machair fect The Observatory Oxon June 24th 1786. From the Banbury Road beyond St. Giles' Church the residence of the Revd. Doct. Hornsby Professor of Astronomy. Drawn for the use of Miss Anne Hornsby. The Professor's Eldest Daughter and my Scholar.* Further inscribed with lines from *Paradise Lost,* IV, 598-9,

> *Now came still Ev'ning on, and Twilight grey*
> *Had in her sober Liv'ry all things clad*

Purchased (Magdalen College Fund), 1925 [1925.47]

Lit.: Brown, no. 956

¶ Brown, following C.F. Bell's inscription on the mount, identified another drawing in the Ashmolean (Brown, no. 1260) as the preparatory study for this drawing. However, as often with Malchair, it is not possible to be certain about the relationship between different versions of the same composition, and the undated drawing may very well be that of Miss Hornsby.

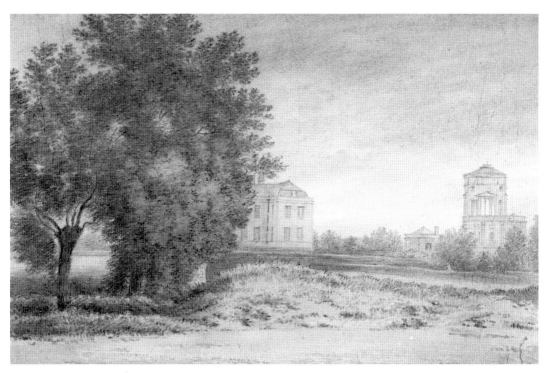

52

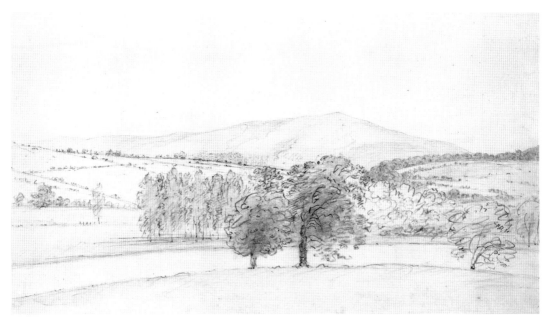

53

54

53
The Longman from Walcot House, Shropshire

pencil and stump and wash on laid paper,
279 × 466
inscribed in pencil on *recto*, *5*
inscribed in pencil on *verso*, *The Longman from Walcot House Shropshire Sept 26 – 1786 11/ Monday*
Presented by Ian Fleming-Williams, 1996
[1996.486]

¶ Walcot House was bought by Clive of India in 1764 and extensively remodelled by Sir William Chambers. This drawing was made during a visit to Malchair's patron, Lord Clive, and is one of the few of this size made entirely on the spot. The landscape is built up from the lightly sketched hills in the background, the details of the trees and hedgerows added in the middle distance, the pencil rubbed with the fingers over the hills and on the hill in the foreground, and lightly washed over, and the foreground put in with vigorous swirling pencil strokes and final dabs of wash. The result transcends the painstaking reworking of many drawings of this period, and retains striking freshness and immediacy.

54
Worcester College

pale watercolours over pencil, 204 × 323
inscribed on *verso*, *In Worcester College Oxon – October 7 – 1786 – /2*
Purchased, 1928 [1928.109]
Lit.: Brown, no. 957

¶ The mediaeval buildings of Gloucester College, a Benedictine foundation, survive on the periphery of Worcester College. The humour in the scurrying figure of a don was perhaps unintentional: like most draughtsmen unskilled in drawing the human figure, Malchair could not help making caricatures.

55

View from the Warden's Lodgings, New College

watercolours over pencil, 299 × 448

inscribed on *verso, A View taken from a Window of the Warden's Lodgings in New College Oxon. Nov. 20 – 1786 – 10/ – this drawing served as a lesson in the Art of Perspective to the Lady of Dr. Oglander the present Warden of that College. The Greate Gothic Window is at the East Ende of All Souls Library – the Lowe Building intercepted by the lopped trees in the back part of Hartford College, above which appears the lofty pile of Gothic building, called the Schooles'*

Purchased (Magdalen College Fund), 1925 [1925.48]

Lit.: Petter, p. 113; Brown, no. 958

¶ The view is taken looking west, with the morning sun casting strong shadows into the gardens behind the Warden's lodgings. This is the most demanding of Malchair's lessons in perspective, and even the master has not entirely succeeded in the mechanically exact representation of each building. The evocation of the shifting patterns of light and shade, however, is masterly.

For Mrs Oglander and her drawing of this scene, see cat. no. 97.

56

Christ Church from St Aldate's

pencil and watercolours, 331 × 400

inscribed on *verso, 27 – 1787 – 10/*

Purchased, 1928 [1928.173]

Lit.: Brown, no. 1266

¶ This represents the culmination of Malchair's interest in the representation of landscape lit by the sun from behind, and has no parallels in contemporary painting. Indeed, it was not until J.M.W. Turner began his explorations of similar phenomena in the 1840s that such experiments were repeated. The hallucinatory quality is created by pure

55

56

watercolour with minimal pencil work, by topographical inaccuracy – even in the eighteenth century, a view of Christ Church framed by buildings in this way would have been impossible – and by the intense unreality of the figures, especially the awkwardly foreshortened steaming horse and cart on the left. As Malchair wrote of such scenes in his *Observations*, 'Wounderfull effects are observable when the objects are between the sunn and spectator, butt they are so little knowen that fiew would subscribe to the truth of them, were they ever so well represented.'

57
A Stream behind a Row of old Houses
pencil and pale watercolours, 210 × 323
inscribed on verso, *April 12, 1787 – 9/*
Purchased, 1928 [1928.110]
Lit.: Brown, no. 959
¶ The particular stream has not been identified – it may be Trill Mill Stream – but is typical of those in the parishes of St Aldates' and St Thomas's which survived until the 1960s.

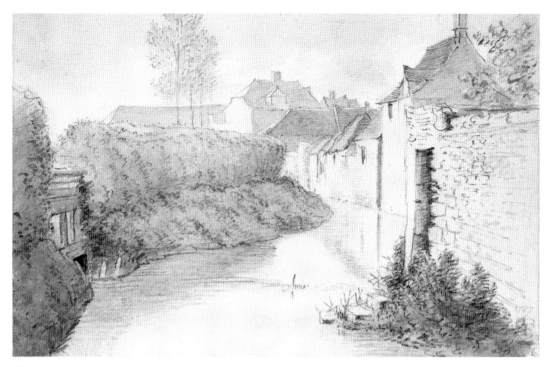

57

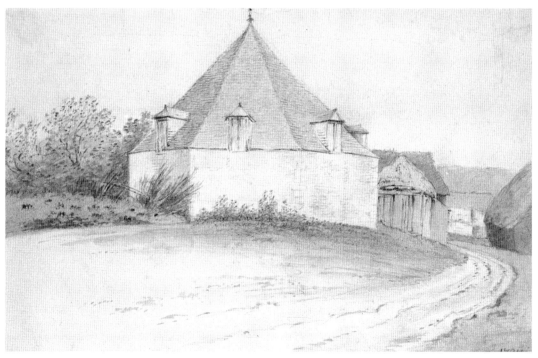

58

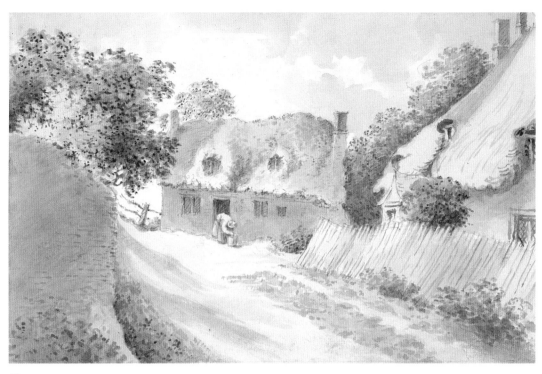

59

58
Cock Pit, Holywell
grey wash over pencil, 205 × 323
inscribed in pencil, lower right, *1787*
inscribed on *verso, The Cock Pit Holywell Oxon –
May 11 – 1787 – 11/*
Purchased, 1928 [1928.111]
Lit.: Brown, no. 960
¶ Five years after his earlier finished view of
the cockpit (cat. no. 36), Malchair made
another drawing, probably with another pupil.
The view is essentially the same, although the
trees have been cut down, and, more
inexplicably, the pitch of the roof is much less
steep. The style of the later drawing is much
more expressive, the pencil in the brickwork
less careful and the wash applied more freely
and with a broader brush.

59
Cottages in a Village Street
watercolours over pencil, 211 × 323
Purchased (Magdalen College Fund), 1925
[1925.61]
Lit.: Brown, no. 975
¶ The date is probably *c*.1785, and the site
unidentified but perhaps in one of the villages
near Oxford where Malchair was a frequent
visitor, such as Besselsleigh. This is one of
Malchair's most successful coloured drawings,
the bright tints combining with the jaunty
pencil work to create an engaging but highly
artificial scene of rustic simplicity.

60

Copy after Claude

watercolours over pencil, 163 × 206
inscribed on *verso, From a picture by Claude belonging to Mr Malchair*
Purchased, 1928 [1928.113]
Lit.: Brown, no. 976

¶ The inscription indicates that this is copied after an oil painting by Claude. However, none of this composition is recorded, and, although the general arrangement of trees and architecture is reminiscent, the tower is much more slender than those in Claude's works, and the original painting may have been no more than a pastiche.

61

Christ Church Meadows

watercolours over pencil, 137 × 188
Purchased (Magdalen College Fund), 1925
[1925.56]
Lit.: Brown, no. 970

¶ Perhaps a view from Christ Church Meadows towards Iffley, this is one of a group of small drawings in which Malchair's limited range of colours is wholly convincing.

62

Christ Church Meadows

pencil and watercolours, 125 × 162
inscribed in brush and grey ink over pencil on *verso, Christ Church meaddow Oxon – May 6th 1788 /7*
Purchased (Magdalen College Fund), 1925
[1925.49]
Lit.: Brown, no. 961

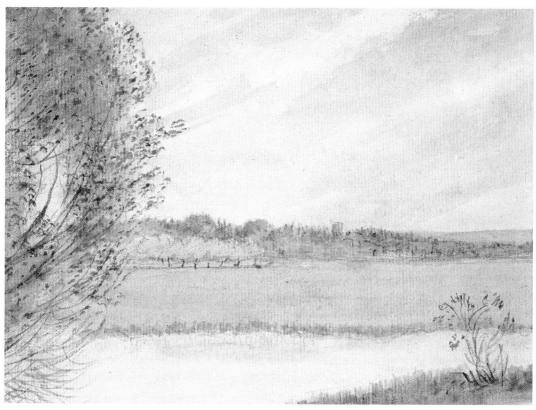

61

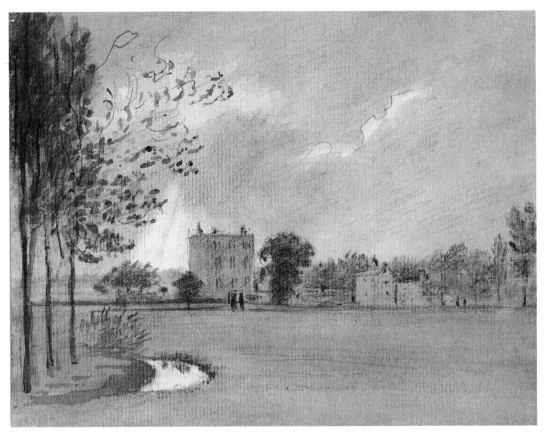

62

¶ This is probably a view looking east towards St Clement's, in which the colour is laid in almost unmodulated washes, and combines with the texture of the paper to create a tonal drawing of great intensity.

63

63
The Ferry at Hinksey
watercolours over pencil, 209 × 261
Purchased, 1928 [1928.114]
Lit : Brown, no. 977
¶ The drawing of one of Malchair's favourite spots (see cat. no. 67) was engraved in aquatint by Mrs Howorth in *c*.1788, which the artist described in a letter to Dr Wynne as,

> *incomparably imitated, it is a little drawing of the little Hovel and pigsty at Ferry Hingsley humble objects indeed but deare to your Memory and Mine as it recales to oure Meindes former happy days indeed.* (Minn, 1957, p. 100)

Ferry Hinksey Road was an ancient route out of Oxford to the west (and thought by the monks of Oseney to be the site of the Oxen-

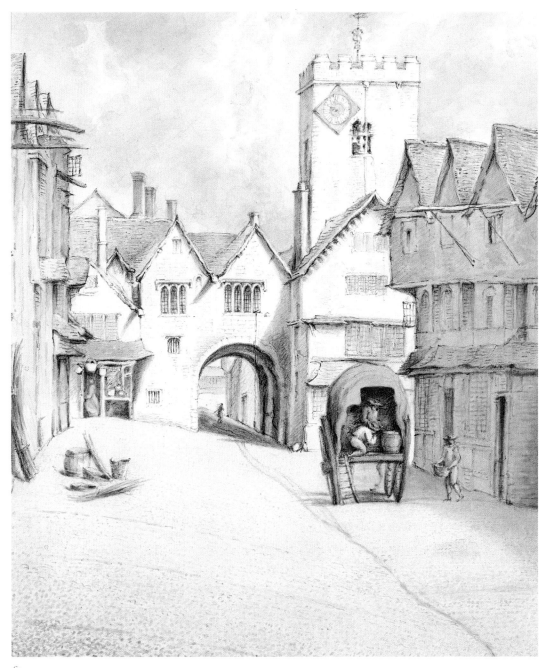

64

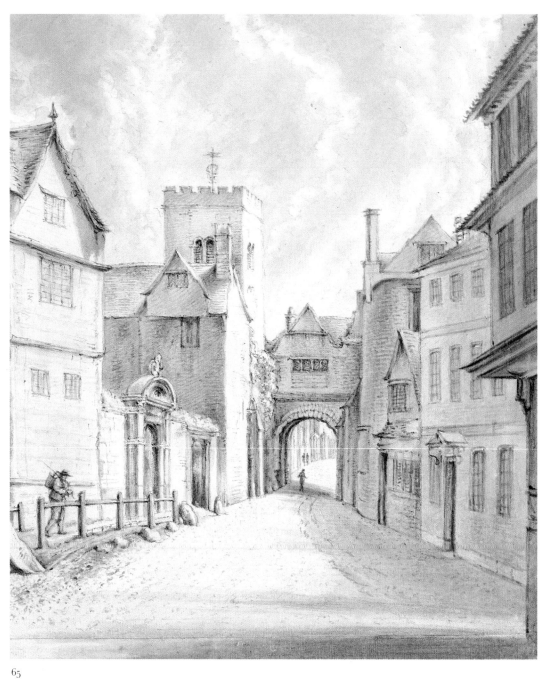

65

ford). The double-ditched path survives, though the ferry, long since vanished, has recently been replaced by a bridge.

64
North Gate from the Cornmarket

pencil, brush in grey ink and watercolours, 315 × 270

inscribed in ink on a separate strip of paper, *View from the Corn market of – North Gate Oxford – taken down in 1771. [...]is Gate is better known at Oxford by the name of Bocardo. After this Drawing was made an Aq[...]nta Print by M^{rs} E. Howorth in the year 1788 – and published in Jan: 89. by J.B. Malchair.*

Prov: Ian Fleming-Williams; Sotheby's, 21 November 1984, part of lot 5
Lent by the Warden and Fellows of Green College

65
North Gate from St Giles

pencil, brush in grey wash and watercolours, 315 × 270
Prov.: Ian Fleming-Williams; Sotheby's, 21 November 1984, part of lot 5
Lent by the Warden and Fellows of Green College
Lit.: Minn, 1957

¶ The mediaeval North Gate straddled the Cornmarket just north of St Michael's Church. By the eighteenth century, it had been extended to accommodate the prison, or Bocardo, above. The gate was seen as one of the principal obstacles to traffic in Oxford and was by far the most important monument to be destroyed as a result of the Mileways Act, passed in March, 1771.

Malchair's two drawings were made specifically for the aquatints he published in January 1789, and based on drawings made before the gate was destroyed in August 1771 (*Jackson's Oxford Journal*, 17 August 1771), although it is remotely possible that they may

have been made from memory. They include suitable figures, such as a waggon being loaded with provisions outside the Anchor Inn, and a broom and other domestic paraphernalia opposite. They are also among the most carefully finished drawings Malchair made, to ensure the success of their translation into aquatint. From correspondence between Malchair and his old pupil, Dr Wynne, published by Minn, we can follow the genesis of the aquatints made after these drawings by Mrs Howorth. Malchair himself had the idea of publishing the drawings,[1] the subscriptions being taken by the fashionable London book seller, Thomas Payne. He probably met the engraver, Mrs Howorth, at the Three Choirs Festival, for her father was Dr Lane, Canon of Hereford Cathedral. She was the wife of a naval captain on half pay, living in Shappel Row, Pimlico, who had fallen on hard times, and now did for money what she had previously done for pleasure.[2] Dr Wynne evidently canvassed for subscribers on Malchair's behalf, and there was some doubt over the number of impressions that could be taken from the plates, Mrs Howorth arguing for only 100, while the printer Jackson maintaining that 500 were possible. He was asked to judge whether the aquatint had progressed far enough to print.

Among the subscribers from Oxford, Malchair listed his old friends, Lord and Lady Clive, Peter Carew, Dr Wynne, the Revd John Gooch, and the Revd Peter Rashleigh, together with several who are not otherwise known to have been associated with him, Lords Bessborough, Gage, Duncannon and Sheffield, and Sir John St Aubyn, the last a neighbour of Rashleigh's in Cornwall.

1. Minn (p. 98) mistakenly believed that Jenner was Malchair's brother-in-law and respponsible for the publication of these and other prints.
2. Two of her etchings are in the British Museum, Bull Albums, II, nos. 86-7.

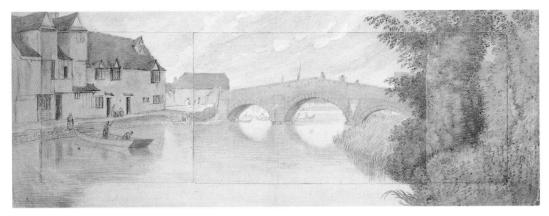

66

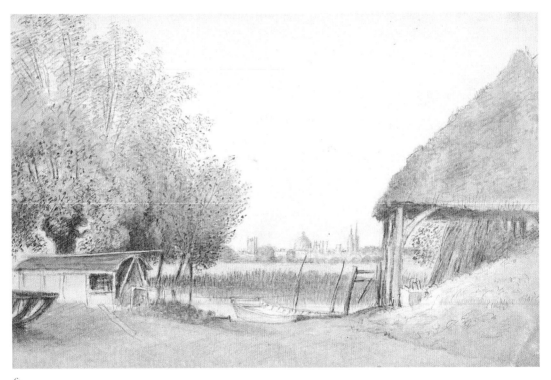

67

66
A View of Hythe Bridge, Oxford
watercolours over pencil, drawn on three
sheets pasted onto a larger, leaving a narrow
border around the margin, 274 × 763
inscribed in ink on *verso*: *A View of the Heigh
Bridge at Oxford. taken by the River Side opposite the*
*dwelling houses at the North ende of Fisher-Rowe June
9. 1789. /4 / The Milk-Man on the Bridge did more
particularly engage the attention of my St. Thomas
Parish Spectators. The Center part of this Drawing
was done on the Spot with my Scholar M^r. Austin
Fellow of S^t John's College, Oxon. / The Sides were
added to compleate the Scene, which is imperfect*

without those Accompaniements, Artists too often draw at improper times and comme away with only the portion of a whole. So that theire / works have the apearance of injury by amputation.

Acquired between 1928 and 1943 [O.A. 294]

Lit.: Brown, no. 962

¶ The pupil mentioned in the inscription is James Austen, eldest brother to Jane, a Fellow of St John's who studied with Malchair in 1789-90. There is a smaller version of this drawing in the Ashmolean (Brown, no. 1287), which Brown believes to be a preparatory study, but which was surely a copy by the artist to fit the bridge into a composition of a more conventional shape, without the large mass of foliage on the right. The details, of the figures on the bridge and on the wharf, are simplified but similar.

The view shows the Fisher Row community of houses on the riverside, with Hythe Bridge, the main route out of the city to the west.

67
Ferry Hinksey, near Oxford

watercolours over pencil, 219 × 339

inscribed in pen and ink over pencil on *verso*, *At Ferry, Hingsey near Oxford. June 15 – 1789 – /7 / This was the most favourit Villa of M[rs] Malchair when livinge: here my miende is fullest of her, / here I love to roam.*

Purchased (Magdalen College Fund), 1925 [1925.50]

Lit.: Brown, no. 963

¶ The scene has hardly changed since the last time Malchair drew it, on 13 June 1775, less than two years after his wife's death:[1] the line of willows is similar, as is the vista over the

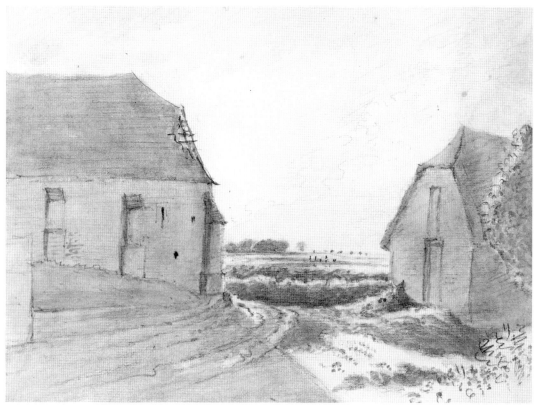

68

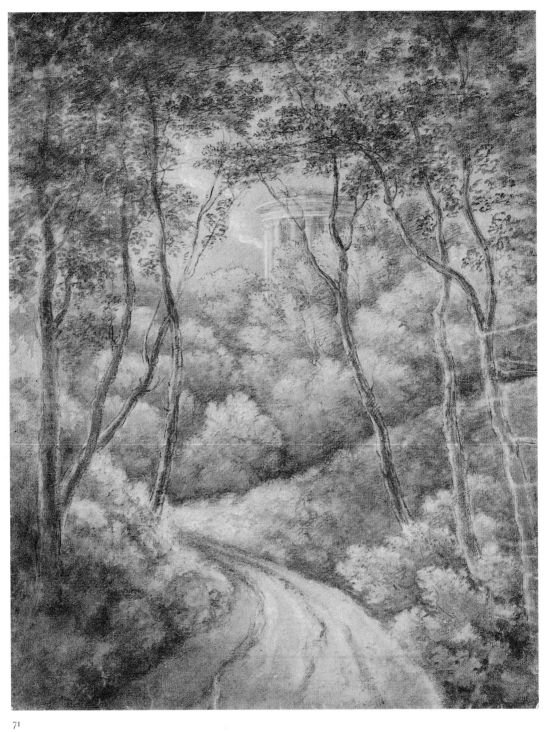

71

meadows to Oxford, and the ferry at the river bank is in almost exactly the same inviting position.

1. CCC, IV. fol. 43.

68

Holywell, Oxford

pencil and watercolours, 206 × 268

inscribed on *verso*, *Hollywell Oxon – June 22 – 1789 – /7*

Prov.: Squire Gallery, February 1930, sold for £4-10-0 to L.G. Duke (no. D 694); Messrs Colnaghi; Iolo Williams

Lit.: Williams, p. 92

Lent by Mr & Mrs E.A. Williams

¶ The large cruck barn opposite Holywell Church was built by Merton College in the thirteenth century. It is seen on the left, with the smaller barn on the right; both are included in Edward Shrivenham's map of Holywell Manor of 1758. Malchair's drawing may have been made after a visit to the Cock Pit, and the subject is really a pretext to study the sunset on a warm, summer evening.

Malchair had made a dramatic view of the interior of the large barn in 1777 (CCC, VIII, fol. 2).

1. Merton College Archives.

69

Montgomery Castle

pencil and grey wash, 382 × 567

inscribed on *verso*, *27 September 1789*

numbered by Crotch in red chalk on *verso*, *3*

Prov.: Iolo Williams

Lent from a private collection

¶ The third, last and only surviving drawing of Malchair's modest journey into Wales in September 1789, this shows the ruined mediaeval castle as a single, strange element in the phantasmagoric landscape. Already, Malchair's style was becoming looser, but still

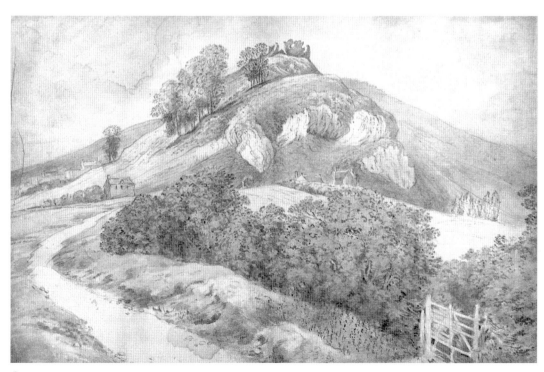

69

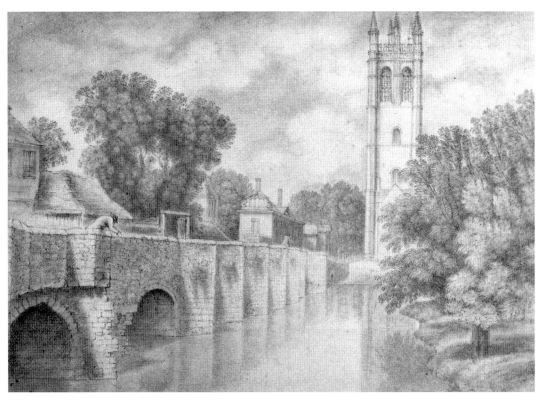

70

involved painstaking work in pencil and minute brushstrokes for foliage, and it was not until 1795 that he succeeded in transcending the technique he had taught himself to depict the quiet calm of Oxfordshire.

70

Magdalen Bridge and Tower

pencil, 288 × 403
Purchased (Magdalen College Fund), 1925 [1925.64]
Lit.: Brown, no. 980

¶ Old Magdalen bridge over the River Cherwell, beyond the old city wall at the eastern end of the High Street, was some 600 feet long and consisted of twenty arches. It was the main entrance to the city from London, and, being inadequate for the large volume of traffic, a prime candidate for demolition.[1] After the passing of the Mileways Act, Malchair made an initial study of the bridge from the north on 26 November 1771 (CCC, I, fol. 40), but, in the following summer, as the demolition was being prepared, he undertook a serious campaign to record the appearance of the old bridge from all angles; among other monuments threatened by demolition, only Friar Bacon's study was treated to such a prolonged examination. On 2 June 1772, he drew it from the south-east; two days later, he made two drawings of the bridge, one, a detail of the last two arches on the east side, and the other from St Clement's looking west; on 10 June, he sketched the roadway from St Clement's; and finally, on 18 June, he made a bird's eye view from Magdalen tower (CCC, III, ff. 27, 30-1, 36-7). He developed the view from St Clement's in a pair of larger drawings,

the first, cat. no. 70, probably made late in 1772 and copied from the sketch dated 4 June 1772; and the last, a more finished drawing,[2] with additional figures on the bridge, another on the bank of the Cherwell, cows grazing under the trees in the meadow, and picturesque ivy over the arches, dated 6 August 1788, in preparation for Mrs Howorth's aquatint, which was announced in *Jackson's Oxford Journal* on 13 February 1790:

> *Mr Malchair announces that an aquatint done by Mrs Howarth of Magdalen Bridge, from a drawing he made before the old bridge was taken down, is available from the bookseller Daniel Prince.*

This was the fourth of Malchair's drawings to be reproduced by Mrs Howorth, and Prince exclaimed to the antiquary, Richard Gough, in a letter of 14 February 1790 that her 'most delicate acquatint' was 'more like a drawing than anything I have yet seen'.[3]

1. T.W.M. Jaine, 'The Building of Magdalen Bridge', *Oxoniensia*, XXVI (1971), pp. 9-71.
2. formerly in the collection of A.P. Oppé; sold, Sotheby's, 30 March 1983, lot 30.
3. John Nichols, *Literary Anecdotes*, VIII (London, 1808), p. 48.

71 (illustrated page 116)
Landscape with a Path through a Forest and classical Temple
pencil and white chalk on blue paper, 413 × 323
Prov.: E.H. Coles (d. 1954); bequeathed to

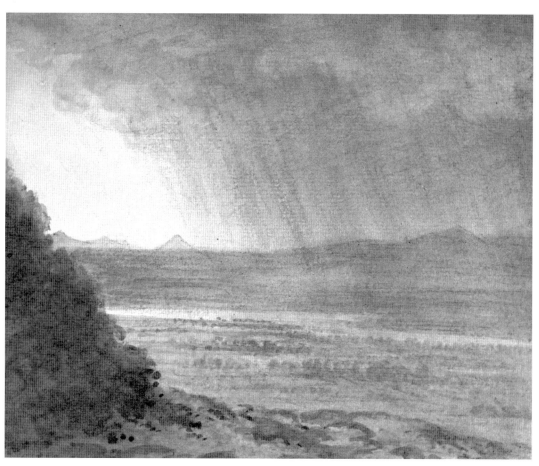

72

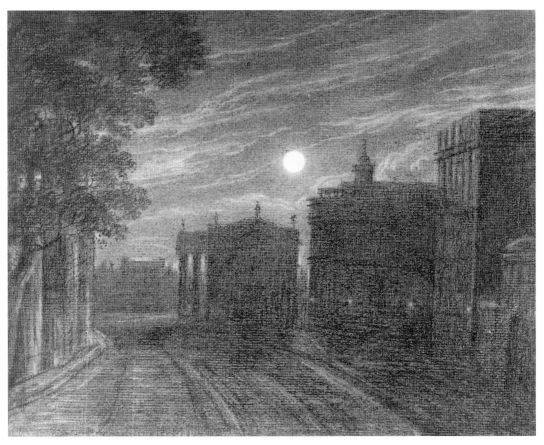

73

A.P. Oppé (no. 2594) and by descent;
Sotheby's, 30 March 1983, part of lot 31; Ian
Fleming-Williams
Presented by Ian Fleming Williams, 1996
[1996.489]
¶ Malchair had little time for imaginary
landscapes, and few survive. In his *Observations
on Landskipp Drawing*, he included four small
imaginary compositions in black and white
chalks on blue paper, and there are a further 8
attributed to him in the Ashmolean (Brown,
nos. 1182-9). All these drawings are unsigned,
and their attribution to Malchair rather than
his pupils remains a matter of conjecture.

72

**A Distant View of the Severn from an ...
Near Lord Deuces in Glost**

pencil and watercolours, 198 × 165
Purchased (Magdalen College Fund), 1925
[1925.62]
Lit.: Brown, no. 978
¶ The seat of Francis, third Baron Ducie
(1739-1808), was at Tortworth, in
Gloucestershire, where Malchair's friend, the
Revd George Cooke, was presented as rector
by his college, Oriel, in 1799. This drawing of
a storm approaching over the Severn from the
west was clearly made on the spot: the initial
pencil work is rapid and scribbly, and the
watercolours swift and assured.

73

Broad Street, Oxford

soft black chalk and scratching out, 220 × 280

Prov.: Ian Fleming-Williams

Lent by R.E. Alton, M.C.

¶ Malchair lodged at 12, Broad Street from at least 1772, and this view was therefore the most familiar of all that he drew. He made at least three drawings of it by moonlight: a large version at 6 p.m. on New Year's Day, 1790, another rather similar, and a smaller version.[1] The present drawing may have been made a few years earlier, and is unusual in its highly wrought technique, with no wash and extensive scratching out to mark the edges of the clouds. The paper is coarser than usual, and Malchair has made full use of its strong grain to vary the texture surface of the drawing.

1. Respectively Victoria and Albert Museum: see Lionel Lambourne and Jean Hamilton, *British Watercolours in the Victoria and Albert Museum: An Illustrated Summary Catalogue of the National Collection* (London, 1980), p. 244; Yale Center for British Art: see Louis Hawes, *Presences of Nature: British Landscape 1780-1830* (exh. cat., Yale Center for British Art, New Haven, 1982), no. VI.22; Ashmolean Museum, Brown, no. 1125.

74

The Entrance to Oxford from London, from Recollection

pencil and watercolours, 196 × 320

inscribed in pencil on *verso, From recollection the Entrance to Oxford from London / July 16 – 1790 – /9*

Purchased (Magdalen College Fund), 1925 [1925.22]

Lit.: Brown, no. 919

¶ The colour in this drawing, whose correct date has recently been revealed, is emotive rather than descriptive, in common with many of Malchair's late drawings made from memory.

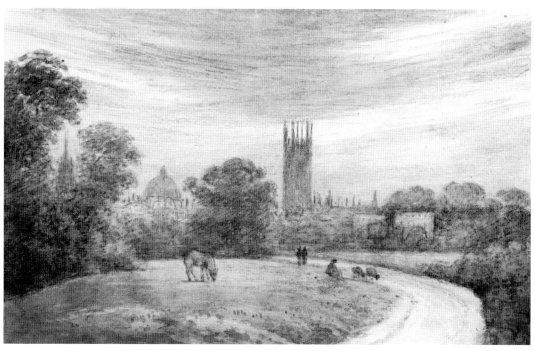

74

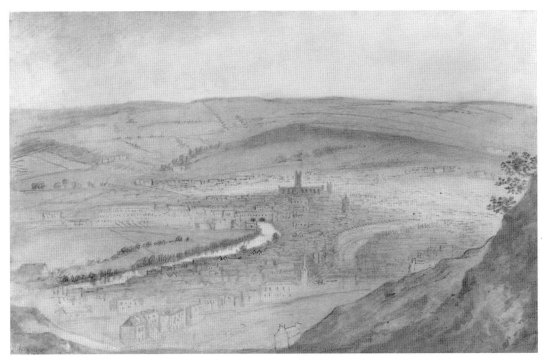

75

75
Bath from Lansdowne
pencil and brush in ink and watercolours,
281 × 448 (sight)
inscribed on *verso, Bath Sept 23 Oct 1 1790 – 4
taken from Gay's Place on Lands Down*
Prov.: L.G. Duke (no. D 190); Messrs
Colnaghi; Ian Fleming-Williams
Lit.: Williams, p. 92
Lent from a private collection
¶ Not since his early days at Bristol had
Malchair been offered panoramic views of this
kind, and he took full advantage of the
opportunity. The mist in the valley, created by
rubbing breadcrumbs over the drawing; the
silver streak of water in the centre, and the
delicate grey-green colouring are all rendered
with great sensitivity. Such a high viewpoint
was condemned by artists faithful to the
Picturesque, who generally included a varied
foreground and more theatrical perspective.

76
A Country Lane with Cottages amid Trees
pencil and black and white chalks and grey
wash on straw-coloured paper, 141 × 177
Purchased, 1925 [1925.73]
Lit.: Brown, no. 989
¶ The scene, although probably imaginary, is
a late experiment in drawing while looking
directly into the sun.

77
A Ruin partly overgrown with Trees
brush in brown wash, 181 × 228
Purchased (Magdalen College Fund), 1925
[1925.74]
Lit.: Brown, no. 990
¶ Brown notes that the style is reminiscent of
Alexander Cozens's, and suggests that it may
be by a pupil of Malchair's. However, there
are comparable drawings in the *Observations on
Landskipp Drawing*, in which Malchair has

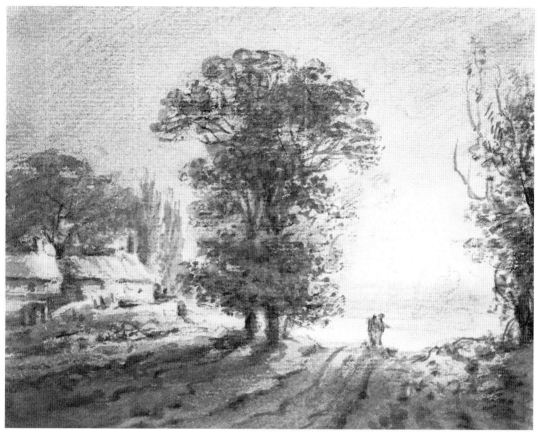

76

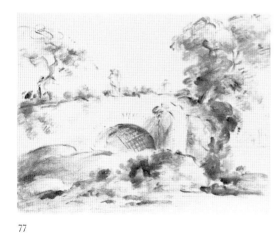

77

experimented with unusual media and styles. This example may be compared with one in the *Observations* in what Malchair called 'smutch of candle' (fol. 85), more conventionally known as 'lampblack', applied with a stiff brush. The scene is imaginary, and the drawing a technical exercise rather than an example for a pupil.

78

Oxford from Shotover Hill, from Recollection

watercolours over pencil, 196 × 317
inscribed in pen and ink over pencil on *verso*, *Jan. 10 – 1791 – from recollection, the apearance of Oxford from Shotover Hill in flode time* / and in pencil only, *time when the water was out.*

78

Purchased (Magdalen College Fund), 1925
[1925.51]
Lit.: Oppé, pl. IIc; Williams, p. 92; Brown, no. 964

¶ The view from Shotover Hill became one of the most hackneyed of all during the nineteenth century, and local artists and visitors included it amongst their portfolios. It was evidently a favourite with Malchair's friends, for he began at least two versions for Crotch and his wife, both completed by Crotch himself.[1] This version shows Malchair at ease in his handling of watercolours: the colours are still muted, but even the foreground is drawn in with the brush.

1. Ashmolean Museum, 1996.498; Norwich Castle Museum

79
View from Merton College

watercolours over pencil, 202 × 325
inscribed on *verso*, *Feb. 28 – 1791 – / 5 From the*

Roomes of Mr. Nares at Merton Coll. Oxon.
Purchased, 1928 [1928.112]
Lit.: Kenneth J. Garlick, *Eighteenth Century Master Drawings from the Ashmolean* (exh. cat., Baltimore Museum of Art; Minneapolis Institute of Art; Kimbell Art Museum, Fort Worth; Cincinatti Art Museum, 1979-80), no. 45; Brown, no. 965

¶ Garlick identifies Mr Nares as Edward Nares (1762-1841), who was a Fellow of Merton between 1788 and 1791, before becoming Librarian to the Duke of Marlborough at Blenheim. He returned to Oxford as Bampton lecturer in 1805, and was elected Regius Professor of Modern History in 1813, a post he held until his death.

Nares studied with Malchair from at least 1 May 1789, when his master made another drawing from his rooms, showing the spire of Christ Church cathedral through the trees of Merton Grove (Brown, no. 1273). The disparity in date would suggest not that Nares remained

79

at the same stage in his lessons for two years, but that the later drawing was made on the spur of the moment to capture the particular effect made by the setting sun at five o'clock on a winter's afternoon. The result is one of Malchair's most poetic and evocative works. The range of colours is very restricted, grey-green, blue and a delicate pink, with the trees drawn in pencil and redefined in grey wash on top of the long horizontal strokes of watercolour in the sky and ground. The only sign of human life is the house which apppears between the trees on the right.

80

The Old Welsh Bridge, Shrewsbury
pencil and grey wash
dated on *verso, 21 October 1791*
Prov.: Ian Fleming-Williams
Lent from a private collection
¶ In his commentary on the reduced copy of this drawing at Cardiff, Malchair called the

bridge 'a beautyfull ragged bbitt probably existing no more, for in 1795 an ugly new bridge was considerably advanced close by the Venerable old one.' Of the two mediaeval bridges at Shrewsbury, the 'English Bridge' was pulled down and replaced by John Gwynn in 1768-74, and the Welsh Bridge was indeed put up between 1793 and 1795, to the designs of John Carline and John Tilley.

81

Christ Church Meadow
pencil and grey wash
inscribed in ink over pencil on *verso, May 26 – 1792 – 10/ Christ Church Meaddow Oxon*
Fol. 20 of a sketchbook of 45 ff. of drawings, measuring 290 × 186
Lent by the President and Fellows of Corpus Christi College [MS CCC 443 (IV)]
¶ The second part of Malchair's last sketchbook, used between 6 December 1790 and 24 July 1793, is in many ways a

80

recapitulation of all that has gone before, while the first part, begun at the opposite end, was used fitfully for landscapes around Oxford and in Berkshire between 22 May 1775 and 25 November 1778 (ff. 38-45). In addition to topographical drawings of varying degrees of finish and of scenes that Malchair had drawn many times before, among them studies of Queen's Lane (fol. 2), Little Gate (fol. 3), the Observatory (ff. 9, 14), Balliol Grove (fol. 25), there are three lessons with new pupils, all in Christ Church Meadows.

82 (illustrated page 2)
Malchair's Study
brush in grey ink over pencil, 480 × 295
inscribed in pencil on *verso*, *July 9 – 1794. / Melchiors Study*, and in ink, *by himself Oxford July 1794. /7*
Prov.: presumably given by the artist to his pupil, the fourth Earl of Aylesford; by descent at Packington

Lit.: Ian Fleming-Williams, 1971, fig. 5
Lent by the Rt Hon. the Earl of Aylesford
¶ The portrait of the artist's studio had been a conventional theme in European painting since the fifteenth century, sanctioned by the classical story of Apelles and the sacred legend of Saint Luke. Malchair had no studio, and drew the study of his house in Broad Street instead, perhaps as a souvenir for Lord Aylesford. He included no portrait of himself, but the disparate objects accumulated over a long life: prints, albums, portfolios, plaster casts of classical sculptures, musical instruments, as well as domestic articles such as a bowl and a pair of slippers, a coal scuttle and a bowl on the floor. Through the window are the rooftops of Ship Street he had drawn twelve years earlier (cat. no. 35), lit by the evening sun, which is also reflected in the glass of the bookcase beside the window and the coal scuttle. While such a composition would have appealed to Dutch artists of the seventeenth

81

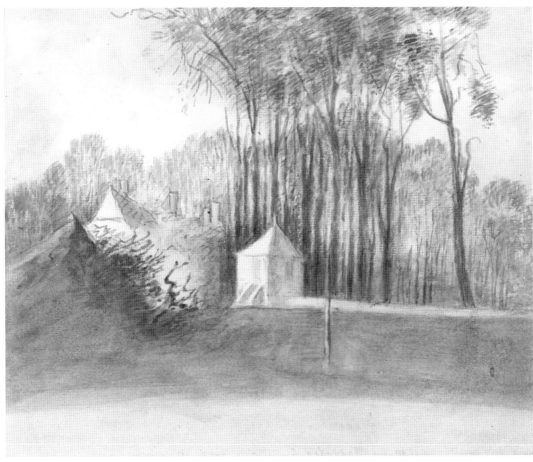

83

century, it has no parallels in contemporary English art, and seems to look forward to the Romantic studies of the next generation.

83
Fire in Magdalen Grove
pencil, brush in black ink, and watercolours, 246 × 290
inscribed in ink on *verso*, *The South side of St Mary Magdalen Grove Oxon. Feb. 17. 1795*
Prov.: Ian Fleming-Williams
Lent by R.E. Alton, M.C.
¶ This is Malchair's last drawing of a fire, a gentle winter bonfire rather than the huge conflagrations of earlier years.

84
Nant Rhyddod near Dinas Mawddwy
pencil and grey wash, 438 × 297
inscribed on *verso*, *Nant Rhyddod near Dynas Mouthwy in Marionet Shire / July 28 – 1795 – / 1*
numbered in red chalk by Crotch on *verso*, *27*
Prov.: Iolo Williams
Lent from a private collection
¶ The mill at Nant Rhyddod was some four miles from Dinas Mawddwy. In his list of the drawings made on his Welsh tour of 1795 (see Appendix), Malchair noted simply that 'this place is wild and worthy of the painters attention.'

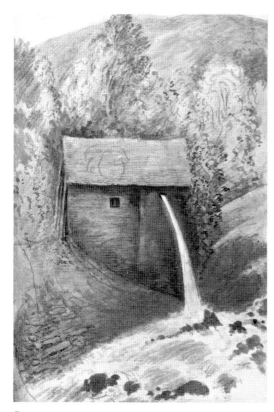

84

waterfalls. His commentary on the reduced copy of this drawing in the album at Cardiff reads:

> *A shoot of Water in Dinas M. These lesser falls are often more broken and picturesque than the greater, which for the most rush down resistless in a broad and uniform white sheet. The traveler is generaly directed to the waterfalls by the natives, who seems to rate them above all other wounders of theire country.*

1. Thomas Pennant, *The Journey to Snowdon* (London, 1786), p. 81.

85
Dinas Mawddwy
pencil and grey wash, 460 × 281
inscribed in brush in grey ink over pencil on *verso*, *Dynas Mouthwy July 30 – 1795 – /8*; and in pencil, *The water crossing the street and tumbling down the precipice*
numbered in red chalk by Crotch on *verso*, *33*
Prov.: Iolo Williams
Lent by Mr & Mrs E.A. Williams
¶ Dinas Mawddwy was Malchair's favourite place in North Wales, but, as an earlier visitor, Thomas Pennant, commented, 'This *Mowddwy*, notwithstanding it is dignified with the name of *Dinas*, or city, consists of but one street, strait and broad, with houses ill according with its title.'[1] The main street included three inns, each drawn by Malchair, and several

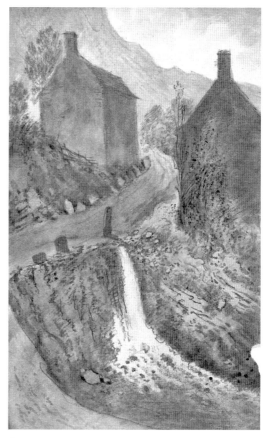

85

86

Craig y Dynas from the Stable Yard of the Goat Inn, Dinas Mawddwy

pencil and grey wash, 464 × 290
inscribed on *verso Dynas Mouthwy Aug. 1 – 1795 – 8-/ Crag y Dynas from the Stable yeard of the Goat.*
numbered in red chalk by Crotch on *verso, 37*
Prov.: A.P. Oppé (no. 2261) and by descent; Sotheby's, 30 March 1983, part of lot 31; Ian Fleming-Williams
Lent from a private collection

¶ The rocky peak of Craig y Dynas towers above Dinas Mawddwy, but Malchair's drawing concentrates on the stable yard, complete with picturesque privy, at its foot.

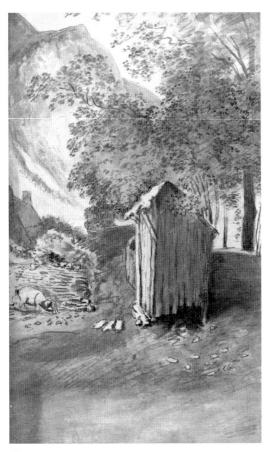

86

87

Moel y ffrydd

pencil and Indian ink, 415 × 552
inscribed in grey wash over pencil on *verso, Moel y Ffrydd – Near Llanummowddy in Merioneth Shire met with M^r Richards* and in pencil, *the clergyman of the place*
inscribed by Dr Crotch in red chalk, *Wales*
Prov.: Messrs Appleby, February 1942, 10 shillings; L.G. Duke (no. D 1035); sold to Paul Mellon, January 1961; exchanged with Ian Fleming-Williams for a self portrait drawing by Stubbs, 1962;[1] presented by Ian Fleming-Williams, 1995, to mark the Centenary of the Tate Gallery, 1997
Lit.: Oppé, p. 194, pl. IIID; Williams, p. 93, pl. 156; Fleming-Williams, 1994-5, no. XIV; Anne Lyles and Robin Hamlyn, *British Watercolours from the Oppé Collection, with a Selection of Drawings and Oil Sketches* (exh. cat., London, Tate Gallery, 1997), under no. 24
Lent by the Trustees of the Tate Gallery
(T 07011)

> *A very wild Mountainous Sceene at Llany-Mowddwy, four miles norwest of Dinas M. and in the road to Aran the chief Mountain of this distric. It is not difficult here to account for the Sublimity, the objects are vast and verry uncommon to Eyes that are only wont to comtemplate the beauties of a rich farming country.*

¶ This was not a conventional subject for the tourist in Wales, but it inspired Malchair to one of his most extraordinary drawings. Despite having been trimmed, especially on the upper edge, where the peak on the left is now too close to the edge of the paper, it conveys better than almost any other drawing the intensity of Malchair's feelings in this sublime landscape, and the majestic power of the mountain that seems to stride across the composition, with two diminutive figures sheltering in an overhanging flap.

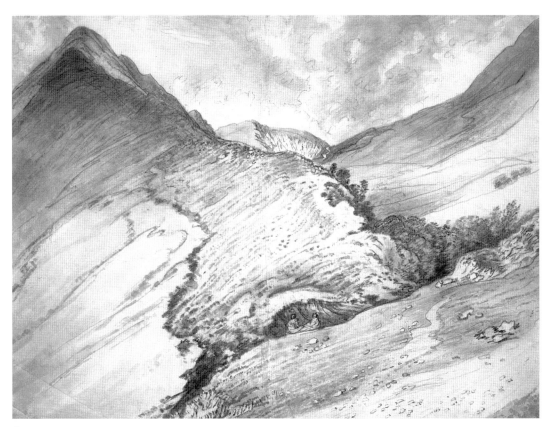

87

88
Bwlch y Groes
pencil and brush in black ink, 372×570
numbered by Crotch in red chalk on *verso*, *45*
Prov.: Messrs Appleby, Feb. 1942, 10 shillings;
L.G. Duke (?no. D1044); Messrs Colnaghi; Ian
Fleming-Williams
Lent by R.E. Alton, M.C.
¶ Like many of the drawings on this last tour
of Wales, this has been savagely cut down,
removing Malchair's inscription. Bwlch y
Groes, the pass of The Cross, lies north-east of
Dinas Mawddwy, near the source of the
Dovey. On the right looms 'a stupenduous
wall of rock about a mile furter on the road to
the Aran. In this sceene the dreary and the
comfortable are happely blended, Mr Pennant

calls Bulch y Gross one of the most terrible
passes in north Wales.'[1]

1. Malchair's commentary on the reduced version in
Cardiff. The reference is to Pennant, *op. cit.*, p. 78

89
Cader Idris
pencil and grey wash, 288×459
inscribed in grey wash over pencil on *verso*,
Thursday August 6 – 1795 –
numbered by William Crotch in red chalk on
verso, *48*
Prov.: Iolo Williams
Lent by Mr & Mrs E.A. Williams
¶ Cader Idris, the seat of Idris, was with
Snowdon one of the principal sights of North

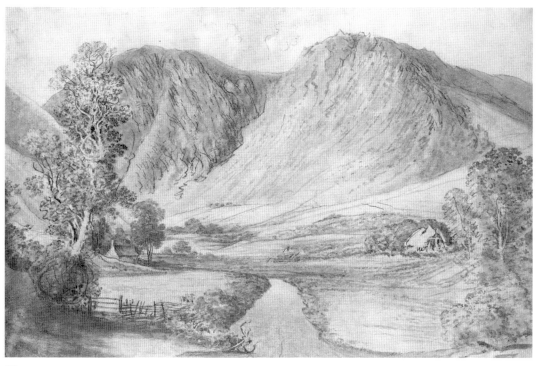

88

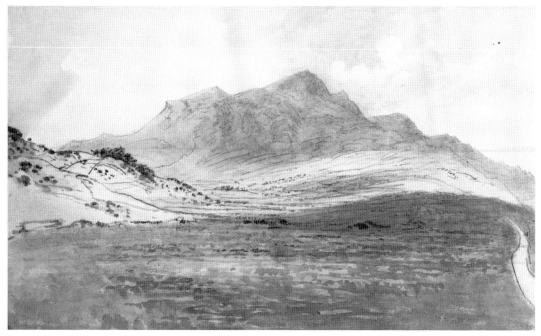

89

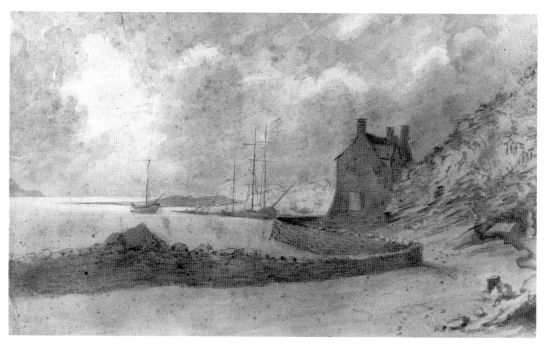

90

Wales, and, characteristically, one that Malchair only drew once. It appears at the end of the pass between Dinas Mawddwy and Dolgellau.

90
Barmouth
pencil and grey wash, 308 × 512 (sight)
inscribed on *verso, 7 August 1795 At turning the corner of the road from Dolgelly*
numbered by William Crotch in red chalk on *verso,* 49
Prov.: Ian Fleming-Williams
Lent from a private collection
¶ Barmouth, at the mouth of the Mawddach, clings to the sand dunes at the foot of the mountains, 'and the houses [are] placed on the steep sides, one above another, in such a manner as to give the opportunity of seeing down the chimneys of their nextsubjacent neighbours.'[1] Malchair spent three days there, and made seven drawings, most of distant views of the wide bay, but two of the town itself (Crotch, nos. 52-3).

In his manuscript diary, Malchair recorded that this drawing was made while turning the corner from Dolgellau to Barmouth, when the travellers had a 'sudden surprise [for] the skey hapend to tourne favourable ... thye clouds opening, a Sun beeme glanced on the waters which gave surprising effect to that simple landskip' (see Appendix); while he noted of the miniature copy that 'the drawing is totaly beholden for its effect to the brewing of a thunderstorm.'

Fleming-Williams wrote of the drawing,

In none did he capture a passing effect more successfully than in his drawing of Barmouth Harbour; a drawing that records with remarkable economy and detachment, yet with intense feeling, the drama of a last gleam of sunlight that momentarily appeared before a coming storm. Such telling simplicity is seldom found except in the work of the aged for whom there is meaning in little else. (Fleming-Williams, MS, V)

1. Pennant, *op. cit.,* p. 104.

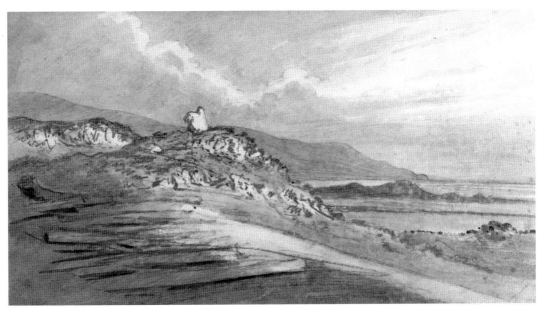

91

91
Barmouth
pencil and grey wash, 229 × 406
inscribed in grey wash on *verso, Aug-8-1795- /7 Barmouth*
numbered in red chalk by Dr Crotch, *54*
Prov.: Iolo Williams
Lent from a private collection
¶ Here, Malchair and his companions heard 'a Sect called the jumpers at theire abominable and rediculous devotion', but the drawing is a study in light and shade built on the most flimsy pretext, a rock of curious shape rising out of the sand.

92
Harlech Castle
pencil and grey wash, 335 × 438
inscribed in grey wash on *verso, Aug-11-1795- /2 Harlech Castle*
further inscribed in red chalk by Dr Crotch, *from the SE* and numbered, *57*
Prov.: Iolo Williams
Lent from a private collection

¶ Malchair commented of this reduced copy that

this must have bin the most impregnable place in the days of Archery; the Rock is exceedingly sharp and steep. It is an Istmus which stretches from inland toward the Sea than descends from the Castle precipituous to the Marsh for the Element has long since retired from hence. This promontory is Seen from a greate distance for three parts of the compass. If the immagination bee allowed to convieve this rocks to bee the bones of the earth, all here is nothing but bone, the patches of mossy turf between are often so small and swampy as to make the footting intollerable. Thes sharp and upright points of rock readdely sugest the Idea of Vegitation or Crystallic ramification, and the Castle seens rather to have grown upp than built.

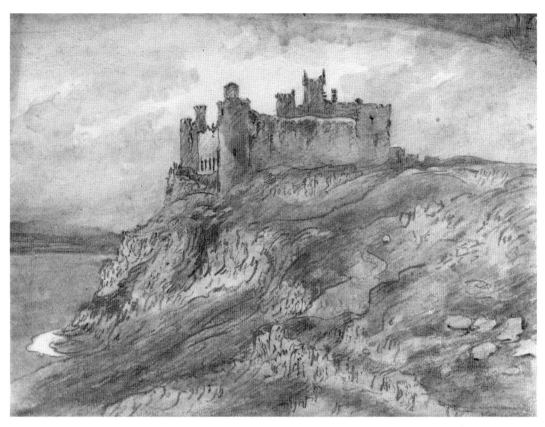

92

93

Midway between Pont Aberglaslyn and Beddgelert

pencil and wash, 368 × 502 (sight)
inscribed in grey wash on *verso*, *August 15 – 1795 – /7 midway in the road from Pont Aber Glaslyn to Beth Callerd*
Prov.: Iolo Williams
Lit.: Williams, pp. 92-3
Lent from a private collection

> *A Glims of the immediate attendants on the mighty snowdon, the waters come from the lakes of Finnon LLass, one of the flanks of Snodon. This scene is in the same pass.*

A 'solemn evening light' spreads over the valley.

94

Glin Dyffyrth Bridge between Corwen and Kenniogge in Denbyshire

pencil and grey wash, 541 × 393
inscribed in grey wash on *verso*: *[G]lin Bridge between Corwen & Kenniogge in Denbyshire Buld in 1793. This Glin is verry Deepe & wide – and the Bridge is Stupendious, tho' not the work of the Devil. August 21 – 1795 – -3/*
numbered in red chalk by Dr Crotch, *70*
Prov.: Messrs Spencer, 25 February 1943, 30 shillings, with 4 other drawings to A.P. Oppé (no. 2260); Sotheby's, 30 March 1983, part of lot 31; Ian Fleming-Williams
Lent from a private collection

> *Glyn Bridge near Corwen in Denbyshaire. on can hardly hesitate to attribute this Gape to the effect*

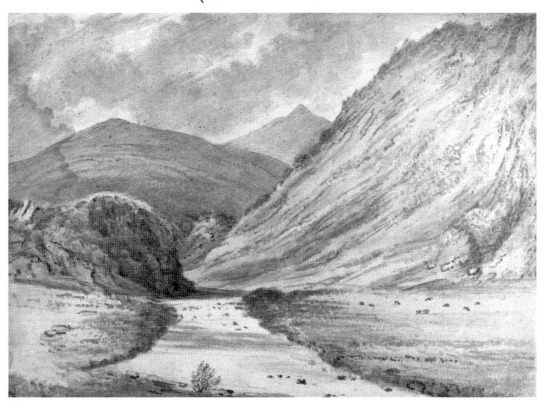

93

of an Earthquack. this bridge is a noble specimen
of Welsh architecture, it was finished in 1793 so
that it wil be a long while before the devil can
claime the merit of the work. It rained hard at the
time of drawing this but who can forbare seezing
thes stupenduous Works of Arte and Nature at all
events?

¶ In the upper part of the composition, the
edge of the hill echoes the shape of the bridge,
the sky is now reduced from trimming.
Beneath, the combination of bold, squiggly
lines of chalk and large brushstrokes of dark
wash create an almost overwhelming
impression of downward movement in the
rushing torrent and the sides of the gorge,
which a small tree on the right bank struggles
to withstand.

95
The Observatory, from Recollection
dark grey ink and wash, 197 × 277
inscribed in pencil on *verso*, *The principal entrance*
into the Garden of the Observatory Oxon. Further
inscribed in ink, *The Observatory at Oxford – As it*
appears from the principal Gate into / the grounds.
July 3 – 1797 – / 8. from recollection.
Purchased, 1925 [1925.21]
Lit.: Brown, no. 918
¶ As K.T. Parker and Fleming-Williams
suspected in their notes and as recent
remounting has revealed, this is a very late
drawing: only the drawing inscribed 'Mr
Malchair's last effort 1799' (Brown, no. 1076)
bears a later date. Malchair was by this time
nearly blind, and it is impossible not to see this
drawing, which repeats the composition of
many of its predecessors, as an elegiac

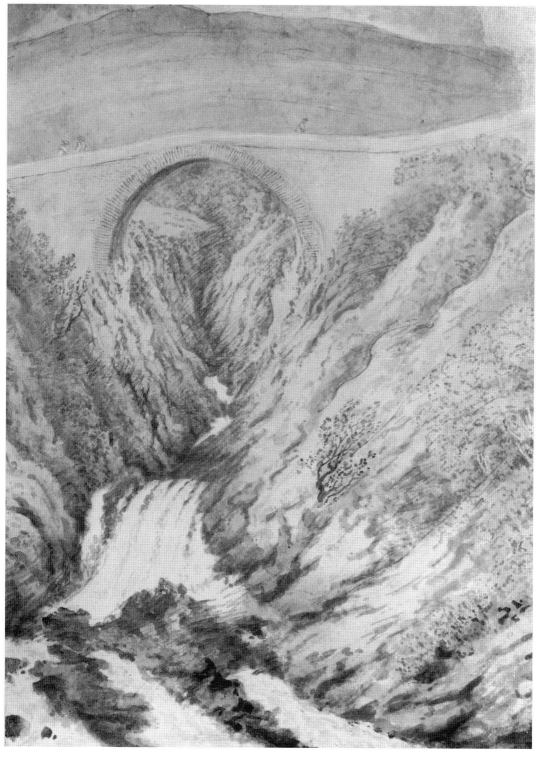

94

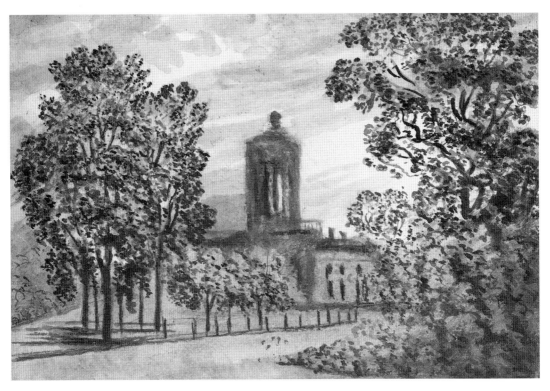

95

meditation on his friendship with the Hornsby family, on his artistic relationship with the observatory itself, and on his failing powers of observation, recollection, and evocation.

96
Observations on Landskipp Drawing
album of 117 pp., bound in vellum, 158 × 202
inscribed in ink on upper board: *Observations / On Landskipp Drawing. / with many and various / Examples / Intended for the use of beginners. By J. B. Malchair / Oxford / 1791.*
Fol. 1 inscribed *Rules and Examples for the drawing / of Landskipp according to the practice / at Oxford* [in ink], *where little time can / be spared for secondary attainemen / -ts.* [in pencil]
Prov.: Hardcastle; Revd Joseph Jefferson; given to Mrs S.C.J. Wood, 18 April 1868; Kenneth A. Jameson, Birkenhead, 1948, and London, 1957; Sotheby's, 19 December 1960, no. 256; Ian Fleming-Williams

Lit.: Leslie Parris, *Landscape in Britain, c.1750-1850* (exh. cat., Tate Gallery, London, 1973), no. 88; Peter Bicknell and Jane Munro, *Gilpin to Ruskin: Drawing Masters and their Manuals, 1800-1860* (exh. cat., Fitzwilliam Museum, Cambridge and Dove Cottage and Wordsworth Museum, Grasmere, 1987-8), pp. 24 5, no. 10
Presented by Ian Fleming-Williams, 1996 [1996.497]
¶ For discussion, see pp. 19-20.

97
Jane Mary Oglander (fl. 1779-1820)
A View taken from a Window of the Warden's Lodgings in New College Oxon.
watercolours over pencil, 299 × 455
Presented by Ian Fleming-Williams, 1996 [1996.499]
¶ From the indications in the *Observations*, it

would appear that this represents a fairly advanced stage in Malchair's instruction of a pupil. The attribution to Mrs Oglander, wife of the Warden of New College, is based on the inscription on the verso of cat. no. 55. In its favour, it may be noted that the drawing is not an exact copy of Malchair's, for the shadows are longer and the sun has evidently moved an hour or two. It is also clearly the work of a pupil: the drawing is much clumsier, the whole composition lacks the assurance of the master's, and individual elements are carefully outlined. Some passages, such as the top of the wall in the foreground, and the shrubs without leaves, were probably drawn by Malchair himself. It must be admitted, however, that the lesson was a difficult one.

Jane Mary Rayne was the daughter of the vicar of Netherbury, near the Oglander family seat at Parnham, and the wife of John Oglander, who was Warden of New College between 1768 and his death in 1794.[1] This is the only record of her lessons with Malchair, although she was later a prolific artist, and, after her husband's death, taught her niece, Fanny: together, they went on sketching expeditions in Scotland, Wales and the Lake District. Her mature drawings owe more to her later teacher, John Glover, than to Malchair.[2]

1. Cecil Aspinall-Oglander, *Nunwell Symphony* (London, 1945), p. 170.
2. Apart from that of style, the only evidence that she studied with Glover is an inscription on a drawing sold at Sotheby's, 16 July 1998, lot 60.

98
Heneage Finch, fourth Earl of Aylesford (1751-1812)
Landscape with an Octagon
pen and brown ink and grey and brown wash, 208 × 277
Purchased (Hope Collection), 1943 [1943.112]
Lit.: Brown, no. 301

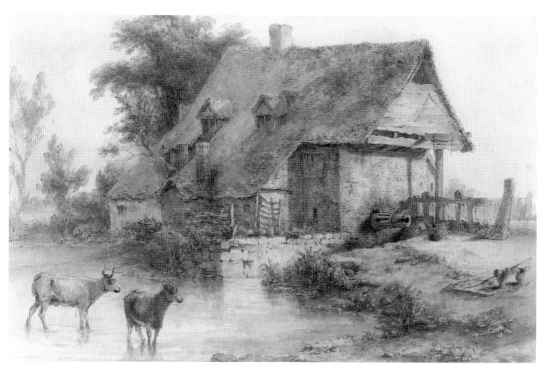

99

¶ The building is mildly reminiscent of Friar Bacon's Study on Folly Bridge, and may be imaginary. Aylesford's drawings after he left Oxford are difficult to date, but this would appear to be from *c*.1790.

99
A Water Mill with Cattle watering
pen and brown ink and wash and watercolours, 266 × 415
Prov.: Sir Bruce Ingram
Purchased, 1963 [1963.89.6]
Lit.: Brown, no. 302
¶ From an album of drawings from nature dated 1803, this was made on one of Aylesford's numerous tours. Malchair's influence and style had by this time been completely superseded by Aylesford's interest in Rembrandt.

100
Dr William Crotch (1775-1847)
Classical Landscape
pen and brown ink on coarse paper, 317 × 520
inscr. in ink, verso: *Copied by Wm Crotch Oxford March 1802. / from an etching by Rousseau / from a pen drawing of* <u>Bolognese</u> */ varied from one by An. Carache's his master*
Presented by Ian Fleming-Williams, 1996 [1996.484]
¶ In his *Observations*, Malchair recommended that the beginner should copy the landscapes of the Carracci as engraved in Jabach's collection. He may have made such copies himself – there is a group of such drawings in the Ashmolean (Brown, nos. 1194-9) – but this is one of the few documented examples by a pupil (another, by Lady Beaumont after Caylus after Carracci, is in the Ashmolean; Brown, no. 372). It is on an unusually large scale, crudely drawn, in a medium that neither Malchair nor Crotch found sympathetic, but serves its purpose of enabling the pupil to

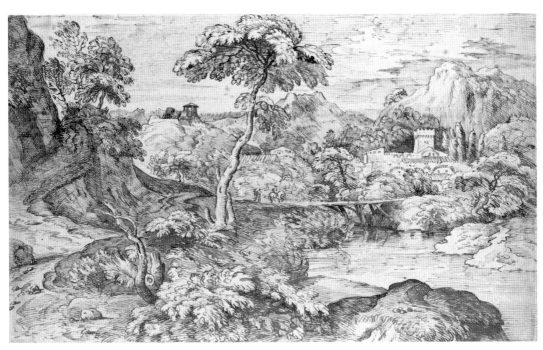

100

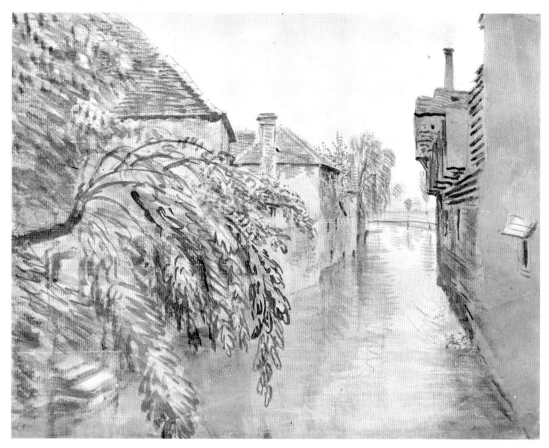

101

study the structure of the classical landscape. As if to emphasise that such practices were foreign to him, Crotch has omitted the reclining nude figure in the foreground of the original.

101

Mr Morrell's Brewhouse, Oxford
brush in grey wash and black ink over pencil on laid paper, 287 × 355
inscr in pencil on *verso*: *No 2 May 24 1803 / Mr Morrell's Brewhouse / near the Castle Oxford / Wm Crotch*; further inscribed in brush and black ink, *with EL*
Prov.: Messrs Appleby, May 1942; L.G. Duke (D. 790); sold for £12 in October 1961 to Ian Fleming-Williams

Presented by Ian Fleming-Williams, 1996 [1996.485]
¶ The narrow canals and waterways of St Aldate's and St Thomas's provided Malchair with many subjects, and Crotch no doubt accompanied his master on walks in these parishes. Oxford has always been celebrated for its brewing, the main rival firms of Morrells and Halls both established in the eighteenth century. The site of Morrells' brewery on the main road in St Thomas's had been occupied by other breweries since 1563, and, when the brothers Mark and James Morrell took it over in 1797, it was a flourishing business.[1] This view of the brewery shows the little stream running up the west side. Like Malchair,

Crotch recorded not only the date, but also the name of his companion, EL, for Edward Lock, to whom Crotch gave an album of drawings and prints in 1838 (now in the Royal Academy of Music).

1. See Brigid Allen, *Morrells of Oxford: The Family and their Brewery, 1743-1993* (Oxford, 1994), pp. 1-28.

102

Part of Kenilworth Castle
black chalk and watercolours, 294 × 422
inscribed on *verso, 215 T'other side John of Gaunt's Buildings Kenilworth Castle WC MGS Aug 10 1802 11 am The gate was lowered or it would have been too prominent a feature*
215 Wm Crotch No 5 Aug 10 1802 11 am Part of Kenilworth Castle built by John of Gaunt. Mill Heathfield Aug 28 1809 WC. MGS
Purchased, 1940 [1940.47]
Lit.: Ian Fleming-Williams, 'Dr William Crotch (1775-1847), Member of the Oxford School and Friend of Constable', *Connoisseur*, CLIX (1965), pp. 28-31
¶ Crotch would have known of Malchair's drawings of Kenilworth (see cat. no. 48), and may have visited the ruin on his suggestion. The elaborate annotation, copied and modified at a later date, is typical of Crotch's large drawings, as is the numbering. The reference to Heathfield Mill is inscribed beneath a blank outline, where a smaller drawing was glued to the *verso* of the larger; the whole sheet may have come from a large sketchbook.

103
Revd Peter Rashleigh (1746-1836)
The Thames near Medmenham Abbey
pencil, grey wash and watercolours
Fol. 6 from a sketchbook of 23 ff. of drawings, and 3 ff. blank, bound in decorated reversed calf, 214 × 279
Presented anonymously through the National Art Collections Fund, 1986 [1986.1]

Lit.: *National Art Collections Fund Review*, 1986, p. 165, no. 3203
¶ The attribution of this sketchbook was confirmed by Ian Fleming-Williams in a letter of 22 May 1963 to the owner, in which he noted that, in addition to the style, the inscription on the verso of fol. 5, dated 11 July 1774, gives as the artist's companions Bouverie, Carew and Malchair; while a drawing by Malchair of the same date gives the names of Sir Thomas Frankland and Rashleigh. Fol. 4 of Rashleigh's sketchbook, when his companions were again Malchair and Frankland, shows a similar scene to another of Malchair's, dated 26 May 1774, inscribed with the names of Rashleigh and Frankland.

Peter Rashleigh was the fourth son of Jonathan Rashleigh, M.P., of Menabilly, Cornwall. He matriculated from University College on 30 October 1765, was admitted B.A. in 1772 and M.A. in 1775, and after various livings, appointed rector of Southfleet in Essex in 1788, where he remained until his death. He was a Fellow of All Souls' at the time this sketchbook was made, but studied with Malchair as an undergraduate, and went on sketching expeditions with him between 1769 and 1774.[1] The majority of the drawings in the sketchbook, which is badly mutilated with many leaves removed, range in date from 29 March to 30 August 1774, and cover term-time at Oxford, a brief excursion down the Thames to Medmenham Abbey in Berkshire, and a summer vacation in Cornwall, where Rashleigh visited his father at Menabilly, and went on a walking tour with Reginald Pole Carew. The final leaves show a view from Mr Clayton's library at Harleyford in Buckinghamshire, where Malchair spent a few days in 1769;[2] and Christ Church meadows in 1775, with one of the temporary bridges erected during the demolition of Old Magdalen Bridge.

Rashleigh was by no means Malchair's

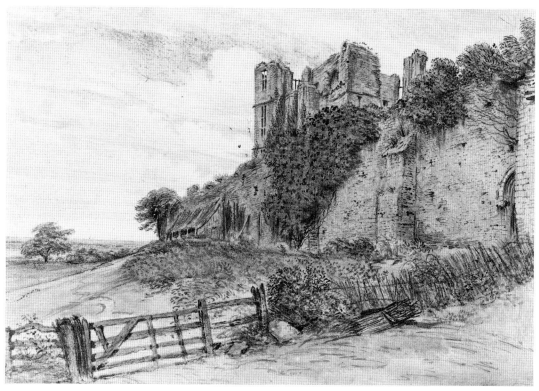

102

most talented pupil, but he has learnt some of his lessons well: the point of view is carefully chosen, and the technique, meandering outlines in grey wash over pencil, and simple washes, clearly adapted from Malchair's.

1. CCC, I, ff. 5, 21, 24, 27, 31, 41-3.
2. CCC, V, ff. 18-20; Bodleian Library, MS Top. Oxon. b. 93, no. 38.

104

Windermere from Low Wood
pencil and watercolours on white laid paper, 321 × 416
inscribed in ink along lower margin, *aug.t 1780 / Windermere / from near Low Wood*
inscribed in pencil on *verso, Lake of Winandermere Westmorland from near Low Wood. Tom Jacksons the Pack Horse Aug 2d 1780 9/*
Presented by Ian Fleming-Williams, 1996 [1996.501]

¶ Rashleigh made a tour of the Lake District in 1780, and filled a sketchbook with drawings.[1] This view shows the inn on the east side of Lake Windermere, which was a standard hostelry for visitors to the lakes, and the great basin at the head of the lake, which gave wide-ranging views of the Furness and Cumbrian mountains.

1. according to Ian Fleming-Williams's notes; I have not traced this sketchbook.

105
Revd William Henry Barnard (1767-1818)
Houses in Holywell Street
pencil and grey and yellow washes, 308 × 385
inscribed by C.F. Bell on the old backing, *Part of Holywell Street (?) Oxford*
Prov.: Walker's Galleries; Ian Fleming-Williams; Sotheby's, 9 April 1992, part of lot 8; Abbott and Holder

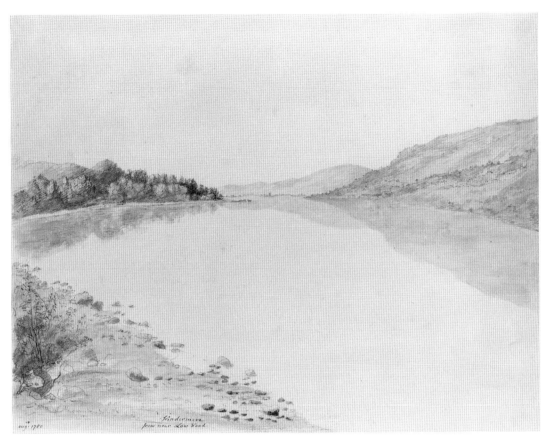

104

Presented by Miss Anne Lyles in memory of
Ian Fleming-Williams, 1998 (1998.141)

¶ Barnard was one of Malchair's most faithful
disciples, who arrived at Oxford with a fully
formed drawing style, characterized by crisp
ink outlines, but abandoned it wholeheartedly
under Malchair's influence. He travelled
widely in the decade following his ordination
in 1793, visiting the Wye Valley, Ireland, and
even Madeira. His drawings of Oxford, which
date from 1793 to 1795, include many that are
deceptively similar to Malchair's. This example
shows the first few houses belonging to
Wadham College on the north side of
Holywell Street, the farthest building being the
King's Arms on the corner of Parks Road.

106 (illustrated page 39)
Revd William Henry Barnard (1769-1818)
Portrait of Malchair playing the Violin
pencil and brown and yellow washes, 240 × 171
(sight)
inscribed in ink, *Malchair*; further inscribed in
red chalk on *verso*, W.H. Barnard Malchair
Prov.: Sotheby's, 29 January 1947, lot 44;
Walker's Gallery; A.P. Oppé (no. 2314); given
by Miss Armide Oppé to Ian Fleming-
Williams, *c*.1985
Lent from a private collection

¶ Four portraits of Malchair are known: the
Self Portrait reproduced here as pl. 1; the head
of Malchair in Sandby's etching of figures at
the Rysbrack sale in 1764; and two affectionate
and not wholly serious figures attributed to

Malchair's pupil, Barnard, of which this is the more accomplished (the other is in the Ashmolean; Brown, no. 318). Since Barnard did not matriculate from Pembroke College until 1790, the drawing must show Malchair in his final moments as a violinist.

107
John Constable (1776-1837)
Glaramara from Borrowdale
pencil on wove paper, 409 × 343
inscribed faintly in pencil on *verso*, *Will you Sup with me at 9 o clock to […] Wed Morn^g*
Prov.: Sir John and Lady-Witt; Sotheby's, 19 February 1987, lot 110
Lit.: Ian Fleming-Williams, *Constable and his Drawings* (London, 1990), pp. 89-91; Fleming-Williams, 1994-5, no. 12
Lent by David Thomson
¶ Like Malchair, Constable rarely went on sketching tours, but rather sketching while visiting friends and family in different parts of England. His tour of Westmoreland and Cumberland in autumn, 1806, was, however, made for its own sake, and produced some ninety drawings. This is among the largest and most powerful, and marks a new departure in Constable's drawing with the pencil. Fleming-Williams has speculated that William Crotch, whom Constable had come to know recently, had shown him Malchair's large Welsh drawings that he had been given by George Jenner, and that this prepared him for the spectacle he found in the Lake District. Certainly, the drawings he made in Derbyshire in 1801 are quite different, spare but florid in the chalk and fluid in wash. To an artist accustomed to the pastoral peace of Suffolk or Oxford, the enormity of the mountains in the Lake District or Wales offered a release from past practices and demanded a new means of expression. Even if Constable had not seen Malchair's Welsh drawings, he would have understood and sympathised with their

solution to the problem of representing the primeval grandeur of nature.

108
Tunes composed by John Malchair for the 3 stringed Violin in 2 Parts or Books, also Part III consisting of others for the common Violin, The whole adapted by Wm Crotch for the Piano Forte
oblong quarto manuscript, bound in calf, the pages numbered from 1 to 52, with preliminaries iii to viii
Prov.: T.W. Taphouse, from whom bought by the Bodleian Library, 10 December 1878
Lent by the Curators of the Bodleian Library (MS Mus. d. 32)
¶ The tunes included in this volume all derive from Malchair: those in the first part and the first twenty-two of the second, from a manuscript, written 'in a very large hand'; the remainder, written down by Crotch from Malchair's fiddle playing after he became blind. Those in the second category bear dates from 13 June 1783 (III, no. 28) to 3 December 1799 (II, no. 31), and were dictated to Crotch on his daily visits to his ailing master in Broad Street.

109
The Third Collection of Tunes
oblong quarto volume, inscribed by Malchair on a paper label on the upper cover, *Vol. 3 The Third Collection of Tunes*
Prov.: Robert Jones, and presumably by descent; Lewis Davies Jones of Bangor, by whom presented to the Folk Song Society, July 1907
Lit.: Maynard Dean-Smith, 'The Preservation of English Folk Song and Popular Music; Mr. Malchair's Collection and Dr. Crotch's *Specimens', Journal of the English Folk Dance and Song Society*, VII (1953), pp. 106-11; Willetts 1983
Lent from the Vaughan Williams Memorial

Library, Library and Archive of the English
Folk Dance and Song Society, Cecil Sharp
House

¶ This is the third volume of the set of at least
four devoted to native music collected by
Malchair; according to Lloyd Williams, it was
found by Lewis Davies Jones in 'a heap of
rubbishy second-hand books on a stall in
Bangor market'. It is written entirely in
Malchair's hand up to p. 118; the third tune
on p. 119 and the whole of p. 120 are in the
hand of Dr Crotch, the upper part of pp. 126-7
and the whole of p. 132 are again in
Malchair's hand, and the remainder in a third,
unidentified hand.

110

The Arrangement

oblong quarto volume, bound in half calf with
marbled boards, of 19 ff., 278 pp.

inscribed by Malchair on a paper label on the
front cover, *The Arrangement* [*Vol. 4.* crossed out]
*Being an Extract of the Welsh, Irish, and Scotch
Tunes, contain'd in the foregoing Vols, & placed in
seperate Classes.*

Lent from the Library of the Royal College of
Music (MS 2091)

¶ According to an inscription on fol. 2, this
volume was begun on 8 June 1795, and
'consists of Welsh, Irish and Scotch tunes,
which before were collected promiscuously in
several books, but now are all written in one
book and the musick of each of those Nations
by itself a distinct Class'. Malchair intended
the collection to be a comprehensive
illustration of the various categories and styles
of national music, 'probabely all the different
characters of Melodie that ever were, and are
now in use with the nation it belongs to.' The
laborious undertaking occupied some years,
and the final pages were written by Dr Crotch.

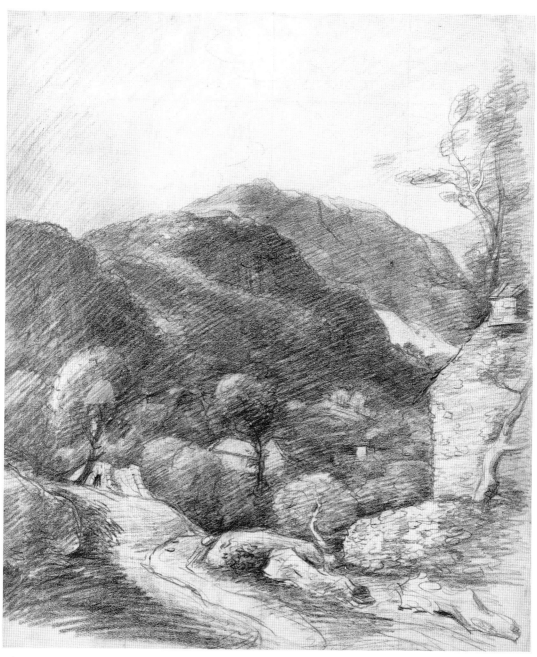

107

Select Bibliography and Abbreviations

Malcolm Andrews, *The Search for the Picturesque* (London, 1989)

Carl Paul Barbier, *William Gilpin: His Drawings, Teaching, and the Theory of the Picturesque* (Oxford, 1963)

Peter Bicknell and Jane Munro, *Gilpin to Ruskin: Drawing Masters and their Manuals, 1800-1860* (exh. cat., Fitzwilliam Museum, Cambridge and Dove Cottage and Wordsworth Museum, Grasmere, 1987-8)

Brown
David Blayney Brown, *Ashmolean Museum Oxford, Catalogue of the Collection of Drawings*, IV, *The Earlier British Drawings: British Artists and Foreigners working in Britain born before c.1775* (Oxford, 1982)

CCC, I [-XI]
Corpus Christi College, Oxford, MS CCC 443, eleven sketchbooks by Malchair and a pupil

The Picturesque Landscape: Visions of Georgian Herefordshire (exh. cat., ed. Stephen Daniels and Charles Watkins, University of Nottingham, 1984), pp. 34-7

Margaret Dean-Smith, 'The Preservation of English Folk Song and Popular Music: Mr Malchair's Collection and Dr Crotch's *Specimens*', *Journal of the English Folk Dance and Song Society*, VII (1953), 106-11

L.G. Duke, *Catalogue of my Collection of Early English Drawings and Watercolours* (unpublished MS, begun 1942; Tate Gallery)

Judy Egerton, 'L.G. Duke and his Collection of English Drawings', *OWCS Club Journal*, XLIX (1974), pp. 11-29

The Diary of Joseph Farington, ed. Kenneth Garlick and Angus Macintyre, II & IV (New Haven and London, 1978-9)

Fleming-Williams 1965-I
Ian Fleming-Williams, 'Dr William Crotch (1775-1847), Member of the Oxford School and Friend of Constable', *Connoisseur*, CLIX (1965), pp. 28-31

Fleming-Williams 1965-II
Ian Fleming-Williams, 'John Skippe: Notes on his Life and Travels', *Master Drawings*, 3 (1965), pp. 268-75

Fleming-Williams 1968
Ian Fleming-Williams, 'Appendix I: Drawing Masters' and 'Appendix II: Amateurs', in Martin Hardie, *Watercolour Painting in Britain*, 3 vols (London, 1968), III, *The Victorian Period*, pp. 212-244

Fleming-Williams 1969
Ian Fleming-Williams, John Malchair of Oxford: Some newly discovered Drawings', *The Connoisseur* CLXX, (1969), pp. 170-71

Fleming Williams 1971
Ian Fleming-Williams, 'The Finches of Packington', *Country Life*, 15 July 1971, pp. 170-4; 22 July 1971, pp. 229-32

Fleming-Williams 1990
Ian Fleming-Williams, *Constable and his Drawings* (London, 1990)

Fleming-Williams 1994-5
Ian Fleming-Williams *et al.*, *Constable, a Master Draughtsman* (exh. cat., Dulwich Picture Gallery, 1994; Art Gallery of Ontario, Toronto, 1995)

Fleming-Williams MS
Ian Fleming-Williams, chapters II-V (each paginated separately) of an unpublished biography of Malchair (copy in the Archives of the Department of Western Art, Ashmolean Museum)

J. Foster, *Alumni Oxonienses*, 4 vols (Oxford, 1800-00)

Louis Hawes, *Presences of Nature: British Landscape 1780-1830* (exh. cat., Yale Center for British Art, New Haven, 1982)

Holland-Martin MS
Twelve letters from Malchair to John Skippe, in the Holland-Martin family Archives

Henri Lemaitre, *Le Paysage anglais à l'aquarelle 1760-1851* (Paris, n.d.)

Anne Lyles and Robin Hamlyn, *British Watercolours from the Oppé Collection, with a Selection of Drawings and Oil Sketches* (exh. cat., London, Tate Gallery, 1997)

John H. Mee, *The Oldest Music Room in Europe: A Record of Eighteenth Century Enterprise at Oxford* (London and New York, 1912)

Minn 1943-4
H. Minn, 'Drawings by J.B. Malchair in Corpus Christi College', *Oxoniensia*, VIII-IX (1943-4), 159-168

Minn 1957
H. Minn, 'Letters of J.B. Malchair, the Eighteenth-Century Oxford Artist', *Oxoniensia*, XXII (1957), 98-103

A.P. Oppé, 'The fourth Earl of Aylesford', *Print Collectors Quarterly*, II (1924), pp. 262-92

Paul Oppé, 'John Baptist Malchair of Oxford', *Burlington Magazine*, (1943), pp. 191-7

Petter
H.M. Petter, *The Oxford Almanacks* (Oxford, 1974)

Kim Sloan, 'Drawing – A "Polite Recreation" in Eighteenth Century England', in *Studies in Eighteenth Century Culture*, II, ed. Harry C. Payne (Madison, 1982), pp. 217-40

Kimberly Mae Sloan, 'The Teaching of Non-Professional Artists in Eighteenth-Century England', unpublished Ph.D. thesis, Westfield College, University of London, 1986

John Sparrow, 'An Oxford Altarpiece', *Burlington Magazine*, CVII (1960), pp. 4-7

E. Waterhouse, 'Paintings and Painted Glass', in *The History of the University of Oxford*, V, *The Eighteenth Century*, ed. L.S. Sutherland and L.G. Mitchell (Oxford, 1986), pp. 857-64

Account of a lecture on Malchair given by the Revd Dr Henry Wellesley in *Proceedings of the Oxford Architectural and Archaeological Society* (1862), pp. 148-51

Williams
Iolo A. Williams, *Early English Watercolours and some Cognate Drawings by Artists born not later than 1785* (London, 1952)

S.L.F. Wollenberg, 'Music and Musicians', in *The History of the University of Oxford*, V, *The Eighteenth Century*, ed. L.S. Sutherland and L.G. Mitchell (Oxford, 1986), pp. 865-87

Appendix

The following list, formerly in the collection of Ian Fleming-Williams, is in Malchair's handwriting, and was made after his return to Oxford in September, 1795. The entries have been numbered according to the numbers written by Crotch on the *verso* of each drawing.

A List of the drawings which were made on a toure in the Oxford long Vacation of the year 1795

20. July 22. A view of part of the River Severn and the country on each side of it (as seen from the Stinch Combe Hill in Gloucester Shire: this drawing is from recollection. At the time of Viewing this sceen a rainy cloud passed over the center of it the darkness of which produced a solemn effect.

21. Part of the same River from below Stinch Combe hill drawn at Sun Set, the strong light bursting from behinde a dark cloud was inimitable.

22. July 23. A view of the road in a laine under Stinch Combe hill near Mr. Wallingtons at Pears Court, being viewed at sun sett the effect was Gloomy which sett of to great advantage a briliant light on the naked bank on which the sun glanced trough the trees.

23. July 24. Newnham Ferry, the Church stands on a rocky bank, this sceen was assisted by a stormy skye, it was lowe Water, but the Sandy bottom even apeard enchanting through the prismatic effects of the storm.

24. July 26. A View of the Church at Welsh Poole, Drawn under the Wall of Powis Castle. In the distance apear the

Mountains which bounde the Northeast part of the Vaile of Montgomery.

25. An other drawing from near the same spot with the one immediately before only that here is seen part of Powis Castle.

26. July 28. Now the country becomes suddenly Welsh and we enter a region of Mountains, here English is an acquired language and much wors spoaken than french in England, by no means so common. The trees are small and twisting often More pictoresque than luxuriant timber trees, the verdure of the ground is More vivid particularly at the foot of the Mountain where it consists of Moss crumbled over with fragments of rock that continually role from the topp and are verry favourable to the painters touch as are also the summits on account of theire cragginess, the collouring here is infenitely more various than in a reach farming country, the buildings are peculiar, Rude Rough and ragged, the people are so too. all produces a new tone of collouring for the pictur, and the pallet Must abound with black brown Russet, gray, which, when mixed with Indico, Oaker, lack and Vermilion in all manner of proportions, wil furnish the proper complexion for that Sort of country, as we may see in the pictures of Salvator Rosa.

The first drawing this day, was a lonely Farm house on the road and near midway between Canoffice and Dynas Mowddwe or Mouthwy, here the Mountains of Dynas first appear on that road.

27. The Mill at Nant Rhyddod four Miles from Dynas, Nant is welsh for Vally; this place is wild and worthy of the painters attention.

28. The entrance in to Dynas M. from the turnepike.

29. The River Dovy in the Vally of Dynas near Pont finant.

30. July 29. The red Lion at Dynas.

31. A View up the streat at Dynas to the South, close by the Great Inn.

32. July 30. A View of Dynas from the nort

33. The water rushing down the bank over the street in Dynas.

34. July 31. In the Meaddow below Dynas looking toward Arran Mouthwy

35. Gross Llewid Mill two miles from Dynas.

36. Pont Finant over the Dovy near Dynas.

37. August 1. In the yeard of the Goat our quarters

38. August 2. A loanely house

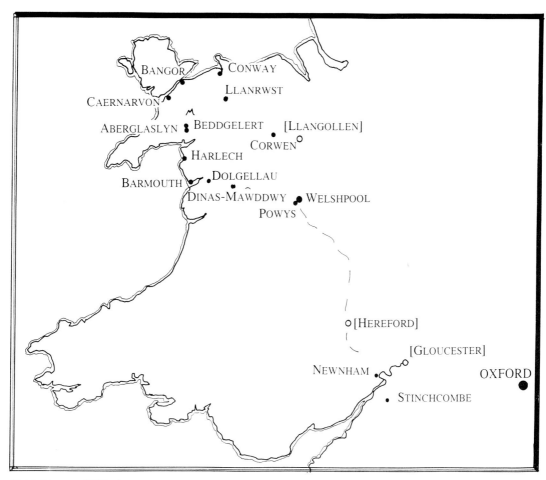

Malchair's tour of Wales in 1795

near Dynas on the road to Dolgethly and under Crag y Dynas this drawing we caled the hedgehog on account of its sharp touch.

39. August 3. In the Street at Dynas looking East.

40. The road from Dynas to Dolgethly by the corner of the Goat a wagon on the left of the spectator

41. A Mill near Dynas on the Dolgethly road.

42. Bridge and fall of water near the mill preceeding

43. August 4. Moel y Frydd near Llanummowddy in the road to Arran Mouthwy

44. source of the River Dovy on the same Road

45. Bulky Gross on the Same Road to Arran

46. August 5. The River Dovy at Pont Finant with the vally & mountains near Dynas, a larger Drawing than the one before and

rather from a better point the paper soaking Wett with rain when drawing.

47. August 6. in the pass between the Mountains between Dynas & Dolgethly

48. The first apearance of Cader Ideris on the same road at the end of the pass.

49. August 7. Near barmouth on the road to Dolgethly.

50. Near barmouth on the same road

51. View of Barmouth harbour at the tourne of the corner from Dolgethly to that place, a sudden surprise, the skey hapend to tourne favourable during our drawing this sceen the clouds opening, a Sun beeme glanced on the waters which gave a surprising effect to that simple landskip.

52. August 8. Part of Barmouth near the harbour, here we had a great crowd of spectators, men women and children chattering welsh like so Many Monkyes, the sea sand whirled over the house, quite coverd our paper.

53. View of the shipping at anchor in barmouth harbour.

54. A rock rising out of the sand at Barmouth, here we heard a Sect called jumpers at theire abominable & rediculous devotion.

55. August 9. Distant View of Barmouth at ebb, from the sea side on the sands.

56. August 11. A View of the North front of Harlech Castle

57. A View of ditto from the southeast

58. Of Ditto from the East.

59. The houses at the entrance of Harlech from barmouth

60. August 12. A view from harlech looking Westward toward Snowdon over the traught or sea sands.

61. Beth Callerd Church

62. Aug. 13. Pont Aberglasslyn from below the bridge this day int Thundered with excessive rain and by the papers we learned that the Storme of that day was universal and verry severe indeed at Oxford, we were forced under shelter during oure operation and the paper was wetted several times.

63. August. 14. Beth Callerd Church from distant.

64. Aug. 15. In the pass between the Rocks near Pont Aberglasslyn, here the winde was troublesom.

65. In the Valley between Pont Aberglasslyn and Beth Callerd a solemn Evening light

66. Aug. 16. Pont Aberglasslyn from above bridge

67. Aug. 18. Eagle tower of Carnarvon Castle, the birth place of Edward the 2d.

68. Ditto from South East across the Stream.

69. Aug. 20. Llanwrust Bridge built by In. Jone.

70. Aug. 21. A Bridge over a deep Glin between Corven and Kennioggi. A masterpiece of Moderne Massonery finished in 1793.

All the drawings Malchair made on his Welsh tours passed to his pupil, William Crotch, whose numbers in red crayon are written on the *versos*. Those currently known all resurfaced in 1942. Their present whereabouts are as follows:

National Library of Wales 4, 10 or 35, 23, 30, 36, 38, 42, 53, 56, 58, 61
National Museum of Wales 31, 32, 60
Tate Gallery 43, 52
British Museum 67
Yale Center for British Art, New Haven 24
Ingram Family Collection 55
Mr & Mrs Edward Williams 48
R.E. Alton, M.C. 45
Private collections 3, 8, 23, 27, 37, 38, 39, 44, 46, 51, 54, 56, 57, 59, 65-6, 70

Nos. 20-22, 26, 28-9, 34-5, 40-41, 47, 49, 50, 58, 62-4, 68-9 did not come to light in 1942 and are presumed to have been destroyed.